COLLECTING MEXICO

COLLECTING MEXICO

Museums, Monuments, and the Creation of National Identity

✿ ✿ ✿

SHELLEY E. GARRIGAN

University of Minnesota Press
Minneapolis · London

Portions of chapter 3 were previously published as "Museos, monumentos y ciudadanía en el D.F. de México," in "Exposiciones, ferias y cultura material en América Latina, 1860–1922," special issue, *Estudios: Revista de investigaciones literarias y culturales* 10/11 (2004). Republished in Stephan González, Beatriz Andermann, and Jens Andermann, eds., *Galerías del progreso: museos, exposiciones y cultura visual en América Latina* (Buenos Aires: Beatriz Viterbo, 2006).

Portions of chapter 4 were previously published as "Collections, Nation, and Melancholy at the World's Fair: Re-reading Mexico in Paris 1889," in "Perspectivas sobre el coleccionismo," ed. María Mercedes Andrade, dossier edition, *La Habana Elegante: revista semestral de literatura y cultura cubana, caribeña, latinoamericana y de estética* 46 (Fall–Winter 2009).

Published by the University of Minnesota Press
111 Third Avenue South, Suite 290
Minneapolis, MN 55401-2520
http://www.upress.umn.edu

Library of Congress Cataloging-in-Publication Data

Garrigan, Shelley E.
 Collecting Mexico : museums, monuments, and the creation of national identity / Shelley E. Garrigan.
 Includes bibliographical references and index.
 ISBN 978-0-8166-7092-5 (hc : alk. paper)
 ISBN 978-0-8166-7093-2 (pb : alk. paper)
 1. Cultural property—Social aspects—Mexico. 2. Exhibitions—Mexico—History—19th century. 3. Museums—Social aspects—Mexico. 4. Mexico—Antiquities—Social aspects. 5. National characteristics, Mexican. 6. Mexico—Cultural policy—History—19th century. I. Title.
F1210.G47 2012
972—dc23

 2012001199

Printed in the United States of America on acid-free paper

The University of Minnesota is an equal-opportunity educator and employer.

18 17 16 15 14 13 12 10 9 8 7 6 5 4 3 2 1

Contents

❀ ❀ ❀

Introduction

❁ ❁ ❁

At the close of the Paris World's Fair of 1889, an exchange of cultural goods was negotiated between the founder and director of the Musée d' Ethnographie du Trocadéro of France and the chief Mexican fair commissioner. With his eye on the mannequins in the Mexican pavilion that had been fashioned to represent particular indigenous races, French anthropologist Dr. Ernest Théodore Hamy petitioned for the "donation or exchange" of these life-size models to form part of a permanent exhibit in the French museum. "Books or other objects" were offered as tentative compensations. After an unspecified number of conferences between the parties in question, there was an agreement that the French government would offer a large vase from the National Factory of Sèvres to the Mexican Secretaría de Fomento as a souvenir of the Paris Exposition. On his return to Mexico in June 1890, José Ramírez wrote of the honor it was to deliver this mass-produced "work of art," which he interpreted as one of the many "testimonies of kindness" shown to the Mexican commission by the French hosts of this world event.

This exchange of mannequins for vase, which forged a sense of equivalency between two such different examples of commercial and cultural production, marked the era of a new diplomatic relationship between Mexico and France. The years of mutual tension that had spanned the decades between Mexican independence in 1821 and the liberal reform of 1867 were now over. And yet involved here was not only the exchange of one material thing for another that ultimately indicated diplomatic compatibility[1] but also the reconciliation of two theoretically opposed qualities of value.[2] The exchanged objects were each representatively "national" and considered to be equivalent to one another and yet had originated from radically different systems of value: one stood for "nation," and the other was a sample of national

1

production. In the swapping of gifts, the mannequins as components of a representative Mexican national collection underwent an immediate yet drastic change in status through their introduction to market value. This particular intersection of value systems that occurs in late-nineteenth-century Mexico—the transcendent, national–mythological perspective and the exchangeable, temporal mode of the commercial product—invites a closer look at the patrimonial objects that formed the Mexican canon during the late nineteenth century. The mannequin story indicates that there is more to these objects than a direct connection to history. When viewed during the phases of initial consolidation, it is the inherent ambiguity, instability, and contradictory nature of those objects that embody transcendent meanings about nation that reveal their true force as storytellers.[3]

Why retell the story of Mexico's political and cultural consolidation through a series of collected objects? First of all, broadly speaking, this project falls in line with a series of critical studies, spearheaded in part by Nestor García Canclini and Nicolas Mirzoeff in the 1990s and evolving into the work of such scholars as Esther Gabara, Jens Andermann, Beatriz González-Stéphan, and Andrea Noble, that contest Eurocentric paradigms of hegemony by recasting stories of Latin American modernities into the lenses of visual, spatial, and material expressions of culture. Second, though the geographical and chronological boundaries of this study are specific, I have found the material object and its peculiar way of embodying ideology to be one that links past, present, and future to different geographical contexts on multiple fronts. Despite the important and obvious differences, the assembly of a collection in the age of virtual museums and digital patrimony has something fundamental in common with both the pre-Columbian and the colonial object displays: the projection of a point of view through things. The set of close readings of a particular series of collection processes offered here provides a vantage point that proves useful, therefore, in myriad contexts—wherever larger questions of identity, social position, and cultural–capital exchanges converge.

Many of the writings through which national projects were articulated during the Porfiriato were bolstered with references to physical objects—be these artistic, archaeological, architectural, or scientific. Somehow, the objects made the stories seem more real. The three-

dimensional, tangible object adds something to the Mexican political narrative that cannot be expressed through any other means: the irreducible truth of physical presence.

Closer scrutiny reveals patterns among the institutionally sanctioned collections of late-nineteenth-century Mexico that point to their curious ability to engender social meanings. Despite their grandeur, the objects highlighted in public speeches and newspaper circulations throughout the Distrito Federal were not referred to so much as isolated artifacts with unique and individual historical circumstances as components of larger collections. Even when a given object seemed to surface publicly as a unique thing, as in the unveiling of a national monument on the Paseo de la Reforma, there was a distinct tendency to regard it as part of a larger project. Transposed into theoretical terms, it can be said that already on its introduction into the public sphere via some form of exhibition, the collected object has shifted into a new economy of meaning—one that foregrounds the collective over the individual and the current act of meaning making over the transmission of original contexts.

Another factor that distinguishes the types of collections that surfaced in late-nineteenth-century Mexico is their official endorsement. Institutions such as the Museo Nacional, the Secretaría de Fomento, the Sociedad de Estadística, and the Academia de San Carlos provided the means for object displays to be linked to abstract and symbolic meanings about the nation. Through the speeches pronounced at the unveiling ceremonies of national monuments, the newspaper commentary following national art exhibitions, and the brochures that accompanied museum exhibits or world's fair pavilions, displayed objects embodied and transmitted social messages to national and international audiences. The coincidence with similar processes in other nations, evident in the concomitant number of museum openings and world's fair events that occurred in Latin America, the United States, and Europe during the last decades of the nineteenth century, adds a competitive tension to the culture of national collecting that approximates the dynamic of the market.

Owing to the historical coincidence of modernization and Mexican political consolidation that were initiated with the liberal triumph of 1867, the creation of a nascent capitalist consciousness developed

alongside the assembly of a national patrimony. As a result, the displayed objects that were introduced to the public visual sphere at this time—whether in the form of temporary public art exhibits or more permanent outdoor public monuments—quite paradoxically embodied aspects of both. In this collision of opposing value systems that underlies the displayed objects studied here, the idea of *nation* acquires a particular type of persuasive force that cannot be adequately understood by examining the official histories of the key icons of Mexican cultural consolidation as separate entities. While the importance of specialist studies is not to be understated, the point of this investigation is to prompt questions that only a comparative study can incite.

In fact, taken together, the theoretical parallels that run throughout the collections studied here—fetishism, origins, narration, order, authority, melancholy, and the rhetoric of error or loss—brought me to the crux of my argument. I do not view the central drive behind national patrimony as capitalist per se—it's not that the patrimonial object pretends to embody a quasi-religious national quality while really qualifying as an object of exchange like any other. What I claim does lie at the very core of patrimony is a dialectical tension *between* those two opposed systems of value. And it is that same tension that not only charges the object with a type of power that could not be equaled were it linked to only one system or the other but also remains largely unrecognized primarily because the commercial side of the dynamic remains, for the most part, hidden. Thus much of the investigation that follows involves teasing out and highlighting that understated and largely unspoken market quality that intersects with national patrimony at the foundational level.

The coincidence between patrimony and product located in this study introduces a problem that goes far beyond that of contemplation versus possession. If the commercial object can be defined by its inherent capacity to be extracted, produced, created, or conceived as a thing that can be used to obtain something else, then the implied value system presupposes the constant possibility of the object's exchange. In this sense, the value system represented by commercial objects presents a potential threat to a community that is still in the process of defining itself. With their connotations of legacy, inheritance, and permanent mythological value, in contrast, the objects of national patrimony that

served as reference points for Mexico's recently reintegrated statehood should stand in stark opposition to the transience of the commercial product. When this is not the case, however, and when the commercial subtext of patrimony shows up as significant yet hidden, there is an opportunity to view the vulnerability of meaning making at its very core. Reconstructing the actual transactions that underlie our culturally sacred objects advances our understanding of identity by shattering the myth of presence—that aura of truth that surrounds hallowed objects—and accessing the concrete transactions and potentially subversive circumstances under which cultural icons come into being.

In Mexico, public collections collided with national policies that took shape under the imperative of order that informed late-nineteenth-century liberal administration and rhetoric. In its double meaning as both command and physical arrangement, the concept of *order* describes not only the introduction of homogenizing reform policies and consolidation efforts that began in Mexico after the liberal overthrow of Emperor Maximilian in 1867 but also one of the key criteria through which to assess the status of national collections attributed with symbolic importance. Two decades later, for example, the *disorder* of the pile of archaeological objects collecting on the patio of the Museo Nacional led to the strategic creation of official physical and disciplinary spaces through which to both nationalize that patrimony and make it accessible to expanding national and international viewing publics. In theoretical terms, this overlap between the physical (the literal spaces in which objects were housed) and the abstract (the disciplinary or academic areas into which such objects were categorized) in the creation of meaningful spaces marks not only a distinct attitude about collecting that shows up in late-nineteenth-century patrimonial discourse but also the emergence of the modern state in the form of physical and abstract referents such as charts, graphs, maps, canons, and disciplines. As argues Jens Andermann with reference to Brazil and Argentina in *The Optic of the State*,[4] the production of visual representations and intentional spaces in national museums, world's fair exhibitions, and national maps was inextricably linked to the establishment of political autonomy during the late nineteenth century.

Independence, Unrest, and the Quest for Order

A brief overview of the political, social, and economic instability that characterized early- and mid-nineteenth-century Mexico will elucidate the pursuit of order that shaped the political and cultural institutions examined in this study. The most obvious challenges for the newly autonomous nation were political in nature, as Mexico faced not only decades of internal political dissent that would render long-term policy making next to impossible but also foreign loans, invasions, and coastal occupations from Spain, France, and England that produced large amounts of external debt.

It did not take long for contrasting political views to clash in Mexico following its independence from Spain. The question that divided the governing constituent body from the time of its first meetings in November 1823 was whether the new republic should be federalist (with a strong state government and separation of church and state) or centralist (with a strong central government and a politically empowered church).[5] Advocates of the federacy based their arguments on the success of the United States and concerns over the despotism inherent to centralized governments. The centralists, conversely, advocated the need for a stronger union following the war and stressed the inherent differences between Mexico and the United States that ultimately rendered any comparison moot.[6]

Though federalists won the initial debate and created the constitution of 1824, clashes and battles between the two opposing factions would set the tone for internal politics until Benito Juárez led the successful liberal Reform of 1876. During the era of centralization (1833–55) under the on-again, off-again presidency of war hero Antonio López de Santa Anna, the presidency was occupied thirty-six different times, with an average term of around seven and a half months.[7] Between 1824 and 1857, there were no fewer than forty-nine different national administrations between the presidency (which shifted hands among sixteen different occupants) and "provisional chief executives," of which there were thirty-three.[8] Although there was a paradoxical degree of continuity due to government offices drawing from the same pool of *hombres de bien*—or the "well-educated professionals and military officials" who assumed most of the first thirty years of national political office—the combined

internal dissent and foreign conflict proved detrimental to Mexican stability during the first three quarters of the nineteenth century.[9]

The Revolution of Ayutla, an armed revolt that expelled Santa Anna from power in 1855, marked the beginning of a two-decade period of political reform and leadership by liberal hero Benito Juárez. Though it was powerful and full of promise, the Juárez administration was temporarily ousted by the French-imposed Austrian emperor Maximilian I (1864–67), who benefited from a short-lived conservative line of support from within that branch of the Mexican elite.

The first of the nineteenth-century foreign invasions of Mexico was an attempted reconquest by Spain that took place less than a decade after independence had been established.[10] Determined to recapture their lost territory, an exhausted group of three thousand Spanish troops commanded by General Isidro Barradas landed at Tamaulipas in July 1829. Sickness and inadequacy of supplies led Barradas to surrender to Santa Anna within three months. The retaliation that ensued against the few remaining Spanish merchants living in Mexico provoked an exodus that negatively affected the already weak Mexican economy.[11]

More foreign encroachments and territorial disputes soon followed. The property damage suffered by French national residents of Mexico during the armed revolts and counterrevolts that plagued the early years of independence led to the French invasion of Veracruz in 1838. Because one of the more famous appeals to King Louis-Phillipe was made by a French pastry cook who, in 1838, claimed that his Mexico City bakery had been ruined by Mexican officers ten years earlier, the first French invasion of Mexico became known as the War of the Pastries. Although the French eventually retreated, Mexico assumed a debt of six hundred pesos in claims for property damage to French citizens.[12]

The loss of Texas in 1836, provoked by a series of grievances between U.S. colonizers and the Mexican government (the most serious of which was the annulment of the federalist government under Santa Anna in 1829), sparked events that would culminate in the Mexican–American War (1846–48) following the state's U.S. annexation in 1845.[13] Between the Treaty of Guadalupe Hidalgo of 1848, which ceded Texas, California, and New Mexico to the United States, and the subsequent Gadsden Purchase of 1853, Mexican national territory was cut by more than half. Despite this national humiliation, however, the communal pain of loss

and accompanying Yankeephobia helped inspire what might have been the first sense of a unified Mexican nationalism.[14]

The inherent link that binds the collective experience of loss with some heroic manifestation of patriotism is an interesting one that will receive further attention in this book. The rich legacy of indigenous ruins, the duration of Mexican colonial occupation, and the tumultuous path toward political consolidation together form the complex substance from which the modern national epic and material cultural referents emerged. In addition, there are strong theoretical links between loss as an originating state and collecting as both an expression of and means of overcoming it. As a result, some of the key material icons of larger national collections (such as the monument to Cuauhtémoc and the baptismal stone of Padre Hidalgo) embody a sense of inherited and collective mourning that imbues the nation's rocky journey of colonial emancipation, political consolidation, and modernization with the coherence that only founding stories can provide.

By the mid-nineteenth century, or approximately forty to fifty years after independence, Mexican politics was divided between the liberal and conservative perspectives.[15] The conflict reached its apex in the War of the Reform (1858–61) with a victory for the liberals, led by the aforementioned Benito Juárez (1806–72), the war hero of Zapotec descent who would serve five presidential terms between the years 1858 and 1872. Meanwhile, the demands of repayment by European creditors, including England, Spain, and France, led to a convergence of their respective troops on the coast of Veracruz in December 1861. Supported by Mexican conservatives and the Church, the French army marched inland, suffered defeat in Puebla on May 5, 1862, and managed to regroup and take the city a year later. Owing to a lack of military reinforcement, President Juárez evacuated Mexico City on May 31, 1863, seeking temporary retreat in San Luis Potosí. Under the influence of Emperor Napoleon III, a delegation of Mexican conservatives traveled overseas to offer the Austrian archduke Ferdinand Maximilian of Hapsburg the crown of Mexico, thus initiating the nation's last foreign occupation, which would last for approximately four years.[16]

Supported by the Lincoln administration's concern over Europe's disregard of the Monroe Doctrine, Juárez initiated his battle campaign against Maximilian and his conservative supporters in spring 1866. He

gained ultimate victory in May 1867, when the defeated emperor sur-
rendered his sword in Querétaro.[17] The period that followed, which
would prove to be the longest stretch of political stability since the
colonial era, is described as La Reforma: the victory of the pro-capitalist
and anticlerical liberals over the outdated conservative regime. The
triumphant *liberales,* although not exempt from internal dissonance
among themselves,[18] had to search for historical justification of a new
order that was capable of assembling a coherent citizenry from among
a vast linguistic, geographic, and economic heterogeneity.

Marking an end to decades of turmoil, the political reforms that
characterized the liberal triumph of 1867 shared the goal of propagat-
ing a sense of order through educational, social, and economic reforms
such as the nationalization of primary school education and the comple-
tion of the Mexico–Veracruz railroad. However, the potential foreign
investors who were desperately needed for economic stabilization were
detracted by the image of lawlessness and savagery that marred the na-
tion's international image and the rampant banditry that still rendered
travel within the country dangerous. As a result, the liberals prioritized
civil order.[19] Pronounced before the Juárez government in Guanajato
in 1867, Gabina Barreda's "Oración cívica" outlined the positivist per-
spective on reform.[20] One of Barreda's principal intentions with this
speech was to apply the Comptian doctrine of positivism to Mexico,
thus planting the rational basis for a philosophical and material order
capable of arranging the nation's chaotic past into a coherent and unified
perspective:

> To make quite clear that during all that time when it seemed that
> we were sailing without a compass and without a sense of direction,
> the progressive party, despite a thousand pitfalls and immense fierce
> resistance, has always headed in the right direction, even attaining after
> the most painful and successful of all our battles, the extraordinary
> result that we, amazed and surprised by our own achievement, are
> experiencing today, that of bringing to light the great social lessons
> learned as a result of the painful experiences which anarchy produces
> everywhere, and which cannot be erased until a truly universal doc-
> trine unites all intelligent minds into a common purpose.[21]

Known as the *científicos*, the inheritors of Barreda's positivism became the ruling elite during the Porfiriato. Their "scientific manifesto," to quote Leopoldo Zea, was pronounced in 1880 by Pedro Gutiérrez, a candidate for the governorship of San Luis Potosí. Published in the newspaper *La Libertad*, the manifesto highlights the centrality of scientific knowledge as a basis for "establishing the adequate conditions of order for society." Preoccupations over social rights were overshadowed by the prioritization of work and material advancement, which, it was emphasized, could only be achieved when the government was able to guarantee social order.[22]

It was during this time of fragile political stability in the late nineteenth century that there appears to have been a concerted and simultaneous effort by political and cultural institutions, such as the Secretaría de Fomento, the Academia de San Carlos, the Sociedad de Estadística, and the Museo Nacional, to fortify a sense of national coherence by assembling a national patrimony. Bolstered and propagated through displays of collected things, the creation of a series of complementary core national stories formed the key means through which to justify the presence of the autonomous Mexican nation, to create U.S. and European economic alliances, and to convince a divided citizenry to unify under the umbrella of an ideologically consolidated nation. The collections that resulted from this effort together produced the effect of order by disseminating a new and collective story of origins which, together with Barreda's advocacy of Comte's positivism, helped ground the sense of nation that came into being during the Porfirian era in various sets of material evidence.

Establishing Origins: In Theory and Practice

Once the liberal triumph was secured, the need for a new perceptual order inspired the search for a new and modern beginning that could reconcile the antagonistic extremes of decades of political strife on one hand and the assumption of positivist discourses of progress on the other. From the *liberales* to the later *científicos*, the Mexican imperative of progress articulates itself across a decisive lack of political consensus. The resulting political rhetoric straddles the divide that separates the dream of a strong position in the European league of nations from the

nation's irreducible and radical political, social, and cultural hetero-geneity.[23] After decades of civil strife had essentially crippled cultural production, the public collections that manifest must sustain a series of difficult reconciliations not only as liberals and conservatives alike are called on to contribute to the creation of a common patrimony but also as the needs of symbolic and market capitals intersect and collide.

Paraphrasing Hegel, Michael Taussig reminds us that the person or event implicated in history occurs twice: first as physical event and later as a historical and ideological reference point.[24] Likewise, in the perceptual logic of the collection, its beginning cannot be adequately described through the mere act of acquisition; it is also a retrospectively drawn boundary that is determined only after a series of related objects has been intentionally gathered and arranged.[25] While failing to coincide with the disparate origins of its individual objects, the collection resurrects the series of beginnings that it has missed and strategically reframes them into a shared point of view that asks to be regarded as objective and historical rather than subjective and aesthetic.

It was the need for a new beginning and the introduction of a collective perspective that were at stake in the *liberales'* public efforts to reconcile with the conservative factions once their own political hegemony was secured. As observes Stacie Widdifield, the rhetorical shift from a combative to a conciliatory slant is decipherable in the newspaper and other print circulations of and around the year of 1869.[26] In a manner that is analogous to the political projects of pre- and postemancipation from Spain, the rhetoric of revolutionary change before the Reform that had elaborated a strict set of ideological denouncements (principally of the theocracy and military repression) shifted into more conciliatory postures following the liberal triumph. Justo Sierra's historical justification of the military presence in national history, for example, posing as retrospectively sympathetic to the doomed conservatives, represents an exact ideological reversal of the traditional liberal perspective:

> Our poor grandparents! And how stupid are we, their grandchildren, to insult them with our irreverent irony when, going by the way we feel, we would have been incapable perhaps of the tiniest part of the effort that they needed to even live, always trying to bring order out of chaos, maintaining an imperfect and worrisome but positive control

by the Parliament over the administration, clutching to their breast, covered with mud, bloody and torn, but ours, the flag of our country.[27]

Partly in response to the widely publicized French accusations of Mexican barbarism after the assassination of Maximilian, and partly in reaction to the traditional liberal contempt for violence of all forms (including, and especially, that which culminates in revolutionary acts), Sierra here elaborates a justification of the ubiquity of the armed forces in Mexican political history. Addressed to future generations of Mexican leaders who may demand accountability for the omnipresence of the military in national history, Sierra's text is not so much restorative as assimilatory in the perspective that it constructs.

In fact, it is through the strategic manipulation of perspective that Sierra's choice in narrative intersects with the perceptual mode of the collection. The accountability that the author constructs for the nation's future liberals, like the origin of the collection that can only retrospectively be marked, is an example of history as narrated (or marked) from a projected future perspective. History, or the new arrangement of events that constitutes the historical perspective, is produced in the process of assembling what is still unfinished (in this case, political consolidation). This series that is being elaborated (a rearrangement of the events that compose Mexico's military history) requires the selective perspective of a narrator, who writes over the fragmented and partial narrations of the past and weaves them into a conciliatory synthesis of political visions. In this way, such reconciliation becomes, quite paradoxically, both history and future project—a theme that will recur at several points in the investigation that follows.

As Mieke Bal observes in *The Cultures of Collecting*, there are inherent connections between narratives and collections that bind them both practically and conceptually. Among them is the tension that exists between the "objective" event (or the physical object) and the subjective point of view (the narrator or the collector) that inevitably distorts the former while paradoxically offering us our only mode of accessing it.[28] Sierra's strategic layering of subjectivities (that of the former conservatives, the former liberals, and the "new" conciliatory liberal perspective) illustrates this tension between objectivity and subjectivity that characterizes both narration and the collection. There is, in both, that inevitable

gap between the historical or fictional "fact" or the material "truth" of a present object and the point of view through which that gap is bridged. Sierra thus reconciles otherwise opposing political perspectives by constructing an all-encompassing new story that includes them both. This story—which, transferred into the material realm of the collection, becomes a series of carefully selected things—"subsumes and presents the subjective views" of both the liberal and the conservative perspectives.[29] In this way, Sierra integrates what the revolutionary liberals criticized as the exaggerated military involvement in Mexican national affairs with a historical vision that neither opposes the new liberal quest for order nor rouses the defensive reflex of conservative parties. He recalls the events of history not to remember the lost contexts of their unique histories but to arrange them into a synchronous and conciliatory historical view.

In theoretical terms, the first step in the transition from object to collected object, or from objective to narrated history, is a process of emptying. As materializations of a unique and nonrepeatable coincidence of context and circumstance, the object-events that constitute narrative and the collection are emptied of their former content-values and recodified according to their relationships to the other components of a new sequence. The new sequence or series disguises its appropriation of isolated, nonserialized beginnings with its reinvested vision of history as synchronous, relational, and transposable. In the text quoted earlier, Sierra replaces chronology with what Baudrillard would call *seriality,* or a particular arrangement of events through which these acquire meaning only in relation to one another.[30] Also linking the otherwise disparate events of history or the diverse objects that come to constitute a collection is the implicit future-promise of completion (hence Sierra's implicit *destinatario*—the nation's future liberal leaders), which, as has been mentioned and will again be addressed, is dialectically tied to an equally persistent obsession with origins.

Sierra's justification of Mexican military history creates a tentative resolution between the opposing perspectives of revolution and stabilization by extending the boundaries of liberal revolutionary rhetoric. Quoting Comte, Leopoldo Zea points out that for stabilization to occur, the present order must be made distinct from the ideology of revolution: "Once the negative mission of the metaphysical doctrine is achieved, it should in turn leave the field to the positivist doctrine, which must

replace it."[31] There is something about his narrative strategy, then, that allows Sierra to make the irrational and so-called barbarous military history of a former colony fit within the vision of a stabilized nation dedicated to the liberal vision of progress. The text ends with a type of virtual inventory, a single backward glance over the object-events of history that reconfirms the new vision of a reconciled and integrated nation: "When the new nation turns its eyes to the past, it finds it comes to life and allows it to proceed devoutly, not like an august specter, but as the symbol and soul of an imperishable work."[32]

It is not only Sierra's framing of past events as historically over that confirms the newness of the Mexican nation, however. The nation's newness is that of the arrangement, the historical perspective that rewrites the circumstantial phenomena of history into a selective cohesion. Here the arrangement that Sierra offers is a list of military conflicts, dating back to the independence movement, that effectively and collectively prevented the military from ever withdrawing its presence. Attached to the inventory of the old nation is the cradle of the new era, which is allegorized in an account of the infancy of the late Benito Juárez. In this way of framing a historical perspective, the present status of the new nation remains just outside the point of narration, its place interrupted by another mark of beginning—that of the person of Benito Juárez, the liberal leader.

In a symmetrical manner, the biography of the hero ceases at exactly the point at which he would have emerged in the text as a fully integrated "liberal *consciente*."[33] Here the anticipated future-present (as the text is dedicated to tomorrow's leaders), which assumes the continuation of the liberal consolidation, is justified in the historical–biographical narrative. The closing points of both the national and personal inventories are not endings at all; rather, they are more like resting places, where each narration was simply left off in implicit invitation to the next addition to the chain of beginnings. A narrative template is established, and within it, as in the politically consolidating nation that must stitch radically opposed ideologies together, the completed story is not the point. Such is the perceptual mode of the collector, whose aim is arguably not so much that of attaining completion as of proceeding toward it in an indefinitely repeatable process of addition and rearrangement. And in the same way in which the conclusion is suspended, the

beginning is also demoted in the sense that it becomes an *effect* of the act of arrangement (or narration) rather than a point of causality or true originating force. Implied here in the logic of the storyteller or collector is the idea that beginnings are neither original nor permanent in that they are not only infinitely repeatable but replaceable as well.

Despite the importance of origins, locating the beginning of a narrative is as difficult as determining the beginning of a collection. Does the narrative begin with the first chronological event or at the point of its appropriation into a point of view? If the object exists before its appropriation, its transition to collected object reenacts its lost, untold beginning. If the "beginning" for the collected object is not constituted by any original act of making but rather by its introduction into a particular series, then its material origin is subsumed within the serial context. Ironically, however, this new series depends on the very origin that it replaces and cannot exist without it. Both collections and narrations are elaborated through obsessions with the lost contexts of their objects or originating events. At the intersection of collection and narrative as discursive modes, beginnings are dialectical in nature, situated in the tension between the loss and reconstruction of originating contexts.

Economic Underdevelopment

Linked to the history of political unrest as addressed by Sierra were the social and economic challenges that were inherited from the rigidly conservative economic hierarchy of the colonial regime as well as certain physical impediments to development (such as climate, geography, and the late construction of a railroad) that hindered national growth following independence. By the 1880s, the Mexican economy had finally begun to grow after decades of stagnation that stood out not only in comparison with the more developed financial systems of Europe and the United States but also with Latin American nations such as Chile, Argentina, and Brazil, in which small capital markets had been in operation since the 1860s.[34]

There are several complementary interpretations as to why this was the case. In Michael Meyer and William Sherman's *The Course of Mexican History*,[35] early contributions to Mexico's precarious financial situation

include the maintenance of an oversized military, inherited debt from the colonial period, the mass departure of the Spanish middle class following Spain's failed invasion of 1829, and overreliance on international loans.[36] In his contribution to Stephen Haber's *How Latin America Fell Behind*, Carlos Marichal in turn examines the lag in development of a reliable circuit of capital markets in nineteenth-century Mexico due in part to the government's failure to assume responsibility for its debts and the consequent mistrust of government bonds sustaining private corporations.[37] Along these same lines, Mark Wasserman discusses the lack of banking institutions for the private sector and the forced loans applied by liberal governments to the Catholic Church, in which reserves were quickly depleted despite the prior accumulation of huge wealth in the form of land assets.[38] In his contribution to Haber's study, Enrique Cárdenas frames the lags in Mexican production and domestic and international trade in terms of the drastic narrowing of the mining sector. Combined with the disappearance of capital following the war for independence, there were few resources left for productive activity or investment, and it wasn't until the last two decades of the nineteenth century that the appearance of the railroad, the slow revival of the mines, and the onset of industrial development together secured new levels of economic growth.[39] In *The Mexican Economy*, Bortz and Haber also examine the strategic and detrimental use of cronyism—the economic alliances that bound the Díaz government to (foreign and domestic) private asset holders who were favored with exaggerated privileges in exchange for their property investments.[40]

It is precisely this sense of political and economic precariousness that provides such a fertile ground for the fervent pursuit of a national canon of things. The Díaz regime of the late nineteenth century strategically used cultural capital both to reinforce the nascent sense of a collective "ethnic and cultural" nationalism among the economic elites and to stimulate the national economy by attracting foreign and domestic investments.[41] The nationalization of scientific discourses, art pieces, and archeological objects during this time period of political and economic instability served the double purpose of creating a stable cultural repertoire, on one hand, and attracting investments to stimulate economic modernization, on the other.

The Museum as Venue for Political Stability

Mexico's Museo Nacional is, of course, central to the association between collecting and state formation from the late eighteenth century onward and, indeed, one of the key stages on which the larger dynamic between patrimonial and marketable objects plays out during the late nineteenth and early twentieth centuries. The colonial wonder cabinets that were nourished through more than two centuries of illicit commercial trade between Manila and Acapulco, the efforts initiated by the Jesuit priest Francisco Xavier Clavijero (1731–87) to collect and preserve the objects and manuscripts of Mexican antiquity, and the Jardín Botánico of New Spain created under royal decree by Carlos III all paved the way toward the foundation of the cultural institutions covered in this study. During the pivotal year of 1790, the discovery of the famous monoliths known as the *Piedra del Sol* and the *Coatlicue* led to enthusiastic public support and monetary contributions toward New Spain's first established museum.[42] This initiates an historical transition from private to public, in which the endeavors of private collectors, such as Clavijero and Italian historian–ethnographer Lorenzo Boturini (1702–53), were indispensable in their contributions to the permanent national museum collections of the next century.

Through its function as official storyteller, the national museum became one of the principal promoters of political stability during the liberal era. As an institution, it also depends directly on the intrinsically shared qualities of narration and collection to exercise its persuasive effect. In Flora S. Kaplan's *Museums and the Making of "Ourselves,"* for example, museum historian Luis Gerardo Morales-Moreno describes the nineteenth-century national museum as a type of exhaustive visual canvas in which successive waves of political administrations manage to use the very same sets of exhibited objects as objective proof of their own particular and mutually conflicting logics:

> The National Museum between 1825 and 1925 was not merely a hollow concept of an abstract cultural symbol of nations. It was, in fact, a collection of events in movement—wars, struggles, revolutions, military invasions, and political disorder—that were transformed into symbols and displayed as images. The exhibition halls served

as kinds of "historiographic canvases" or "social scenery from the political imagination."[43]

It is not the display, continues the historian, but the interpretation of that display that changes from one year to the next; the same coat of arms exhibited year after year is subject to layers upon layers of differing political readings. It is in fact this capacity of the national collection to subsume all subjective points of view into the synthesized, socially accessible, and cohesive story that gives the collection its ambiguity as well as its persuasive force.

Cultural Consolidation through Objects

Scholars such as Stacie Widdifield, Mauricio Tenorio-Trillo, and Luis Gerardo Morales-Moreno have provided excellent studies addressing the phenomenon of late-nineteenth-century Mexican patrimony from the perspectives of history, art history, and museum studies (respectively). The creation of a national painterly canon, the assembly of nationally representative collections for representation in the booming world's fair events, and the consolidation of the Museo Nacional during the four decades that span the period 1867–1910 are each foundational acts in the creation of a national symbolic repertoire. Faced with problems of funding, political disagreement, public disinterest, and competing priorities in other administrative realms, the creation and institutionalization of a Mexican cultural inheritance were no simple matters. And it is perhaps for this very reason that there is room for a synthesized view of some of the key institutions and dynamics of patrimonial consolidation that mark this charged era of Mexican self-actualization.

In fact, it is the combined perspective on various late-nineteenth-century Mexican national collections that reveals the capitalist logic with which they were imbued. The mutual implication of cultural and monetary capital, a phenomenon also studied in detail by Robert Aguirre in the context of Victorian England and its imperial thirst for pre-Columbian objects, can be traced in part to their shared premise of accumulation. Whether we look at the status of the nineteenth-century art school or the national museum collection, each of which houses its own compelling tale of object pageantry, there is a dynamic, unstable,

and fluctuating relationship at work between displayed objects and the meanings that they come to engender. Like the mannequin exhibit referenced earlier, what may be exhibited as an object with transcendent national value in one context serves as an instrument of barter in another.

Along with its unifying political function of generating transparty national histories and iconographies, then, the modern collection in its various forms was also an expression of rampant cosmopolitanism. Mexico's first politically integrated stories of *lo nacional* (via the designation of national heroes, official histories, architectural styles, and artistic representations) had to be selected, erected, and propagated to vastly heterogeneous populations at the same time that international styles and cultural references were incorporated through periodicals, history writing, educational reforms, and renovations to the capital cities. If the question of modernization for Mexico depended largely on the success of its insertion into the international market, then the cultural offspring of the new, officially sanctioned, and politically consolidated national histories could not but reflect the nation's strides toward progress through varying degrees of contemporary European influence.[44]

Mexican Modernization in Broader Contexts

While far from a closed topic, the issue of how to view Mexican and the greater Latin American processes of modernization within the broader context of Europe has been addressed from critical perspectives within Latin America. Owing to factors such as recent colonial histories, inherited repressive economic policies, turbulent formative years as autonomous nations, and the concomitant lack of institutional bases, the arts did not consistently develop as independent social agencies in Latin America as they did in the United States and Europe. Ida Prampolini points out a particular way in which the general unease about the developmental chasm between Mexico and Europe surfaces in nineteenth-century Mexican art criticism: there is a marked preoccupation with hurrying up and educating the public "in strong but concentrated doses" in issues related to European aesthetic and cultural panoramas.[45]

Although problematic and reductive, the characterization of Latin

American development as uneven or irregular in every arena from economics to aesthetics tends to show up in discussions devoted to the subject, whether they are grounded in literary studies or economic analyses. Authors such as Nestor García Canclini, Beatriz Sarlo, Ángel Rama, and Julio Ramos have addressed the particularity of Latin American cultural development from a variety of literary and cultural perspectives and with different national, transnational, and cultural contexts in mind. Each frames the experience of modernization through a focus on one or more key loci of intellectual and material activity: urban centers and their construction, lettered culture, the arts, and mass media. In *The Burden of Modernity*, Carlos Alonso posits another alternative to the traditional concept of European organicity versus the forced and secondary nature of Spanish American modernity. Rather than searching for a definition of Spanish American modernity in the failed or problematic application of European discursive formulas to the uneven context of Spanish America, Alonso defines the "global" or universal phenomenon of modernization from the perspective of local strategies and practices: "The deployment in the Spanish American context of a repertoire of discourses identified with modernity."[46] The trick in confronting this issue, it seems, is to address the specific nature of Latin American cultural development without (1) overgeneralizing to the extent of glossing over the irreducibly local circumstances of individual cities and nations, (2) failing to draw parallels among processes of development where they do exist, and (3) positing Europe or the United States as the "authentic" models of development according to which alternative processes can only measure as secondary.

Marshall Berman's *All That Is Solid Melts into Air* addresses the phenomenon of uneven development within the context of sixteenth- to eighteenth-century Europe, in which the most important historical phase of modernity began in the political and social currents of industrialization and the French Revolution.[47] What catches my attention in Berman's work specifically is his Marxian reading of the destructive or dark aspects of modernization in section 2, which stems from the tireless cycle of invention and destruction triggered by capitalist enterprise:

> Even the most beautiful and impressive bourgeois buildings and public works are disposable, capitalized for fast depreciation and planned

to be obsolete, closer in social functions to tents and encampments than to "Egyptian pyramids, Roman aqueducts, Gothic cathedrals."[48]

While the author was referring specifically here to Engels's reaction to urban development in mid-nineteenth-century England, Berman's approach to the phenomenon of European modernization connects with this study on two counts. First, despite criticisms of the exclusively Western scope and breadth of Berman's book, the author's approach in fact can be read as debunking the presumed hegemony of Western development by calling attention to the a priori precarity of modernization as a phenomenon—an idea also reflected in the work of nineteenth-century European authors such as Goethe (as Berman himself points out) and the French decadents, including Baudelaire. In other words, it is not that Spanish America failed to effectively implement the vocabularies and infrastructures of modernity but rather that a seamless process of development was impossible to adopt owing to the precarious nature of modernization itself.

Second, it is this commonplace presumption of a hierarchical value distinction between "tent" and "pyramid" that I wish to question in the Mexican context. In other words, it is not so much that the modern objects, buildings, and monuments of the nineteenth century suffer a type of depreciation when compared to the artifacts of antiquity but rather that the circumstances of modernization are such that the acts of perceiving and assigning meaning tend to conflate these oppositional cornerstones of "higher" and "lower" categories of value. The investment in autochthonous cultural heritage was strategically used in Mexico to trigger urban development and establish links to the larger, more developed markets of Europe by creating an aura of cultural distinction. Ancient symbolic patrimony was channeled into a variety of apparently contradictory signifieds, which ranged from scientific discourse to patriotic hymn and, finally, capital interest. Likewise, modern aesthetic practices and objects were viewed not only as components of a transcendent new canon but also as the products and catalysts of a developed and solid national economy—a perspective that often led to the well-documented overreliance on European cultural models.

Despite the vast political and social challenges they faced, those

nations that stood in the former viceroyal territories of Spain were the most readily disposed to initiate the processes, discourses, and rhetorics of modernization that were initiated by Western Europe and the United States during the nineteenth century. In the cultural sphere, this was done in multiple ways, including a reclaiming of ancient national heritage through the gradual nationalization of archeology in Mexico, Peru, and Brazil; the hiring of French architects to design modern urban public spaces (such as in the capital city of Argentina); and an overall increased attention and allocation of resources throughout Latin America to national museums.[49] Yet modernization in its initiative phases was a conflicted, difficult process in which European cultural models were assessed, analyzed, and reconfigured to fit the irreducible particularities of local political circumstances and cultural practices. As Michaela Gielbelhausen indicates in her investigation of museum architecture, efforts made toward the preservation of a specifically *national* history (via the creation of national history museums in Chile, 1811, and Mexico, 1825, and/or decrees prohibiting the exportation of objects of antiquity in Peru, 1822, and Mexico, 1825) were, by the late nineteenth century, outnumbered by fine arts academies and museums apparently dominated by European (mainly French) influences.[50] The colonial legacy, both internally and externally imposed, presented formidable obstacles to Latin American nations trying to establish cultural autonomy while paradoxically turning to European models. As will be seen in chapter 4, for example, those Latin American nations exhibiting their wares in nineteenth-century world's fair events, such as the Exposition Universelle in 1878 France, had to share a common pavilion—the Spanish American Syndicate—while their European neighbors represented themselves with individual edifices and exhibits.

In a study that reconstructs some of the key moments, particularities, and variations in nineteenth-century Latin American cultural production, Jens Andermann and Beatriz González Stéphan's *Galerías del progreso: Museos, exposiciones y cultural visual en América Latina* offers an innovative comparative study of material, visual, and exhibition culture in various regions and venues within *fin de siglo* Latin America, including Guatemala, Chile, Argentina, Venezuela, Mexico, and Brazil. In Mexico in particular, there was a spirit of friendly competition that manifested with Argentina, which indicates a sense of kinship among

the cultural and political administrators of those nations that were considered more advanced along the paths of modernization. The archive of Mexico's participation in the Exposition Universelle de Paris, for example, contains a folder featuring the blueprints and construction details of Argentina's pavilion for the same fair. In a letter dated November 7, 1889, after the fair's closing and exchanged between members of the Mexican commission, engineer Gilberto Crespo informs General Carlos Pacheco that Mexico and Argentina were the Latin American nations that the French considered had "most distinguished themselves for the great effort put forth to create installations that were worthy of the exhibited riches."[51]

Even the elite Mexican guardians of national patrimony who are studied here, while trying to exorcise the shadows of a colonial history, cannot be excused from inadvertently reinforcing the very colonialist discourses that bound them. As Margarita Díaz-Andreu observes in *A World History of Nineteenth-century Archaeology*, the "binary set Westerner–Other . . . is a more powerful, imagined entity composed by as many others as Westerners defining them."[52] The simultaneous resistance to and repetition of the colonial gaze that describes one of the central paradoxes of Mexican modernization can be located in gestures of competition such as that described earlier, in which Mexican cultural event administrators congratulated one another based on their abilities to gain European approval. The acknowledgment of a hierarchical cultural rank within Latin America based on the creation of displays intended for European audiences indicates the depth and ubiquity of the colonialist perceptual residue underlying nineteenth-century exhibition culture: it both motivated and limited the very impetus to self-actualize.

While the assembly of a national and public patrimony throughout the nineteenth century is a phenomenon that was pursued with particular fervor across Latin America, the United States, and Europe, unique to the formation of national collections in Mexico is the difficulty of settling into a position from which to write about it. There is a complex set of circumstances that feeds into the creation of a nationally representative repertoire of things for a nation that was still in the process of consolidating culturally, linguistically, and politically. While the work of historians and art historians, such as Mauricio Tenorio-Trillo, Fausto Ramírez, and Stacie Widdifield, and museologists Miguel Ángel Fernández and Luis

Gerardo Morales-Moreno has paved the way for this study in terms of determining the parameters of late-nineteenth-century national artistic canons and exhibition culture, this investigation is specifically grounded in material culture studies in the commitment to theorize the political and social contexts in which meaning is created around objects. Along with scholars such as Robert Aguirre, who explores nineteenth-century British imperialism as it played out in the desire for pre-Columbian objects, and Jens Andermann and Beatriz González Stéphan, who trace the visual and material cultural productions that contributed to the pursuit of national sovereignty in Latin America, this study foregrounds the tensions that surface in material culture as indispensable historical markers for the understanding of modern national and postnational identities.

Chapter 1 develops an argument about art, aesthetics, and marketing gleaned from the three-volume edition of nineteenth-century magazine and newspaper articles provided in Ida Rodríguez Prampolini's 1964 publication *La crítica de arte en México en el siglo XIX*. Drawing from such newspapers as *El Partido Liberal, El Siglo XIX, La Patria, El Monitor Republicano,* and *El Imparcial* as well as from the famous contemporary journalist Ignacio Altamirano's commentary on the expositions of Mexico's famous fine arts school, the Academia de San Carlos, it becomes apparent that the commercial and social promotion of a national aesthetic that should remain at the same time a "true" representation of national culture and not a "vulgar" material commodity was an inherent tension that surfaced both within and outside the Academia. At the same time, a set of popular genres that were not so highly regarded by the guardians of institutionalized artistic hierarchies offered an alternative to the confines of the painterly canon that conjugated the emerging commercial culture with national imagery. Banamex's recent publication of privately commissioned works from the nineteenth century provides a vivid example of the extent to which private commissions provided the basis for the development of a national painterly expression that has recently begun to gain national and international public attention.

Chapter 2 centers on writings that surfaced around the museum institution during the late-nineteenth-century nationalization of the sciences. In a way that parallels the artistic reconciliation of commercial (international) and national values in chapter 1, the urgency around

establishing a specifically national claim to Mexican archaeology surfaces after foreign scholarship and interest had dominated the field for centuries. Using a selection of writings from the published annals of the Museo Nacional of Mexico, and focusing specifically on the example of the Salón de Arqueología as inaugurated in September 1910, the museum is analyzed as a site of collective memory, in which a national reclaiming of archeological patrimony is inextricably linked to the question of educating the contemplative citizen to recognize herself as such.

Chapter 3 contains a study of the national monuments that were erected in Mexico City from approximately 1867 to 1910. In direct contrast to the archaeological exhibit and its partial reliance on suppressions and secrets, the public monuments that proliferated during this time were intended to project the heroes and events that represented liberal national history in a way that could be directly apprehended by both national and international viewing publics. A closer look at the processes of construction, however, reveals a subtle and complex set of negotiations that proposes the canonical monument less as a definitive answer to the need to consolidate Mexican self-representation and more as a plastic embodiment of a fluctuating and dynamic negotiation among national and international influences. A reconstruction of the stories behind some of the monuments that were constructed along Mexico City's famous boulevard known as the Paseo de la Reforma reveals an interesting set of divisions in their functions as pieces of patrimony and commerce and as markers of social class.

Chapter 4 offers a new perspective on Mexico's participation in the Exposition Universelle de Paris in 1889. Although this theme has been covered in detail by historian Mauricio Tenorio-Trillo,[33] there are three compelling reasons to revisit the subject. First, world's fairs are privileged venues for investigating the intersection of patrimony and commerce in public visual culture during the late nineteenth century, and the Paris expo of 1889 is the most documented event of its kind. Second, the Palacio azteca, the pavilion built to house the Mexican exhibit at the 1889 expo, presents itself as an emblem of the central topic of this study: the intersection of patrimony and commerce in the creation of postcolonial Mexican identity. Finally, there is room for a more specific theoretical argument from which to understand the vast documentation

of this particular fair. This chapter builds on Tenorio's work in such a way that it connects the Palacio azteca to diagnostic debates around Mexico's supposedly retrograde aesthetic development, comparisons with European and U.S. fairs, and the problem of transcendent versus commercial value.

The focus of chapter 5 is the shifting protagonism of statistics in Mexican administrative circles during the Porfiriato, a subject briefly approached by Tenorio-Trillo in *Mexico at the World's Fairs* in the context of world's exhibitions.[54] The Porfirian *científicos* advocated for the integration of political tensions into a new vision of the modern state, which was described as a passive "guardian of material order," as opposed to the proactive conservative oligarchy that had predominated Mexican politics since colonial rule. In the privileging of order as a philosophical and political orientation, the status of national statistics acquired a type of powerful discursive force that places it in direct analogy to ideal governing. In this final chapter, it is argued that through the adoption and standardization of the statistical table in late-nineteenth-century Mexico, the ideological slant of the collection was realized to its fullest potential. The fetishism of order as a system of signification promoted the science of statistics as an indispensable language for the expression of nationalism from within an internationally sanctioned code and provided a base on which to construct local infrastructures. Through statistical gathering, publication, and display, the material components that supported the abstract notion of nation achieved a degree of visibility that was unparalleled in what came to constitute the indexes of an ideologically translated patrimony.

The purpose throughout is to present concrete manifestations and studies of national collections in late-nineteenth-century and early-twentieth-century Mexico to reveal the patterns that emerge among them in terms of the dialogue with international influences against which the parameters of national representation formed. This study builds on the premise that complicating our way of thinking about representative public collections not only offers a common ground for interaction among a plethora of disciplines but also paves the way for this discussion to continue as questions of patrimony and nation navigate the current spaces and speeds of globalization. Because we have been conditioned to relate to national patrimony not only as citizens

but also, implicitly, as consumers, we tend not to see their limits or to question them as generators of meaning. By sifting through concrete material examples of Mexican national collections during the apex of nineteenth-century consolidation and modernization, it becomes possible to understand how it is that patrimonial objects are able to be so persuasive in embodying the weight of meanings that they do.

1

Fine Art and Demand: Debating the Mexican National Canon, 1876–1910

✺ ✺ ✺

One of the primary arenas in which consumer demand had a marked impact on the shape and development of a national canon was the fine arts. Note the following patron's perspective as he navigates his entrance into the Academia de San Carlos[1] in 1891:

> I humbly gave my obolus—a ten cent coin that a person who was neither very kind nor very attractive demands at the doors of the Academia—and I entered the art sanctuary, desiring to experience at my ease, [although] confused among the motley crowd that invaded the salons, the aesthetic emotion of the beautiful.[2]

In this aficionado's account, there is a particular tension that surfaces repeatedly to interrogate the status of national art in late-nineteenth-century Mexico. The exchange of the coin for access to the public art exhibition introduces an uncomfortable economy of the sublime, a precept that underwrites the search for a national aesthetic with the problem of making it equivalent to a calculable abstract value. For the spectator cited earlier, the democratization of art undermines the experience of the sublime and confuses his ability to locate himself as a viewing subject.[3] The public's "invasion" of the salon compromises the aesthetic experience at the same time as the implied collective accumulation of entrance fees sustains its very possibility.

Examining the contradictory impulses of sanctuary and marketplace that collide in the preceding description, this chapter centers on the commercial subtext that underlay a significant portion of the

propaganda, the promotional and the critical rhetoric that surrounded the creation of a canon of national art in Mexico between 1867 and 1900. In the endeavor to create a national painterly canon during this time juncture, there are two opposing protagonists: first, the conservative scholars and painterly traditions that were imported to the Academia de San Carlos from Europe, and second, the emergent liberal art critic as represented by Ignacio Altamirano and José Martí. Though both sides are concerned with creating a national painterly tradition for Mexico, they conflict in terms of how to go about doing so. Each perspective invites foreign influence, although in ways that differ quite radically. Whereas the cultural administrators represented by the Academia look to the traditional European canon to imitate and maintain the lofty standards of the sublime as practiced there, the liberal art critics encourage painters to cater their productions to what the U.S. and European consumers should wish to buy: local representations of the exotic Mexican flora and fauna. History has confirmed the liberal point of view, as genre painters such as José Agustín Arrieta and Germán Gedovius, who produced works for private art patrons that were not then considered to be part of the high canon, have now been retroactively deemed to embody a specifically Mexican nineteenth-century aesthetic.

When viewed in the larger context of national political consolidation and the reestablishment of diplomatic relations with Europe, the published debates around Mexican national painting during the late nineteenth century reveal a type of dynamic oscillation between the two contradictory types of value that form the backdrop of this study: the transcendent–sacred and the commercial–exchangeable. Born at the seam of national political consolidation and the infancy of commercial and cultural globalization, Mexican art wavered at the pens of its critics between two forces. On one hand was the idealistic drive to maintain an unqualified relationship to the sublime and, on the other, the practical needs dictated by popularity, circulation, and consumption. As a result, creating standards for a national painterly canon was complicated by flirtations with commercial enterprise.

Given this conflation of national and international boundaries, it seems that the negotiations, dialogues, and conflicts around the creation of a Mexican painterly canon at the late-nineteenth-century time juncture in fact preface the dialogues that would reconfigure the

administrative debates on patrimony in the context of globalizing econo-mies and cultures one hundred years later. National culture consolidates through dialogues, intersections, and overlaps with the universal or global standard. Centripetal and centrifugal forces coincide.

While the art that was produced during the second half of the nine-teenth century in Mexico fails to attract the scale of international criti-cal attention such as that inspired by the muralist paintings that follow the Mexican Revolution (1910–21), the era was in fact a time of strong advocacy for Mexican painting. From the time of Benito Juárez's "lib-eral triumph" in 1867, associates and friends of Mexico's Academia de San Carlos (Figure 1.1), a national fine arts school and exhibition space, regularly called for increased public awareness of the need for a national painterly canon—a preoccupation that was complicated by the difficulty of creating consensus around exactly what its expressions should be. The reestablishment of the liberal regime marked the end of decades of civil strife with political conservatives, who soon bore the brunt of the blame for the stagnation of national fine arts in the diagnostic periodi-cal commentaries that appeared frequently during the last few decades of the century. Art critics also published a large influx of negotiations regarding how to go about creating a national painterly repertoire.[4] Newspaper articles dedicated to the debate around which paintings, which painterly genres, and which artists best represented the rising status of the newly politically consolidated and modernizing Mexican nation abound in papers such as *El Siglo XIX, El Partido Liberal, El Uni-versal,* and *El Monitor Republicano.* Within the galleries of the Academia of San Carlos, the careful practice of universal artistic genres led by European instructors began to merge with the more subtle, less prolific pursuit of specifically "national" themes.

Political Eras and Artistic Directions

A brief overview of the artistic directions pursued by the Academia de San Carlos during the reigns of the Conservative, Liberal, and Sci-entific political parties that held administrative power during the sec-ond half of the nineteenth century will set the course for this chap-ter. In her introduction to the National Bank of Mexico's *Catalogue of the Nineteenth Century,* Angélica Velázquez Guadarrama locates the

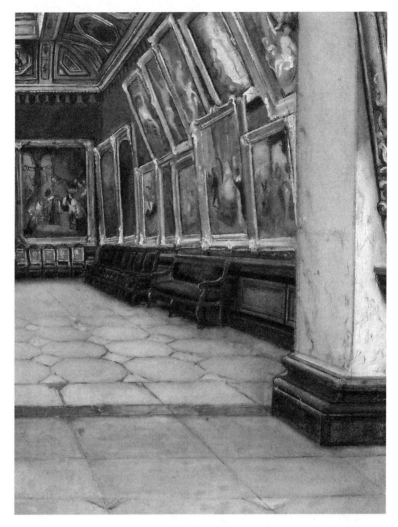

FIGURE I.I. Alberto Bribiesca, *View of the Academy of San Carlos*, 1884. Courtesy of the Colección Banco Nacional de México.

cultural elite's concern for creating a repertoire of national imagery as coinciding with the end of the Mexican war with the United States in 1848. As early as 1843, an internal restructuring of the Academia led to the arrival of Catalan professors Pelegrín Clavé and Manuel Vilar, who were to lead the Academia's conservative curriculum in painting and

sculpture—which focused on biblical and classical themes—until the liberal restoration in 1867.[5]

As Fausto Ramírez has indicated, the former Austrian emperor Maximilian (1864–67) started creating a secular representation of the nation through a number of artistic projects that featured a series of national heroes (including such unlikely associations as Miguel Hidalgo, José María Morelos, and Agustín Itúrbide), most of whom were subsequently retained by the liberal project that immediately followed.[6] As for the pursuit of a national canon that began after the liberal reforms, Stacie Widdifield offers an invaluable analysis of Academia director Ramón Álcaraz's invitation for artists of all political affiliations to participate in a contest for the best painterly representation of a national theme for the Fourteenth Exposition of the National School of Fine Arts of Mexico (formerly the Academia de San Carlos) in 1869. This public invitation set the course for a series of annual and biannual contests for drawing and painterly composition, events by means of which "the patriotic iconography called for by the critics was consolidated" between 1867 and 1900.[7]

In the subsequent era of Porfirio Díaz and the Scientific Party (1876–1910) that followed the liberal reform, political and cultural administrators used the arts to promote and negotiate status among the nations of economic hegemony at international events such as the world's fair expositions, in which Mexico had participated regularly since the Philadelphia Centennial Exhibition of 1876.[8] In short, as Ida Rodríguez Prampolini's compilation of over one thousand late-nineteenth-century to early-twentieth-century newspaper articles indicates, cultivating the arts and exploring ideas around a Mexican national stylistic and thematic canon was a topic of regular discussion and debate decades before the so-called Mexican Renaissance and the revolutionary muralists broke international ground in the creation of Mexico's most widely circulated contribution to modern art history.[9]

Notwithstanding the efforts to encourage the creation of a specifically Mexican repertoire of paintings during the period outlined previously, the Academia remained largely conservative in terms of artistic pedagogy and production. The pursuit of "Mexican" themes as represented in national historical paintings, the most respected genre among the secular paintings of the nineteenth century, constitutes a most definite

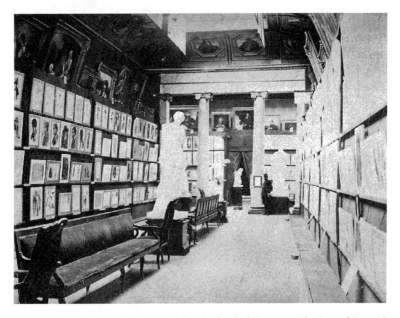

FIGURE I.2. "The Exposition in the National School of Fine Arts. The Second Room." In *El Arte y la Ciencia: Revista Menusual de Bellas Artes e Ingeniería,* February 1905. Courtesy of the Hemeroteca Nacional de México.

and important minority relative to the classical and biblical themes that dominated the Academia's exposition rooms.[10] In response to the aforementioned 1869 contest for the best painterly expression of a national theme, for example, only three paintings dedicated to national history were submitted for display out of a total of over two hundred exhibited paintings.[11] Likewise, a comprehensive glance at the lists of exhibited paintings submitted for the annual and biannual exhibitions of the Academia dating from 1869 to 1898 reveals that a steadily increasing yet still relatively small percentage of the total exhibited display of paintings was dedicated to Mexican historical or other modern themes that lent themselves to expressions of Mexicanness (including allegory, portraits, landscape paintings, genre paintings, and still lifes).

For the most part, biblical and European classical subjects constituted the status quo of the Academia's painterly repertoire, both within its curriculum and on the exhibition floors.[12] The persistent gaps in the national painterly canon, which critics such as journalist–writer–professor Ignacio

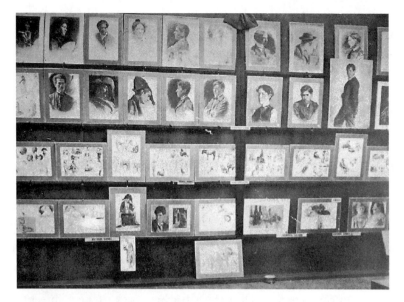

FIGURE 1.3. "Exposition in the National School of the Fine Arts [1905]. Drawings of Sres. Antonio Gómez y Gilberto Galindo." In *El Arte y la Ciencia: Revista Mensual de Bellas Artes e Ingeniería,* February 1905. Courtesy of the Hemeroteca Nacional de México.

Manuel Altamirano claimed were due as much to the relative lack of governmental and public financial support as to the Academia's a priori conservative inclinations, were not unnoticed by Mexican nationals and in fact spurred several public laments by frustrated art critics anxious to witness the development of a national school at the Academia's exhibitions (Figures 1.2 and 1.3).[13] Combined with the general public's lack of consistent access to the institution,[14] the conservatism of the School of Fine Arts rendered the institution incapable of inspiring the formation of both an artistically fluent public and a repertoire of artists in touch with the impulses of a truly national artistic expression. A central influence behind the dialogues surrounding the status of national art during this time period, Ignacio Altamirano claims in a published reaction to the Exhibition of 1880 that Mexican national self-representation was systematically undermined by the students' incorrigible tendency to imitate traditional European schools.[15]

European Influences on the Academia

Indeed, the heavy impact of inherited painterly themes, teaching techniques, and exhibition practices from Europe—a fact for which the Díaz era is perhaps too easily overlooked in terms of the creation of a national repertoire—is impossible to ignore. The dense hanging practice that is evident in the images of Academia exhibitions, for example, is a direct reflection of eighteenth- and nineteenth-century gallery traditions in Europe. This tendency to hang paintings closely together with minimal wall space between frames or with frames touching is reflected in exhibition images from world's fairs, galleries, and museums alike during this period, which begins loosely around the mid-eighteenth century and extends to the end of the nineteenth. The first volume of Bruce Altshuler's *Salon to Biennial: Exhibitions That Made History,* for example, contains an image of the Gallery of Fine Arts from the 1867 Universal Exposition of Paris in which a series of cramped and precariously hung paintings compete for wall space.[16] Reaching back to the eighteenth century, Johann Zoffany's *The Tribuna of the Uffizi* (1780) and Gabriel de Saint-Aubin's depiction of one of the French Royal Academy's biennial painting and sculpture exhibitions called *Salon de 1767,* which features one of the galleries of the Louvre, reflect the same practice.[17] In "The Architecture of Daylight," an exploration of the exhibit and lighting processes of eighteenth- and nineteenth-century European galleries and art museums, Michael Compton observes that both of the exhibit practices that were considered commonplace by the mid-eighteenth century—the display of varied works together, and that in which the paintings were organized by school—required for the walls "to be as densely hung as possible."[18] Put simply, the galleries and buildings could not keep up with the gallery owners' and curators' desires to expand their collections and displays as quickly as possible.[19] Likewise, in "Picture Hanging and Gallery Decoration," Giles Waterfield describes the "cluttered hang" as one of the four groups of picture-hanging styles that span the past two hundred years of Europe (with emphasis on Great Britain) and attributes this style to a "shortage of space and lack of thought about display."[20] In such hangings, observes the author, wall arrangements were largely limited to considerations of the sizes of the paintings destined for exhibit. While this style in Britain and France

was particularly applied to temporary exhibitions, the second half of the nineteenth century shows increasing criticism of this tendency. Nevertheless, images from British exhibit houses, such as the Fitzwilliam Museum (1895), the Wallace Collection (1897), and the York City Art Gallery (1879), "vividly illustrate the jumbled quality of the typical late Victorian provincial gallery."[21] Together with the images of paintings reflecting eighteenth- and nineteenth-century British and French gallery shows in Giles Waterfield's *Palaces of Art*, Dominique Lobstein's *Les salons au XIXème siècle: Paris, capitale des arts* and John Ford's study on German–British gallery owner and businessman Rudolf Ackermann provide ample material to support the claim that this style of exhibition hanging as pursued by the Academia de San Carlos was a direct cultural import brought in by the school's European teachers.

According to an 1843 decree that called for the reorganization of the Academia under interim president General Antonio López de Santa Anna, the new directors of the school were to be selected from "among the best artists to be found in Europe."[22] Despite the difficulties of finding candidates willing to relocate to Mexico, the Catalan Pelegrín Clavé was selected from a group of three contenders, and he signed his contract in Rome in 1845.[23] Another Catalan by the name of Don Manuel Vilar became the new director of sculpture, thus initiating what would become an "all-foreign directorial staff" imported from Europe. English medalist J. James Bagally became the director of *grabado en hueco* (casting dies), and a fellow countryman by the name of George August Periam arrived in 1853 to take charge of the class of engraving. In 1855, the Italian Eugenio Landesio was hired to direct the class of landscape painting, and a Milanese artist by the name of Javier Cavallari took charge of architecture in 1856.[24] This staff would direct the Academia until 1863, when the new president and liberal reformer Juárez disbanded the governing board, downgraded Clavé's position to that of director of painting, and replaced him as general director with the Mexican-born Santiago Rebull.[25] When Clavé, Landesio, Cavallari, and others refused to sign a protest against the French invaders in March 1863 (arguing that as foreigners, they should not take sides), they were fired. Following the successful entry of the French army in June of the same year, they were reinstated to their former positions.[26] Although Clavé left Mexico for his native Barcelona following the liberal triumph

of 1867, close ties to his replacement as director of painting, former student Salomé Pina, guaranteed his continued influence on the school up until his death in 1880.[27]

The Academia building itself also reflects European aesthetic influences. In 1859, following a series of earthquakes that damaged the old building of the Hospital Amor de Dios (which had been used as the Academia building since 1791), the aforementioned Cavallari began restorations of the facade. The restorations, which synthesized Mexican materials and European tastes, included meter-thick walls made of *tezontle* (red volcanic rock), a large front door with two marble bases for the arch, and four Corinthian columns made of marble imported from Carrara, Italy.[28] Between 1859 and 1862, Cavalleri made significant revisions to the various galleries and structural features of the building with the help of Italian sculptor Antonio Piatti. During the late nineteenth and early twentieth centuries, a set of deteriorating plaster casts that had been collected on the patio of the Academia led director Román S. de Lascurain to petition in 1896 that a glass and iron dome be constructed to protect one of the patios. While the documentation on this subject is scant, it appears that the project was taken up by Lascurain's successor, Rivas Mercado, who obtained permission from the Secretaría de Hacienda e Instrucción Pública in 1904 to contract with a Parisian company called L. Lapeyrere. The finished structure was probably sent from France to Mexico around 1907, where it lay unused first in Veracruz and then in the patio of the Academia. In 1912, architects Manuel and Carlos Ituarte were finally hired by then director Manuel Gorozpe to put it into place.[29]

Together with the multiple lists of book purchases from Europe, records of prize students sent from the Academia to study in Rome or Paris, and the regular importation of plaster casts and other items to enhance the classroom curricula as objects of study, the Academia's heavy reliance on the European cultural repertoire was obvious. Prampolini summarizes the nineteenth-century "European cultural panorama" that Mexico sought to take in as varied and contradictory, a pool that combined the conservative influences of French neoclassical painter Jean Auguste Dominique Ingres (1780–1867) and German painter–Nazarene movement member Johann Friedrich Overbeck (1789–1869) with innovative artists like Louis Daguerre (1787–1851) and happenings like the

Communist Manifesto (1848), Darwin's evolutionary theory, and the constructions in infrastructure that followed the Industrial Revolution.[30] Yet despite the temptation to write off the Porfirian era as unproductive in creating a specifically Mexican national art, newspaper records of the lively debates around this issue, along with sporadic examples of artists who actively sought to produce original works that reflected and defined Mexican taste, invite further consideration. The international practices on display in the images provided here and described in Prampolini's and Báez-Macías' studies paradoxically mesh with the intent of the Academia de San Carlos to foster a specific national vocabulary of the arts precisely by providing a fertile ground for debate. Mexican academy art students were not only learning to master European aesthetic techniques but also witnessing and assessing the associations between nation and art as gleaned from the study of such masterpieces, as well as gaining the skill sets necessary to innovate, invent, and push the presumed and inherited boundaries of aesthetic expression.

This is not to suggest that Rodríguez Prampolini's *Art Criticism of the Nineteenth Century* reflects any sort of consensus around the problem of developing a Mexican painterly aesthetic and what should or should not constitute it. Read together, the articles reveal the overall division of attitudes between, for example, the various conservative and liberal perspectives on art, in which the former tend to lament the degradation of the sublime in the pursuit of more ordinary genres (such as still lives and genre paintings) and the latter seek to amend the disproportionate attention paid to "universal" painterly themes rather than specifically national ones by encouraging the pursuit and commercialization of "typical" (regional and national) themes.

The Democratization of Mexican Art and the Middle-Class Viewing Public

What does appear in newspaper debates dedicated to the arts is a consistent polemic regarding the democratization of art in the Mexican context. Whether lamenting the lowering of standards in the conversations about artworks in general or demanding more hours dedicated to public viewing, a consultation of the opposing viewpoints offered by nineteenth-century Mexican art critics indicates that the creation,

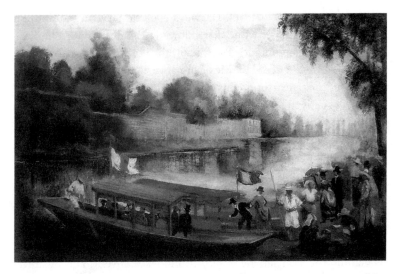

FIGURE 1.4. José María Ibarrarán y Ponce, *Canal de la Viga*, 1899. Courtesy of the Colección Banco Nacional de México.

selection, and determination of a national canon of imagery are inseparable from discussions about what it means to diffuse and democratize art. In fact, at the heart of the debates on how to represent Mexico and Mexican tastes in painting resides the implicit problem of configuring the relationship between art and viewing public. At this time of transition into political consolidation and the creation of the mere idea of a middle-class sector, the traditional historical and class-related boundaries between art and the public were remapped to include and inspire the creation of a broader viewing public.

The growing relevance of the viewing public with respect to nineteenth-century art production is traceable in two ways: first, the newspaper commentaries in which the writer–critic makes a pointed distinction between those of the viewing public who "know" and those who "don't know" (such as the "motley crowd" of the introductory quotation) about art—the implication being that the mere increase in exposure fails to imbue the viewer with the knowledge necessary to understand a given art piece[31]—and second, the increase in venues for a (limited) "public" viewing, suggesting a trend in artistic diffusion; private collectors and artists in the Federal District of Mexico (such as collector Felipe Sánchez

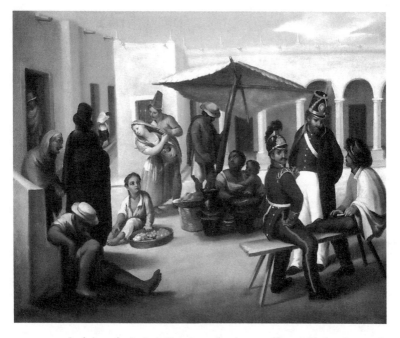

FIGURE 1.5. José Agustín Arrieta, *Escena popular de mercado con soldado,* nineteenth century. Courtesy of the Colección Banco Nacional de México.

Solís or the Barcelona-born artist José Escudero y Espronceda) opened the doors of their homes for art viewings, lent their private collections for temporary exhibits in public spaces such as hotels, and even hung them on the facades of their houses to commemorate national holidays.[32]

A less obvious consequence of the late-nineteenth-century democratization of art was the emergence of a new consumer class. A large repertoire of privately owned art pieces that reflect the activities of the middle class highlights the intersections between art, consumption, and self-reflexivity that describe the buying tastes of a newly emerging middle class. José María Ibarrarán y Ponce's *Canal de la Viga* (1899), for example, which was purchased from a private collector by the National Bank of Mexico in 1976, shows a line of passengers from a range of social classes about to embark on a short canoe excursion, a common leisure activity in nineteenth-century Mexico City (Figure 1.4). *Canal de la Viga* formed part of the repertoire of Costumbrist paintings,

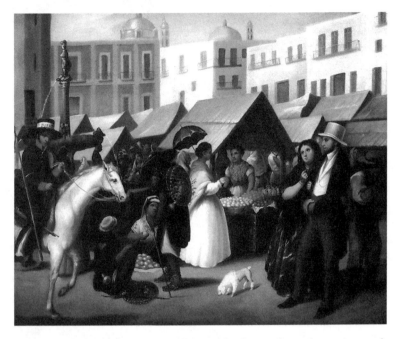

FIGURE 1.6. José Agustín Arrieta, *Escena popular de mercado con dama*, nineteenth century. Courtesy of the Colección Banco Nacional de México.

literary works, and photographs dedicated to the depiction of so-called typical Mexican activities in the nineteenth century.[33] Puebla artist José Agustín Arrieta's *Escena popular de mercado* series (two out of three of which are shown in Figures 1.5 and 1.6), which was commissioned by the German entrepreneur and Mexican resident Joseph Lang during the mid-nineteenth century, also depicts a confluence of distinct social classes at a scene of transaction in such a way that highlights the variety of colors and costumes that so attracted the foreign buying clientele of Mexican artworks.[34]

As observes Elisa García Barragán in her detailed descriptions of Arrieta's *Escena popular de mercado con soldado* and *Escena popular de mercado con dama*, the outside market provides a privileged glimpse of a nineteenth-century Mexican scene of consumption by depicting a space in which members of the distinct social classes interact.[35] In the former painting, a trilogy of characters to the left—composed of the "Celestinesque" elderly woman wrapped in a blue shawl, the seated

indigenous man in a sleeping posture, and the aristocratic figure in dark top hat and cape—are repeated figures from other *costumbrista* paintings by the same artist (see *La taberna, La cocina poblana, Vendedora de frutas y vieja,* and *El mendigo*).[36] In the center, a modest awning covers a woman vendor with her food wares and suckling-aged infant while she looks backward to a standing male figure in humble dress. The interesting play of light in this scene, which casts the centrally positioned vendor in shadows, cuts in from each upper corner and converges at the bottom center. By dimming the central figures of the painting, the artist invites his viewers to take in the whole scene of consumption depicted there rather than referring to the vendor as a single focal point. Flashes of yellow, red, blue, and green are scattered throughout the modest market scene, attracting a mobile gaze and creating a harmonious balance between the cool tones emanating from the sky and the warm hues of exposed skin and consumable displays of food.[37]

The *Escena popular de mercado con dama* presents a more concentrated urban scene and juxtaposes a series of background Pueblan colonial buildings with a central and slightly diagonal stretch of well-populated *tianguis* (market stalls) occupying the *zócalo* (main square). The wealthy class, featured in the foreground, culminates in the central positioning of the *dama* in profile, whose social status is emphasized with her voluminous white gown, gold hoop earring, embroidered shawl, and blue parasol. The groomed French poodle sniffing the ground in the foreground suggests wealth and frivolity next to the indigenous vendors seated on the ground, who are depicted in the midst of an implied transaction. Along with the uniformed policeman to the left, the well-dressed and bejeweled couple to the right (presumed to be the patron Lang and his wife) completes the foreground reference to status and the privileged class. The cluster of movement, vendor stalls, wares, and buyers that occupies the center of the painting is contained within the metaphorical embrace of order suggested by the colonial buildings of the background and the trilogy of policeman, fountain, and horse featured in the left foreground. Overall, there is a thematic harmony and aura of safety permeating the painting as the transience of commerce and the liminality of social class intersection are mitigated by the surrounding referents to monumentality and permanence found in the foreground fountain and background buildings.

Although Arrieta's impact on public visual culture in nineteenth-century Mexico was understated until well after his death, his name began appearing in published literature related to the academy exhibitions of Puebla during the early nineteenth century.[38] During the 1850s and 1860s, having established his reputation as an academy professor and painter of portraits, he contributed paintings to the annual exhibitions of the fine arts academies of Puebla and Mexico City.[39] The first detailed praise of Arrieta's work, published posthumously by Mexican novelist and liberal politician Guillermo Prieto, was written following his visit to the private gallery of Puebla collector and art patron Francisco Fidel Cabrera. During this visit, Prieto describes the displayed painting *Interior de una pulquería* in minute and reverent detail and expresses his own delighted reaction in terms of having his soul "caressed and illuminated" by Arrieta's depictions of the "struggle of traditions" of the middle class.[40] It wasn't until 1963, however, when Francisco Cabrera's detailed monographic study *(Agustín Arrieta, pintor costumbrista)* was published, that Arrieta's contributions to Mexican visual culture gained the high status that marks his reputation today.[41]

Popular Art and National Identity

Despite the value that such paintings have today as representations of Mexican everyday life, *costumbrista* or genre paintings were not regularly pursued in the renovated Academia de San Carlos under the direction of Pelegrín Clavé.[42] Instead, it was the new viewing public that demanded them. Genre paintings, landscapes, still lifes, and portraits, all of which occupied a lower position within the traditional painterly hierarchy owing to their focus on quotidian themes, became popular commissions for private consumption by the new buying public—the Mexican middle class that emerged after the territorial expropriations implemented by the Reform laws were effected.[43] This phenomenon has two implications. First, it appears that the so-called lower painterly genres had an importance that transcended their limited assignment within the traditional painterly hierarchy. Second, a new criterion of evaluation was gaining momentum in the fine arts sector—that of demand.

Slowly and steadily, through the popularity and dissemination of genre paintings in newspaper reviews, genre paintings began to inspire

published reactions that surpassed the confines of mere aesthetic as-
sessment. Art critics began to refer to genre paintings as a base on
which to construct a concept of community and collective identity, to
calculate the nation's level of aesthetic degradation or development,[44]
and to assess Mexico's position with respect to modernity and status on
the international scale. In the following reaction to an unnamed genre
painting by Mexican artist and Academia professor José María Obregón
that was displayed at the 20th Academy Exhibition of 1881, for example,
the viewing subject is encouraged to recognize himself or herself in the
irreducible Mexicanness of the scene depicted:

> The young girl . . . with the finger of her left hand, makes a small
> hole in the wall, which the young ones of our community do in order
> to hide the blushing that results from the effects of [an amorous]
> declaration. This painting, which has so well reproduced one of so
> many customs of this country, detains the spectators [and leaves them]
> smiling as they remember having seen [something like] it various
> times in equal or different scenarios and because of this they can't
> help praising the ingeniousness of the artist who developed it so well.[45]

With this commentary, the critic and artist Felipe Gutiérrez reinforces
the sense of cultural belonging that is linked to the self-reflexive gaze
of the viewer.[46] By drawing on a quotidian pictorial vocabulary that is
linked to a particular time and space, the painting depicting a common,
everyday event becomes meaningful—it rises to the realm of represen-
tation and, in doing so, affirms a sense of place and belonging for the
viewer. The reading–viewing public is here invited to glimpse its own
Mexicanness through the simple act of recognizing an everyday scene.
Implied within the critic's prescribed reaction is the genre painting's
inherent ability to inspire a type of transcendent reaction in the viewer—
one that serves to consolidate a sense of belonging, community, and
citizenry.

The frequency and variety of published commentary on genre paint-
ings between 1867 and 1900 indicate that it was used to qualify a variety of
different types of assessments on the status not only of late-nineteenth-
century Mexican art but of Mexican society as a whole.[47] Some critics
approve of "beautiful" genre paintings but reject the more vulgar or

"grotesque" representations such as Leandro Izaguirre's *The Drunkard* (exhibited at the XXII Exposition of 1892):

> Painters that represent scenes such as *The Drunkard* who instead of providing the public with a moral lesson seem to give them the apotheosis of vice "at the door of the saloon" are artists of a negative range who occupy a certain position in the very abyss of art.[48]

Still other critics encourage the exploration of genre paintings because of their ability to glorify or correct nature,[49] their novelty in Mexico, and their popularity among the Mexican and foreign buying publics alike.[50]

Marketability versus the Sublime: A Clash in Standards

Those critics whose writings reflect the greatest preoccupation with the failing industry of the Mexican fine arts construct their praise around the marketability of genre paintings and emphasize the extent to which the viewing public has given a particular work its verbal and monetary stamps of approval. Witness the following praise of artist Manuel Ocaranza's work, for example:

> His beautiful paintings—*A Broken Lyre, Scenes from a Workshop, Love and Interest, The Punishment, The Mistake, Still Life, The Urupan Café* . . . which deserved general acceptance and which were quickly acquired by individual collectors—were able to reveal to Mexican painters that the public was anxious to see something other than saints and religious themes, whose monotony was truly unbearable.[51]

The idea of looking to public taste to determine what to pursue in the development of a national painterly vocabulary represents a repeated line of reasoning in nineteenth-century critical writings. "Good" painters are those whose works break free of the stagnancies of tradition and also, more important, are those who sell. These painters both boost the fine arts market locally and confer status onto the Mexican nation by receiving international attention.[52] Together with the repeated articles written by liberal art critics concerned with improving the scope, breadth, and productivity of Mexican art by dismantling the traditional

painterly hierarchy that was supported by the Academia's conservative curriculum, the lists of artworks that were submitted to the annual exhibitions from outside reveal that popularity and marketability had a strong impact on the types of national artworks that were produced alongside those of an official sanction.

Notwithstanding its strategic popularization in late-nineteenth-century Mexico, however, the concept of national art retained an un-affected association with the sublime. The power of art, writes critic Manuel Salcedo in 1873, can be observed in its transcendence of time: "Art is superhuman; . . . superimposing itself onto time, it conserves everything live and palpitating: because, in its unending renewal of memories, it is capable of tying the cradle to the tomb."[53] Despite the democratization of the sublime and the repeated association of art with the status of science or industry in the political rhetoric of liberal Mexico, the belief in its transcendent nature shows up in the persistent use of religious terminology to describe it:

> In this matter one should blame the artists because Mexican society has no taste for the arts, for it is their duty to create it, spread it, and develop it; this mission belongs exclusively to the artists, who are the priests of art, and who should be responsible for making it available to the people.[54]

That art must be both powerful enough to unify a public imagination and interesting enough to purchase describes the dilemma in which nineteenth-century Mexican artists found themselves. The overall con-servative focus of the Academia and the consequential production of a large concentration of biblical and classical artworks satisfied the implicit criteria of the sublime but failed to interest the public enough to solidify a national canon or create a self-sufficient fine arts industry. Those artworks that were considered to be "of interest," using the words of Ignacio Altamirano, threatened the lofty criteria of the sublime by inserting a new type of evaluative criterion: that of popularity and, by extension, exchange value.

The increasingly tenuous divisions between sanctuary and mar-ketplace become further blurred when we consider that the public viewing and private purchase of art in the nineteenth-century Distrito

Federal took place often within the same venue. As of 1848, when the first exhibition was held in the Academia de San Carlos, records reveal that the institution was used as much as a marketplace as a fine arts museum: "In this sense, the role that the Academia played as [both] exhibition center and a place for buying and selling artistic works should be emphasized, since marketers were also allowed to exhibit paintings in order to promote their sale."[55]

In theoretical terms, the intersection of patrimony and commercial object that becomes rather blatant in the Academia context can be located in the fetishistic belief system that sustains them both. Both the viewing of a set of objects as pieces of national history (or as an essential or somehow symbolic component of the national culture) and the belief in the collection's ability to construct a totalizing representation of the world, nation, or self call forth a series of perceptual displacements that are only paralleled in fetishism.[56] These displacements, writes Mieke Bal, link all forms of narrative and collecting to fetishism as a meaning-making force. And there is no fetishized object, writes Susan Stewart, that exists independently of the "system of the exchange economy."[57] Precisely because there is nothing inherent in the object itself that prescribes its fetishistic value, it is unimportant whether the belief system that underwrites the object is of a private or public nature. Within each of these realms, the collection inalterably changes the ways in which objects will be viewed and valued.

The principal difference between the commodity and the collection resides in the perceptions of the systems of production with which these are associated. Both systems posit the self as alienated or divorced from the modes of production. The commodity, however, posits the self as "earning" and exchanging according to its capacity, while the collection presents us with a "metaphor of production" in which the world is presented as a given.[58] The self is the "inheritor of value" with respect to the collection[59] and thus the inheritor of membership within the social values that the collection implies, be these private and related to class or public and related to an affiliation with the sacred (either God or the state). The collection "happens" to the self, as does, thus, its sense of social membership. This happening or inheritance of belonging will be further addressed in the next chapter, during the discussion of how nineteenth-century museologists drew connections between displayed

archeological objects and the inert feelings of patriotism that would ideally be awakened within the citizen–viewing subject.

The consideration of fetishism makes a meaningful contribution to the concept of modern origins that grounds this study. Taken together, the proliferation of parades, public commemorations, constructions, and representative spaces that staged the metaphorical rebirth of the Mexican nation during the late nineteenth century created a collective perspective that was to be both learned and, at the same time, quite paradoxically taken as a given. Once displayed, the object of patrimony depends on a fetishistic operation of perception—the seeing of some thing as a possessor of objective representative powers—to convince the spectator of its own givenness. Therefore the task of the nation in the development of its canons of national patrimony is to convince of its ability to become its own representations, its own "makeup," and to will the citizen to do the same.

The use of the Academia's exhibition space as a site for both public contemplation and consumption reinforced the idea for some critics that perhaps one need look no further than to sales receipts to determine what should figure within the nation's nascent painterly canon. Artists, claims this particular band of critics represented by Ignacio Altamirano, must pursue new genres that have flourished in Europe and yet remain still nascent in Mexico such as genre paintings and landscapes. This solution posits the stimulation of an industry of fine arts as the necessary condition for the subsequent development of a definitive national aesthetic.[60] Conversely, as has been argued, critics of the more conservative persuasion wrote numerous periodical articles in support of the moralizing role assigned to the arts in the overall pursuit of national progress and advocated no less than a pure and disinterested conception of aesthetics such as that captured in religious themes.[61]

José Martí also recognized the potential in the connection between painterly canon and commerce. During his residence in Mexico between 1875 and 1876, the Cuban poet actively participated in Mexican artistic debates, publishing his reflections on the Academia's 1875 Exposition in the Revista Universal and clashing opinions with the conservative critic López López as to the direction that the arts should pursue.[62] Whereas López López valued artistic knowledge and expertise, Martí "asked for a painting of sentiment."[63] Advocating for the creation of a new set

of nationally inspired painterly themes, and aware of the negligible U.S. reputation for artistic production, Martí advised Mexican artists to flood the U.S. market with renditions of picturesque themes such as "our wood markets, our flower vendors, our excursions to Santa Anita, our fertile chinampas, perpetual bosom pregnant with flowers" in an effort to overcome their own aesthetic inertia and create a much needed "school of Mexican types." In other words, this idea presented a solution for the aesthetic deficiency of the United States while also satisfying its insatiable appetite for novelty. Furthermore, it would lead to handsome compensation to Mexican artists for their efforts. In other words, the need to pursue the production of works that reflect a Mexican aesthetic sensibility should be done in a way that is "useful." For this reason, Martí advised that the Academia pursue sales over sublimity: "In order to do something useful, why not create in San Carlos a school of truly Mexican themes which would be easy to sell and whose success would thus be assured, and forget about those useless sacred and mythological themes?"[64]

The Banamex Collection: Mexicanness as a Practice of Consumption

While the question of public demand, private patronage, and their role in the production of national material culture in late-nineteenth-century Mexico is a topic that has been far from exhausted, publications on Mexican material culture such as that offered by the National Bank of Mexico (Banamex, est. 1884) do recognize the significance of their contributions. A large number of those nineteenth-century popular artworks that represent specifically national or local Mexican themes and were either commissioned or purchased by contemporary private art collectors have been acquired by Banamex. The bank has served as a patron of the Mexican arts since the mid-nineteenth century, when its purchase of an architectural monument and former baroque residence led to the acquisition of artworks (originally) for the purpose of decoration.

A recently published catalog of the bank's collection of nineteenth-century national paintings reveals the largest private collection of its kind in the nation—408 works altogether, all of which fall within the

categories of the minor genres named earlier and acquired from private collections on reappearing within the commercial art marketing circuits during the mid-twentieth century, around one hundred years after their original purchase dates.[65] Though Banamex purchased these artworks during a time when the federal government showed little interest in their preservation (the 1970s), they now receive the benefits of public attention reserved for historically significant national patrimony.[66]

The existence of such a significant private collection with a strong retroactive claim to national cultural legitimacy in fact redefines the overall concept of the canon in hypermodern terms. Rather than judgments of permanence and transcendence, selecting a canon hinges on the continual negotiations between the centers and peripheries of cultural administration—a phenomenon that has proved constant since the nineteenth century. In Benjaminian terms, the construction of a national painterly archive occurs more within the temporal mode reserved for fashion than in the atemporal and timeless frame suggested by the traditional discursive frame of patrimony. Furthermore, the twentieth-century canonization of this particular grouping of nineteenth-century paintings exemplifies the theoretically inverted relationship between the collection and its own starting point as explored in this book's introduction: as a product of a slow and perhaps unintentional process of accumulation, the story of origin follows rather than precedes the collection's public emergence.

Of interest in the Banamex collection is the number of artworks that attest to the particular ways national themes were articulated through a pictorial vocabulary of consumption, market, and exchange value—terms that describe the social context in which they were produced. José Agustín Arrieta's still life painting called *Glassworks* (Figure 1.7), for example, which was also commissioned by the German entrepreneur–Puebla resident Joseph Lang during the mid-nineteenth century, combines themes of domesticity, class, and industry in a way that presents nineteenth-century Mexicanness from an industrial and participatory standpoint rather than one rooted in connotations of inheritance and tradition. Depicting an exquisite set of glass vases, bottles, and containers resting on a marble mantle before a gilded-frame mirror that reflects a distinctive bourgeois interior, *Glassworks* represents both the exaltation of belongings (the point of which was to compliment and

FIGURE I.7. José Agustín Arrieta, *Glassworks*, nineteenth century. Courtesy of the Colección Banco Nacional de México.

distinguish the patron) and also, as Ángela Velásquez Guadarrama observes, the aura of the product of mass-production and a tribute to the glass factories that were established in Puebla during the mid-nineteenth century—one of which was owned by the patron himself.[67] In homage to this theme of Mexican products, this particular painting features the aesthetic experience of physical reflection or the interplay of objects and light. The mirror in the background and the glass objects found in the foreground complement one another and offset the shadowy interior with abundant details of light, which counterbalance the pull of strong colors found in the central bouquet with subtle flashes of luminescence. The duplication of glass objects in the mirror further emphasizes the delicate plays of light, shadow, and shine on the glass objects, each of which boasts a unique set of exquisite features that the painter manages simultaneously both to understate and highlight. Like the aforementioned *Escena popular de Mercado con soldado* painting, in which the entrepreneur Lang strolls through a typically colorful Mexican market scene with his wife, *Glassworks* suggests that the images used to define any aspect of national culture (one that refers to a particular polity, place, or population) can include a variety of participatory and entrepreneurial pictorial terms. Rather than depicting an inherited, stable, or fixed identity, Arrieta's *Glassworks* projects *lo mexicano* through the lens of the consumer-based practices of production and purchase that emerged during this time juncture.

Though it may seem anachronistic on first glance to read the fabrication of Mexicanness as a conscious exercise in artworks such as this piece (after all, the pieces described earlier were collected according to twentieth-century criteria, for which pictorial themes can be considered national), contemporary nineteenth-century Mexican art critics did indeed define Mexican national identity in an exercise of strategic planning that much resembled a modern business model. In Altamirano's reflections, for example, the question of the canon's origin is displaced by the promotion of consumerism, to which these artists must ultimately aspire. His references to commodity exchange, rather than overtly dominating his commentary, serve a subtle regulatory function in his critique. Rather than overtly interrupting the flow of his gaze, references to the market are comfortably incorporated into the aficionado's reflections as he strolls through the rooms of objects on display:

I don't know why the painters in Mexico do not dedicate themselves a bit more to the painting of fruits, from which they would gain great benefit, in attention to the singular beauty and admirable color of our tropical fruits: foreigners, particularly the inhabitants of the colder countries, love with delirium these fruits of warm colors and opulent forms which reveal the gentleness of our climate, the light of our sun, and the exuberant richness which is the characteristic trait of the flora of the tropics.[68]

In asking the artists to represent themselves by exploiting their own physical surroundings, Altamirano's interest in specifically national content for artistic production is revealed in such a way that cleverly combines nostalgia with marketing. The nostalgic component to themes such as the local flora and fauna is reinforced through his employment of words such as *mexicano, mexicanismo, patria,* or *patriótico* as the highest praise for those works that have succeeded in embodying the Mexican national spirit—and the highest aspiration for those that have not.

Far from limiting the scope of what can be called "national" painting to the traditional genre of history painting, Altamirano consistently links the phenomenon of the national to the notion of commercial interest. This preoccupation repeatedly accompanies the pursuit of Mexicanness in the critic's rhetoric, thus filtering the scope of *lo nacional* through what may be considered "interesting" or "original." By emphasizing interest, originality, and a viewing public that delights in representations of the new and unfamiliar, Altamirano encourages his artists to develop a pictorial vocabulary that represents selfness as filtered through the demands of an international buying clientele.

A Mexican Alternative to the European Canon

By highlighting the products of Mexico's emerging industrial endeavors, certain privately commissioned paintings from the Banamex collection propose an alternative to the practice of inventing Mexican identity through the reproduction of inherited European canons. Still life paintings such as *Poppies* (1911), by Germán Gedovius, a German-trained Mexican painter and Academia professor best known for his portraits, and *Still*

FIGURE 1.8. Germán Gedovius, *Poppies*, 1911. Courtesy of the Colección Banco Nacional de México.

FIGURE 1.9. Félix Parra Hernández, *Still Life*, 1917. Courtesy of the Colección Banco Nacional de México.

Life (1917), by Félix Parra Hernández (Figures 1.8 and 1.9, respectively),[69] exalt local productions by featuring ceramic flower vases that were distinctive products of regional Mexican "manual industries."[70] Depicting an ornate blue and white Talavera vase of blooming red and white poppies set against a dark background and resting on a richly detailed flower print tablecloth, Gedovius's still life contains a subtle visual tension in the competition for dominance that manifests between the intricately crafted object and the glorious canopy it holds.[71]

In fact, Gedovius, whose work had not received significant critical attention since Alfonso Cravioto's 1916 study before it was featured in a 1984 MUNAL art exposition, is credited with helping to dismantle the traditional hierarchy that privileged historical themes over still lifes. Along with Saturnino Herrán (1887–1918), he is now critically regarded as contributing to the aesthetic nationalist movement known as *criollismo*

FIGURE 1.10. Pedro Güaldi, *Showroom of the National Theater*, nineteenth century. Courtesy of the Colección Banco Nacional de México.

in his explorations of an iconography of common objects that helped form a sense of *"alma nacional."*[72]

As the Academia de San Carlos fought to uphold the standards of the traditional European canon by pursuing universal and classical themes and investing in European schooling for its own national artists, an alternative pictorial vocabulary for Mexicanness can be traced through the self-reflexive gaze of the middle-class private collector as represented in the painterly themes described earlier. Whereas the Academia sought recognition largely through the successful reproduction of traditions inherited from the outside, the Mexicanness described in works that were privately commissioned or purchased reflects an alternative mode of describing selfness that is attained through specific acts of monetary participation: Güaldi's consumption of cultural events (Figure 1.10), for example, or the fabricated objects of Parra and Arrieta described previously.

The names of Academia de San Carlos patrons who regularly supported the arts through purchase and sponsorship, who included doctors,

businessmen, and politicians such as those forming the "circle of friends" of President Díaz, appear throughout the published compilations of archive materials from the Academia. They are most often included within the lists of exhibited works that were sent from outside the Academia for the annual exhibitions between 1867 and 1910.[73] These patrons not only supported their favorite artists through private commission but also, on occasion, donated sums of money large enough to sponsor voyages to Europe for further schooling. Their names also appear in the archives of the Academia de San Carlos under the title of "sponsors," or shareholders of the Academia, which earned them preferential access to exhibitions and the potential to win specific paintings set aside for lottery at the close of the official public display.

The Morality of Spending: Materiality Meets Spirituality

It is perhaps in paintings such as Alberto Bribiesca's *Moral Education: A Mother Leads Her Daughter to Help a Beggar* (Figure 1.11) that the moderate, conciliatory position between the two aesthetic extremes of a narrow and "gross materialism," on one hand, and a "simple, disconnected spiritualism," on the other, becomes clear.[74] Displayed at the nineteenth Exhibition of the Academia in 1879, Bribiesca's *Moral Education* depicts an encounter between beggar and mother–child within the confines of the bourgeois domestic interior, in which the mother encourages her young daughter to drop a coin in the humble visitor's hat. Overlooking the scene from above is not the traditional Roman Catholic cross that might be expected in an earlier articulation of the same theme but rather a national map of Mexico. The collection of books, writing desk, lamp, and paintings in the background serves two purposes. First, the objects inscribe the spiritual practice of charity within the secular context of the liberal state, as explains Ángela Velásquez Guadarrama. More important for this study, however, they also illuminate the spiritual side of consumerism—the possibility of framing the exchange of coin for moral ascension within an atmosphere in which the collection of objects in the background seems to spill out from the national map. The implication here is that in its highest realization, the type of spending that is associated with the domestic sphere is ultimately a moral exercise. In this case, the accumulation of objects in the contemporary

FIGURE 1.11. Alberto Bribiesca, *Moral Education: A Mother Leads Her Daughter to Help a Beggar,* 1879. Courtesy of the Instituto Nacional de Antropología e Historia.

bourgeois domestic interior represents not an instance of materialistic hoarding but rather a form of circulation that ultimately reaches the noblest exercises of citizenry.[75]

The moral subtext insinuated within the practices and dynamics of the emerging consumer culture extends to the artistic sphere, in which, as newspaper articles between 1860 and 1900 indicate, the very same Mexican artists who are deemed responsible for producing a sense of national taste wind up as victims of a system that fails to provide even for their material survival. There appear various criticisms of the nation's moneyed classes, who fail to spend their money as responsible Mexican citizens:

> And . . . in the United States there are many artists from there and foreign nations who earn stacks of money, whereas in Mexico, in Mexico . . . painting and sculpture are disdained, the artists don't occupy the elevated position of the Europeans, and the private collectors who have the means to adorn their walls with the product of genius of their compatriots instead bring home [artworks of bad quality] from Europe.[76]

It is the responsibility of the nascent middle class to cultivate a sense of taste capable of contrasting the vulgar accumulations of the rich[77] and also to understand the sense of urgency that links the status of national art to progress on all frontiers:

> Once fine arts play such an elevated role in civilization, because they put their stamp on everything in sight, and to them does the civilized world owe its greatness, it is appropriate that Mexico now recognize that to catch up to the advanced nations it should pay much closer attention to them, inspiring the artists, and should also quit scorning those objects which, mistakenly, are believed to be pure luxury when *both philosophers and naturalists consider them to be an indispensable aid to both science and industry.*[78]

The philosopher and the scientist, on the basis not so much of their individual expertise as their grounding in disciplines of an official sanction, constitute the loci of authority of the modern state who are able to

"see" beyond the immediate pleasures of aesthetic appeal to perceive the highest function of art in its hidden, abstract connections to science and industry. Through a series of arguments imbued with moralistic tones, one discerns a fundamental concern to sway the emerging capitalist Mexican public away from the notion of art-as-decoration and toward a perspective that highlights its centrality to national development on all frontiers.

Further associations between art and commerce appear in the published guides to the late-nineteenth-century and early-twentieth-century archives of the Academia de San Carlos, which include repeated references to a special acknowledgment or "registry of artistic properties" that was granted to commercial products, including product labels (tobacco, cigar, and medical), local maps, and postcards. These commercial products demonstrated a level of aesthetic quality that was strong enough to generate an official form of acknowledgment by the Academia. Undoubtedly, they, too, bridge the conceptually opposed modes of value that underwrite the sublime art piece and the commercial product.

Of the so-called minor genres presented in this chapter, landscape painting in nineteenth-century Mexico could be that which most clearly embodies the dynamic negotiations between fatherland and property (or sublimity and commercial value) through the incorporation of references to mass transit within the sublime expression of nationalism. Academia professor and renowned artist José María Velasco's *Cañada de Metlac* (1897), for example, resolves the implicit dialectic between the essential and the commercial in its apparently effortless incorporation of industrial referents into an organic landscape depiction (Figure 1.12). Constituting the eye's main reference point, the horizontal diagonal ravine that connects foreground to background from left to right pulls the gaze backward in a progression from nature to nature, bypassing the oncoming train in a movement that is not so much dismissive as simply unperturbed by the directional tension presented by the locomotive's face-on progression. The luminescence and painstaking attention given to the detail of the foreground foliage offer it as a focal point that balances the eye's attraction to the reflective quality of the train's surface. The heightened perspective of the spectator also facilitates the train's ultimate translation into the grammar of landscape, as suggested by the

fading quality of the train's emissions, which are transparent enough to reveal the features of the land beneath. The train's right-hand positioning, replacing the characteristic foreground tree common to the landscape genre, constitutes a promise to leave the scene unperturbed. In a perfect conjugation of nature, national landscape, and mass transit, the tips of foliage and the train's emissions pay homage to the Citlaltépetl's peak in implicit trajectories of diagonal lines that converge precisely there. In the economy of imagery represented here, national landscape and commercial development coexist in impeccable balance.

If the vast national landscape scenery as displayed to the viewing public of the nineteenth century offered national spectators the opportunity to locate themselves as citizens by recognizing their own sublime national territory for the first time, it was also used to expose international spectators to the unexploited richness of Mexico's natural resources. Casimiro Castro and cartographer and Academia affiliate Antonio García Cubas's lushly illustrated *Album of the Mexican Railway* (1877), for example, which was published in English and Spanish, featured a richly detailed account of a train plundering through the recently constructed Veracruz–Mexico Railway and was explicitly written to encourage foreign investment. An empty signifier that was strategically transposed into a variety of media (painting, literature, poetry, and, as will be seen, maps and statistics), the Mexican landscape was particularly adaptable to these nineteenth-century endeavors to conjugate the dynamics of the sublime with commercial enterprise.

The postcards that José María Velasco produced toward the end of his life, which also feature views of Mexican natural scenery, highlight the figurative transformation of the grandiose national territory into a consumable form. To borrow Susan Stewart's apt analysis of the transition from painting to postcard, the purchaser of the card symbolically appropriates the monumental and iconic exterior place, thus trumping community membership by subsuming the implied contemplation of the public icon within the individual gesture of consumption.[79] The loss of the expansive view of the painting is supplemented with the sender's narrative in the form of the accompanying written text, and the subjective appropriation of the public realm is reiterated through its transfer to a recipient. As an objective territory (the iconic piece of scenery) becomes narrated into the subjective realm, the postcard's written text provides

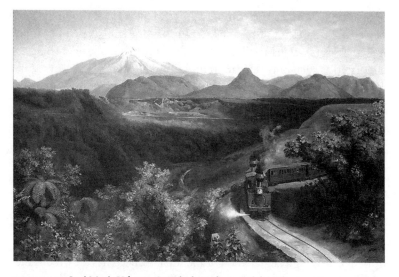

FIGURE 1.12. José María Velasco, *Cañada de Metlac* [*o Citlaltépetl*], 1897. Courtesy of the Instituto Nacional de Bellas Artes y Literatura.

closure to the collective narrative of the landscape painting, allowing for a coincidence of citizen–gazer and consumer–writer. Visible in the upper left corner of Velasco's postcards, the stamp of the Dirección General de Correos affirms the official sanction of the national image as translated into a consumable form and context.[80]

In sum, Mexico's unique position as a newly consolidated nation-state faced with the task of constructing modernity is reflected in the artwork that was produced. The forces of accumulation (consolidation) and dispersion (commerce) coincide in the national images that were produced during this era, resulting in a marked bifurcation between those art pieces that were officially sanctioned by the Academia de San Carlos and those that developed in its periphery within the circuits of private commission and consumption. Writers and art critics such as Ignacio Altamirano and José Martí, who were conscious of the potential of developing a national style and repertoire of imagery by looking to consumer demand, advocated for a more conscientious exploitation of the market's potential when developing a national painterly canon.

This mode of thinking points again to the question of how to locate the elusive and complex origins of collected objects. According to the

logic outlined earlier, the commission or market value should be harnessed to inspire a set of paintings featuring local subject matter rather than the reverse. Thus a national collection forms, but one that would be circulated as such only retroactively—around one hundred years later.

The underlying assumption for Altamirano and Martí was that once the national artistic canon was constructed and sufficient pieces had been accumulated, its dispersion among the buying publics of Europe and America would motivate a shift in the value status of that art and its local reception. Mexican consumers would learn what to buy, and the artists would learn what to paint. What originated as exchange value would thus retroactively confer the nascent artistic *tradition,* baptize an official canon, and reinforce a sense of identity by providing a repertoire of national imagery for the public imagination. Within this dynamic, art's claim to transcendence is ultimately preserved. Marketability, far from representing a degradation of the sublime, becomes the irreducible symptom of a properly explored national aesthetic—one that ultimately allows the emerging Mexican consumer public to recognize itself, or to own, so to speak, the very status of citizen in the everyday pictorial vocabulary that mirrors its own gestures.

2

Our Archaeology: Science, Citizenry, Patrimony, and the Museum

❁ ❁ ❁

By the close of the nineteenth century in the Americas and Europe, the museum institution constituted a common reference point for the symbolic justification of a nation and culture. As such, the Mexican Museo Nacional is a particularly charged venue through which to discover the strategies employed by a nation that faced the task of reclaiming its archaeological heritage from a long history of cultural expropriation. Mexico's prolonged experience of cultural loss through patrimonial confiscation involved both the depletion of important historical artifacts by the Spanish colonizers and foreign explorers and the figurative ownership over pre-Columbian antiquities as exercised in the production and publication of knowledge about them in scholarly treatises.

Mexican archaeology underwent its own reinvention of origins during the Porfiriato—a process of nationalization that involved a reinvigoration of policy (through such motions as the reaffirmation of the original 1825 prohibition against the foreign expropriation of national artifacts)—and also a rhetorical strategy as the expertise on pre-Columbian artifacts was reclaimed from the domains of foreign scholarship and placed into the hands of specifically *national* scientific institutions. Indeed, many original source materials for the study of pre-Colombian Mexico had been expropriated to Europe. Benjamin Keen writes that Francisco Paso y Troncoso, who became director of the museum in 1889, spent much time in Europe photographing these archival materials on ancient Mexico, including the important corpus of documents left by Bernardino de Sahagún.[1] What remains to be seen are the specific strategies employed within the disciplinary and pedagogical networks

of the Museo Nacional to nationalize Mexican archaeological patrimony, reclaim the Museo as an institution driven by national rather than foreign scholars, and market the national collection as a site of collective memory through which Mexicans could recognize themselves as citizens.

Read within the context of the reappropriation of national patrimony, the displayed object of the Museo Nacional materializes an encounter between distinct social forces that traverse the division between public and private domains. For one, it embodies a dialogue between *patria* (the homeland) and *ciencia* (science), in which Mexico as a newly autonomous political entity affirms itself publicly by asserting a specifically national claim to a universal discipline—such as "Mexican archaeology" or "Mexican paleontology" (both terms that circulated within the museum's published annals of this period).[2] At the same time, the *Anales del Museo Nacional* of the late nineteenth and early twentieth centuries offer idealized expositions on displayed objects in which the forces of science intersect with those of emotion in the transcendent experience of the viewer, whose act of contemplation was regarded as deeply patriotic.[3]

The nationalization of Mexican antiquity that occurred during the Porfiriato entailed rebalancing the scales that had previously favored international over national claims to the pre-Columbian Mexican inheritance. Following over a century of foreign dominion over Mexican excavations and scholarly expertise on Mexican antiquity, pioneer Mexican archaeologists and scholars such as Alfredo Chavero,[4] Gumesindo Mendoza,[5] Leopoldo Batres,[6] Jesús Sánchez, and (bridging the twentieth century)[7] Jesús Galindo y Villa[8] and Manuel Gamio[9] all worked strategically to nationalize the field of Mexican archaeology and to defend a place for Mexican antiquity within the great canon of historical traditions. There were two fundamental steps to this process: first, the integration of foreign scholarship into a nascent national scholarly tradition as elaborated in the *Anales del Museo Nacional*, which began publication in 1877, and second, the imbuing of archeological object displays with new, abstract meanings and powers (such as the awakening of patriotic feelings, the completion of national history, and the positioning of Mexico on a firm road to progress). Within this progressive and constructive dynamic, there was a darker side to exhibition culture that also becomes apparent on closer scrutiny: the maintaining of class differences among

the visiting museum public, the suppression of "distasteful" or otherwise threatening patrimonial objects, and the overall lack of concern for the social and political status of contemporary indigenous peoples.

In contrast with the preceding chapter, in which the question of creating a national collection involved the physical production of something new, the objects featured in the context of the national museum were artifacts and sacred cultural monuments that had existed for centuries. The disparate stories of their origins had to be reconstructed in such a way that created a common logic for their association with the modern national image. Thus their transition to collected objects in the nineteenth century was solely conceptual: what had been largely universally regarded as "other" would now be advertised as national property, and with ambitious implications for the future.

Whereas in the case of Mexican national painting, there was an effort to consult the international market as a source for exploring a national style, the museum context reverses that dynamic. Both cases involve the linking of collected objects to an archetypical story of origins (or a transcendent sense of essence), on one hand, and a set of specific consumptive practices, on the other. The strategic positions of the two institutional settings, however, call for distinct approaches. Because pre-Columbian excavations were linked to an international commercial subtext from their colonial beginnings, the development of a Mexican archeological tradition meant that it had to be somehow reclaimed as intellectual property and almost simultaneously re-presented to international scholarly and commercial circuits as a *product* of Mexican efforts and expertise (Figure 2.1). Only then could the nation attain the status necessary to participate in the international scientific intellectual community as a peer.

From Moctezuma's gift to Hernán Cortés (which was expropriated to Europe, displayed in Austria, and written about by Pedro Mártir, Bartolomé de las Casas, and Albrecht Dürer) to the hundreds of artifacts that made their way into European wonder cabinets, museums, and private commercial exchanges from the sixteenth century onward, Mexican archaeological history had for centuries been explored, excavated, and carried away by European and U.S. travelers, collectors, and scientists.[10] As demonstrated in this 1870 letter excerpt, written by Austrian Mexicanist F. Wennisch and addressed to Emperor Franz

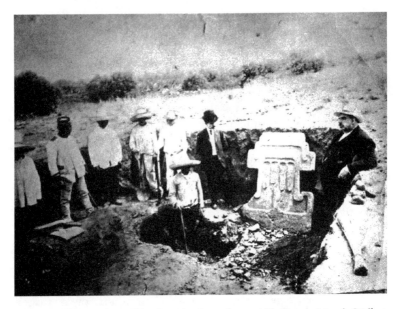

FIGURE 2.1. "Excavations at Teotihuacán. Around 1905–6." In Ramón Mena's *Catálogo del Salón secreto (culto al falo)*. Courtesy of the Instituto Nacional de Antropología e Historia.

Joseph, brother of the former Emperor Maximilian I of Mexico and ruler of the Austro-Hungary Empire (1830–1916), the location of the cultural artifact was often the key determinant of the system of value with which it was attributed:

> Your Excellence has probably become familiar with what was said in Mexico when the liberals entered, that the sword of Cortez was missing. I have found here in the hands of an individual who was still in Mexico during that time and who left with foreign soldiers a sword that he insists was that of Cortez. Judging from the description of the place in which he found it hidden in the Museum, and from the person who sold him the sword, there remains no doubt that it must be the actual sword of Cortez of the Museum of Mexico. . . .
>
> The current owner is willing to sell the sword, he wants to send it to London, even though he has had some good offers here. Until now I have stopped him, because I would prefer that this sword return again to Mexico; I know that it will satisfy them there to see it

FIGURE 2.2. Photograph of the Congress of Americanists of 1910, an event that attracted an international group of famous anthropologists and archaeologists to Mexico to witness a series of events, inaugurations, and business openings associated with the Centennial Celebrations. In Ramón Mena's *Catálogo del Salón secreto (culto al falo)*. Courtesy of the Instituto Nacional de Antropología e Historia.

once again in the Museum of Mexico. I will do everything possible so that this sword will remain in the hands of the current owner, and I am sending the four photographs and waiting for your opinion on this transaction.[11]

Evident in this letter is not only the effort to return the artifact to its rightful location but also to reassign the sword to the proper value system—that of cultural patrimony rather than private property. If the implication here is that the systems of value represented by culture and commerce are mutually exclusive, this is only apparently the case. As demonstrated earlier, there is a mutually supportive dynamic in place in the dialogue between patrimony and commerce: each is a marker of value that heightens the social recognition and desirability of the object in question.

Throughout the nineteenth century, during which the professionalization of archaeology, anthropology, and ethnography spurred increased

interest in pre-Columbian sites and artifacts, numerous organizations were created in Europe and the United States with the objective of studying and exploring the ancient indigenous cultures of the Americas. The Société Américaine de France (founded during the mid-nineteenth century), for example, organized the famous Congresos Internacionales de Americanistas that would take place every two to four years between 1875 and 1972 (Figure 2.2).[12] In the case of the United States and England, as will be discussed in further detail, traveler–explorers such as Stephens and Catherwood and politicians such as Lord Palmerston (1784–1865) justified the expropriation of pre-Columbian cultural artifacts in Mexico and Central America by pointing out the "lawlessness" of the lands in question, questioning the "native's" capacity to safeguard and appreciate their own patrimony appropriately, and emphasizing the collective disinterest of the local populations.[13]

The Collection, the Commodity, and Foreign Interest

The links between pre-Columbian artifacts and international commercial interests, however, were not only imposed from outside. Both the Museo's participation in the late-nineteenth-century world's fair events (held every two to four years between the mid-nineteenth century and World War I) and its hosting of the first international Congreso de Americanistas meeting to be held on the American continent (1895, and again in 1910) indicate the extent to which this highly symbolic institution was nurtured by strong commercial and international links. In "History and Patriotism in the National Museum of Mexico," museum historian Luis Gerardo Morales-Moreno reminds us that in addition to the museum's prominent role in the setting up of Mexican exhibits at the expositions,

> two international Congresses of Americanists were held in the National Museum, one in 1895, another in 1910. These activities conferred considerable prestige on the Porfirio Díaz period and used the display of archaeological pieces to open up international frontiers of trade and development outside Mexico.[14]

While it is not immediately clear from the preceding quotation exactly how it is that the archaeological object in itself embodies commercial

value, W. J. T. Mitchell's notion of "forgetting" offers a theoretical congruence between the collected piece and the commodity in the museum context. Pointing out the doubled process of "amnesia" through which the commodity comes to be fetishized as an embodiment of value in the capitalist society, Mitchell locates the first instance of this productive mode of forgetting in the capitalist's unwillingness to recognize himself or herself as the projector of value onto a given object. The second instance of forgetting, in which the commodity becomes so ubiquitous, familiar, and trivial that it is no longer recognized as something for which its value was artificially constructed, proves suggestive when applied to both the museum context and that of the national monument, as will be discussed in the next chapter.[15] Whereas the "pure" commodity is characterized by its false familiarity, or, in Mitchell's words, the "denial that there is anything magical about it,"[16] the object of patrimony embodies the sacred and the familiar simultaneously. On one hand, the collection of national patrimony is surrounded by a hyperawareness of its value—its ability to transcend history by translating it into material, spatial, and universal terms. On the other hand, it is precisely the givenness of national patrimony's immense value that reveals its true ability to naturalize itself and perform such magical acts as reconciling even the most opposing political interpretations or offering itself as a type of figurative collateral in the context of negotiation for foreign investment or exchange.

Perhaps nowhere are the connections between commerce and patrimony more overt as in the context of the European and U.S. exploitation of Mexican and Central American antiquities. The *Anales del Museo Nacional* (epochs 1–3, tomes 1–7), along with the work of scholars such as Benjamin Keen, Ignacio Bernal, and more recently, Robert Aguirre, contain multiple references to foreign scholarship and its impact on the intellectual traditions dedicated to the ancient cultures of Mexico and Central America. Colonial influences on the nineteenth-century collecting attitude in Mexico can be traced to a few key early-eighteenth-century scholars such as the Italian historian and ethnographer Lorenzo Boturini (1702–53), who collected pre-Columbian antiquities and wrote the *Catálogo del museo histórico indiano,* a catalog of ancient documents, maps, codices, and paintings that was published in Madrid in 1746. During the late 1780s, Bernardo de Gálvez y Madrid, the Count of Gálvez and viceroy of New Spain between 1785 and 1786, sponsored the expeditions

of Spanish botanists Martín Sessé y Lacasta and Vicente Cervantes that led to the eventual publication of *Flora Mexicana,* a comprehensive catalog of the flora and fauna of New Spain. Likewise, the French captain and explorer Guillaume Dupaix was appointed by King Carlos IV of Spain to make a complete survey of Mexico's archaeology and sites of antiquity; he later contributed several objects from his excavations to the postindependence-era Museo Nacional when it opened as an extension of the university in 1825. The famous German naturalist, explorer, and collector Alexander Von Humboldt (1769–1859) traveled through Latin America between 1799 and 1804 and published his famous *Essai politique sur le royaume de la Nouvelle-Espagne* in 1811. Closer to the era studied here, emperor Maximilian I (1864–67) showed special interest in edifying the Museo by declaring its institutional independence and granting it a house in the Calle de Moneda, where it remained until 1964.[17]

Within the vast scope of the subject of nineteenth-century foreign interest in Mexico, it is worth reviewing some of the key figures and means through which the circuits of exchange and circulation between Europe and Mexico were created on the basis of interest in Latin American antiquity and how they helped propagate the urgency behind Mexican scholarly interest in its own past. The combined scholarship of Robert Aguirre, Elizabeth Williams, and R. Tripp Evans features Great Britain, France, and the United States as the main protagonists in nineteenth-century Mexican and Central American excavations.

As the first European nation to recognize Mexican independence in the 1820s, Great Britain harnessed political diplomacy to commercial interest by signing a number of commercial treaties, issuing large loans, and becoming Mexico's principal trading partner during the first fifty years of its independence.[18] Yet it was the establishment of "transatlantic networks of culture," or the movement of objects, information, and ideas between Mexico and Great Britain, writes Robert Aguirre, that "accompanied and enabled" Britain's political and commercial agendas in nineteenth-century Mexico.[19] While Elizabeth Williams points out that the British government did not sponsor individual pre-Columbian archeological expeditions until well into the twentieth century,[20] Aguirre uses the concept of "informal empire" to frame the cultural agenda of individual entrepreneurs and institutions (such as Alfred Maudslay or the British Museum) within the larger arena of commercial investment

that describes nineteenth-century British foreign policy in the region. In addition to marketing concerns, the accumulation of exotic foreign materials fed the nineteenth-century obsession with science as a basis for affirming national sovereignty. In her study on late-eighteenth- and early-nineteenth-century French expeditions in the Pacific, Carol E. Harrison writes of the revolutionary government's rapid nationalization of a rescue mission that had begun only a few years prior as Louis XVI's pet project of Pacific discovery.[21] Thus began liberated France's voyages of discovery to the Pacific and the conjugation of enlightened science with new-regime nationalistic principals. As demonstrated in the combined work of Mauricio Tenorio-Trillo, Robert Aguirre, Jens Andermann, Margaret Díaz Andreu, and Timothy Champion (in their coedited anthology titled *Nationalism and Archeology in Europe*), the association between the modern nation and science would sustain much of the patriotic rhetoric circulating out of Europe, Latin America, and the United States during the nineteenth century.

By the mid-1800s, the United States, Great Britain, and France were each involved in Mexican and Central American expeditions in search of pre-Columbian artifacts for slightly different reasons. France's overtly political and colonial agenda in Mexico, which culminated in the government-sponsored military expedition of 1864, contrasted with England's less centrally organized, more diplomatic, and more commercial form of dominion.[22] Generally speaking, aesthetic judgments also differed among critics from the two nations; British anthropological writings between 1850 and 1900 reflected a marked appreciation for pre-Columbian artistry, whereas French ethnographical and anthropological commentary, which was, as Elizabeth Williams puts it, "much more wedded to 'classical values' in aesthetic judgments," was significantly more critical.[23] The United States, in turn, unable to lay claim to the ruins of Greece, Rome, and Egypt, was intent on bolstering its status as an imperial authority by accumulating formidable collections of New World antiquities and displaying them in the most prestigious museums of New York and Washington.[24] U.S. anthropologist Herbert Spinden's 1913 doctoral dissertation, titled "A Study of Maya Art," inspired an aesthetic appreciation for pre-Columbian art in the United States that would increase during the 1920s and 1930s, judging from the quantity of pre-Columbian-themed museum exhibitions during those decades.[25] In

all three cases, Mexican and Central American antiquity provided the material means through which to promote the national and international status of foreign powers.

One of the principal means of exchange through which knowledge of pre-Columbian cultures circulated in the nineteenth century was, of course, literary. Each of the three studies mentioned earlier references the famous journeys and publications of U.S. travel writer John Lloyd Stephens (1805–52) with British architect and illustrator Frederick Catherwood (1799–1854) as seminal recordings of foreign pre-Columbian exploration. R. Tripp Evans calls their Latin American Incidents of Travel series (1841 and 1843), which included four volumes dedicated to Mayan architecture in Mexico and Central America, "the most complete record of pre-Columbian sites that had ever been produced." Also unique to these publications were their inexpensive production costs, which facilitated a wide circulation and "unprecedented readership in the United States."[26] Yet the impact of this publication far outreached the geographical boundaries of the United States, and in his study on the French explorer–archaeologist and photographer Désiré de Charnay (1828–1915), also a prominent figure in pre-Columbian exploration, Keith Davis identifies the Incidents of Travel volumes as prototypes for nineteenth-century exploration literature and recognizes their impact in both "style and substance" on Charnay's subsequent work.[27]

Situated between the "two distinct eras of Mexican archaeology," the Romantic–descriptive and the scientific, as represented respectively by John Lloyd Stephens and the famous British archaeologist Alfred Maudslay, Désiré Charnay was sent to Mexico by the French Ministry of Education in 1858 to photograph pre-Columbian ruins. Considered by many who studied his work in subsequent years as "less a scholar than an explorer-cum-travel writer," Charnay nonetheless produced a collection of photographs that "set the scientific standard" for future research during his voyages to Mexico and Central America during the mid- to late nineteenth century.[28] Titled Cités et ruines américaines: Mitla, Palenqué, Izamal, Chichen-Itza, Uxmal (1862–63) and consisting of a two-volume set of large-sized photographs and text, this famous publication gave Europe its "first photographic vision of the mysterious Mexican monuments," and as such, argues Keith Davis, merits recognition as a

key contribution to scientific advancement in the field of pre-Columbian archaeology.[29] Owing to its immense popularity in Europe, Charnay's travel account was soon translated into Spanish and republished in Mexico in 1868 and then was published again in English in 1887.[30]

Alfred Maudslay (1850–1931), who began his career as a colonial diplomat and later became one of the most important Mayan scholars of the nineteenth century, made a total of seven expeditionary voyages to Mayan ruins between 1881 and 1894. On his return to England, fellow British naturalists and explorers Frederick Godman and Osbert Salvin offered to publish his work as part of their ambitious series of volumes called *Biologia Centrali-Americana* (1889–1902), in which they attempted an exhaustive documentation of the flora and fauna of Central America.[31] Titled *Archaeology*, Maudslay's edited compendium of notes, photographs, and illustrations filled four volumes. Simultaneous with his work on *Biologia*, Maudslay began to work with his wife, Annie, on a more informal account of his experiences. The resulting manuscript, called *A Glimpse at Guatemala, with Some Notes on the Ancient Monuments of Central America*, was published in 1899.[32]

Beyond the realms of textuality and readership, however, much of Charnay's and Maudslay's respective work involved the reproduction, circulation, and display of objects. As Diana Fane observes in her article on the use of molds and models in pre-Columbian exhibitions between 1824 and 1935, French classical scholar Jean François Champollion's (1790–1832) decipherment of the Rosetta Stone in 1822 had the effect of fueling and justifying efforts to copy the inscribed monuments of ancient America. Désiré Charnay, Alfred Maudslay (who also gathered a sizeable collection of smaller original artifacts from Yaxchilán and Copán), and the American Edward H. Thompson (1857–1935) each made use of casts to reproduce numerous large-scale Mayan monuments, which were then sent to museums all over Europe and the United States for purposes of exhibition and study.[33] Venues such as the University Museum in Philadelphia, the Chicago World's Columbian Exposition in 1893, and the Panama–California Exposition of 1915 (held in San Diego) also welcomed vast U.S. and international audiences to admire grand displays of pre-Columbian artistry and architecture.[34] Keith Davis provides detailed descriptions of the process that Charnay used to create his papier-mâché molds (or "squeezes"), which he used to

make "three-dimensional records of the complex bas-reliefs" at several different sites of Mayan ruins.[35] The low weight of these molds permitted their easy transportation to the Trocadero Museum in Paris and to the Anthropological Society of Washington, D.C., at which point they were transferred to the National Museum for exhibition.[36] Maudslay, in turn, who mentioned witnessing Charnay's paper-molding process at Yaxchilán on their chance meeting in 1882, subsequently invented many archaeological techniques during his travels.[37] With the help of Italian professional plaster worker Lorenzo Giuntini, Maudslay and his team were able to obtain plaster casts of the main stelae, monuments, and zoomorphs at sites such as Quiriguá (Guatemala), Copán (Honduras), and Chichen Itzá (Mexico).[38] Subsequent to his return to England, Maudslay's numerous and immense casts were donated to the South Kensington Museum (later known as the Victoria and Albert Museum), where he and his employed artists Edwin J. Lambert and Annie G. Hunter accessed them regularly to execute the illustrations for the *Archaeology* volumes.[39]

It is important to note here that the writings on and material reproductions of pre-Columbian artifacts that European travelers produced for their own respective scientific communities were avidly consumed by Mexican specialists as well. In his study on Mexico at the world's fairs, for example, a theme again explored in chapter 4, Mauricio Tenorio-Trillo describes Mexican engineer Luis Salazar's pavilion project design for the Exposition Universelle de Paris of 1889 as heavily influenced by Charnay's photographs. Salazar also consulted the work of early-nineteenth-century French explorers Guillaume Dupaix and Jean-Frédéric de Waldeck, whose illustrations of Mayan ruins included such sites as Uxmal (Yucatan) and Palenque (southern Mexico).[40] As will be discussed further, foreign scholarship also appears frequently in the Mexican National Museum's nineteenth-century written annals, usually providing hypotheses regarding the origins and uses of featured objects. Whereas the reliance on foreign expeditionary materials is part and parcel of a long and problematic tradition of Creole courtship with European scholarship, it also provides for a type of symbolic reappropriation of its own antiquity as Mexico underwent scientific professionalization during the nineteenth century. While a given Mayan ruin may have first circulated as a groundbreaking sample of European

expeditionary photography, it would be reappropriated by Mexican scholars and transformed into an embodiment of the nation's ability to display proprietorship over its own past.

While the legal effort to retain cultural objects of antiquity coincided with the original founding of the National Museum in 1825, the Porfirio years reflected an increased urgency to retain and put Mexican antiquity to strategic use. A heightened awareness of the immense foreign interest in pre-Columbian antiquity caused politicians and scientists alike to reevaluate the status and practices of conservation of ancient Mexican patrimony multiple times, and archaeology became a keystone for both nationalistic discourses and diplomatic relations with Europe and the United States.

Strategies for Reclaiming the Archaeological Inheritance

Immediately following the liberal triumph over Maximilian in Mexico, all documents pertaining to the archaeological monuments and collections of private interested parties (including Boturini, León de Gama, Dupaix, and Humboldt) were transferred from the emperor's residence to a separate domicile to be "studied."[41] The special interest in this particular archive dates back to an eighteenth-century intellectual resistance to two basic phenomena in Nueva España: first, the crown's revocation of privileges and denial of high-status administrative positions to Creoles, and second, European theories of degeneration, propagated by representatives like Cornelius de Pauw and William Robertson, which claimed biological foundations for the alleged inherent inferiority of the mestizo race.[42]

What is interesting in this particular transfer of a collection, and what it happens to have in common with every major transformation to occur within the Museo Nacional between the late nineteenth and early twentieth centuries, is its immediate translation into a political event. From the liberal assumption of power in 1867 to the Centennial celebrations of independence in 1910, the Museo Nacional was consistently one of the principal stages on which the rituals of political autonomy were reenacted through public commemoration ceremonies and special exhibits in honor of national holidays. Museum reforms such as the creation in 1887 of the famous Gallery of Monoliths (Figure

2.3), for example, were marked by ceremonies attended by the highest political representatives:

> Director Gumesindo Mendoza . . . began this worthy task . . . to form the current rich collection, which could compare favorably alongside any similar one in Europe or the American continent. . . . The great exhibit room was solemnly revealed to the public on the 16th of September of 1887 in the presence of the president of the Republic, General Porfirio Díaz, and his secretary of public instruction, D. Joaquín Baranda.[43]

Two rhetorical moves for the nationalization of patrimony are evident in the preceding passage. First, there is a challenge to the universally presumed European hegemony over self-representation. Second, there is explicit reference to the official sanction implied by the presence of the highest government representatives at the unveiling of the new museum gallery. In the suggestive advertisement of the national event quoted here, there is a decipherable pattern that shows up quite consistently within the Mexican museological discourse of the era. Cultural administrators like Gumesindo Mendoza combined the literal and figurative placement of objects (into reorganized display rooms and scientific disciplines) with the circulation of strategic texts (such as published speeches, written explanatory labels for exhibited objects, and published catalogs) to reclaim Mexican history from the shelves of foreign canons and create the means through which archaeological objects could represent the promotion of cultural capital in modernizing Mexico. In his 1887 report to the secretary of justice and public instruction, for example, then museum director Jesús Sánchez constructs a metaphorical parallel between the abandoned archaeological objects "of uncalculated value" that had been deteriorating on the patio of the museum and the need to reclaim Mexican patrimony from Europe and the United States, both of which had spent "large sums of money" on the acquisition and study of Mexican antiquities. The placement of such objects within a "large gallery destined for their safekeeping" (the future Gallery of Monoliths mentioned earlier) promised to yield "practical results," which included, on one hand, the correction and rewriting of history and, on the other, the education of an otherwise unlearned public and the

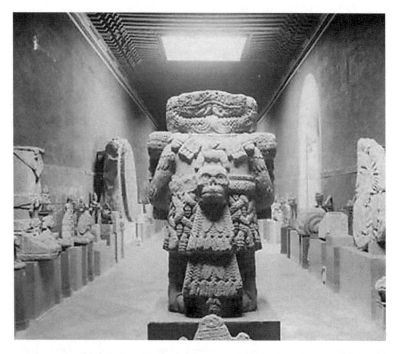

FIGURE 2.3. Gallery of Monoliths, 1887. Courtesy of the Instituto Nacional de Antropología e Historia.

dissemination of the scientific base necessary for all material progress.[44]

The renewed valorization of ancient patrimony extended to the aesthetic realm as well. In March 1903, the Gallery of Monoliths was proposed as a drawing room for the students of ornamentation and architecture at the Academia de San Carlos, who were invited to use the monuments for inspiration to develop "little by little a characteristic taste, which later on could serve to form the national style."[45] The designation of an official space for these monoliths effected their shift in status from mere accumulations to actual products of value and also indicated a conceptual shift in cultural administrative policy from the attitude of accumulation to that of collection. This shift had some obvious physical manifestations, both in the conversion of the heap of accumulated archeological objects into the organized display by a purposeful and seasoned expert and in their transposition into the aesthetic realm as inspirations for a national style. Implied here is the

sense of ascension in class status (in terms of cultural capital) of the Mexican nation through the valorization of its own patrimony and also the conceptual link between national collections of material objects and the ever-broader (and more abstract) categories of officially sanctioned meaning: the sciences, aesthetics, politics.

The correlation between placement (of the museum's patrimonial objects into a designated physical or abstract space) and public (through museum publications or the conversion of such acts of placement into events) resurfaces repeatedly in the late-nineteenth-century *Anales,* and markedly so within the fields of history and archaeology. As mentioned in the introduction and again in chapter 5 in the context of national statistics, the intentional *placement* of displayed objects is of utmost importance for the collection and the mode of perception that it facilitates. Not only does the gesture of placement mark the collecting attitude by grafting the object into the serial context; it also guides the viewer into a mode of seeing that naturalizes the scenography of display and the object performance that it frames. And it is through the meticulous operation of placement that the "seeing as" mode—that ultimately fetishistic form of perception that enables a thing to be seen as embodying an essence—pervades the setting of the exhibit, which is the only form of social presentation available to the collected object.

While, as seen earlier, the placement of collected objects can be understood as a literal problem for the Museo Nacional, the issue extends to the cultural expropriation of Mexican patrimonial objects as well. In December 1896, for example, the newspaper *El Monitor Republicano* published a copy of the bill of protection for archaeological monuments (made law in 1825 and reiterated several times during the nineteenth century), which prevented their removal or restoration by foreign parties, except by national executive approval. An updated map of archaeological sites was mandated, along with a designation of permanent guards who were called on to submit regular reports to the secretary of justice and public instruction. All archaeological artifacts were to be sent to the Museo Nacional, inventoried, and cataloged in an annual report prepared by the museum director for the secretary of state.[46]

The question of placement also surfaces figuratively within the *Anales* in the realm of scholarship. There are a number of submissions, republications, and references to works by those foreign archaeologists,

travelers, and connoisseurs (as well as colonial Spanish monks and Creole scholars) mentioned earlier whose writings had dominated the field well into the first decades of the nineteenth century and whose excavations on Mexican soil were still largely guiding the practice of applied scientific positivism in archaeology. Mexican archaeologists and museum affiliates, such as Leopoldo Batres, Antonio Peñafiel, and Alfredo Chavero, managed to lead excavations despite huge disadvantages in funding, labor, training, and methodology in comparison with their European counterparts.[47] Yet, despite these obstacles, there is a marked intent to reclaim archaeological objects, excavations, and study for Mexican patrimony. This occurs both at the discursive level, as reflected in the *Anales,* and in policy, as demonstrated with the creation of the Directorate of Conservation and Inspection of Archeological Monuments of the Republic in 1885.

In addition to the practical challenges of organizing and funding federally sponsored excavations, the creation of a national vocabulary for Mexican patrimony required the assimilation of thousands of pages of foreign scholarship into the work of Mexican nationals.[48] The contributing authors of the *Anales* thus worked to assimilate, correct, edit, acknowledge, and add to the foreign inheritance that had sketched out the parameters of Mexican archaeology from outside the interests of national patrimony. Overall, the groundwork provided by renowned European contributions to the sciences in general, and to Mexican archaeology in particular, is both overtly appreciated and then lamented and repeatedly corrected by Mexican experts in the field.

In his preface to Jesús Sánchez and Gumesindo Mendoza's *Catalogue of the Historical and Archaeological Collections* (1882), for example, which reveals the blueprints of a nascent network of national scholarship in which to ground the object display, Alfredo Chavero explains that he refused to take foreign scholarship into account because it contained "more fiction than truth" or, at best, only transcriptions of information communicated to Europeans by Mexican scholars.[49]

Examples of such corrections appeared in print and were also incorporated into speeches pronounced in front of prestigious international audiences. In his "Discourse Pronounced September 24 of 1904" to the Congress of Arts and Sciences of the Universal Exposition of Saint Louis, Missouri, Alfredo Chavero provided a uniquely succinct example of the

rhetorical repatriation of Mexican archaeology and anthropology as performed for an international audience in an explicitly commercial setting. While careful to give thanks to the number of Europeans whose work had "enriched our History,"[50] the Mexican scholar initiated his speech with a description of the Mesoamerican practice of recording history as taught in the priestly schools called the *calmecac,* which constituted no less than a pre-Colombian institution for recording history. Archaeology, in other words, was originally an indigenous Mexican practice.

In the same speech, Chavero refuted English philosopher Herbert Spencer's claim that the ancient Mexicans had only communal lands and knew no examples of private property: "In this way, Archaeology has been able to correct an error of the great Spencer."[51] He also maintained not only that Mexican astronomy had perhaps influenced the Gregorian astronomical correction of 1582 but also that the Mexican archaeological calendar (meaning the Sun Stone or the Aztec calendar) far outshined modern chronology in accuracy because it required twenty-three thousand days to pass before an error in calculation would surface.[52] Chavero's pubic gesture of first claiming archaeology as a Mesoamerican practice and then correcting a series of foreign errors in scholarship suggests a specific rhetorical strategy for staging authority and ownership: the powerful claim of origin surpasses whatever past and present deficiencies allowed foreign scholars to lay claim to discoveries made on Mexican soil.[53] In play here are the intricacies of the shifting value systems implied in a nation's simultaneous consolidation of a national patrimony and expansion into the international, "universal" discourses of modernity: despite their vast resources with which to exploit the cultural capital that lay buried in Mexican soil, European scholars would find it harder to trump the genealogical claim to authority that is staked in Chavero's studies. Reference to the heightened accuracy of the outdated calendar allowed the scholar to reclaim a space of authority for Mexican scholarship and also to recast the Mexican artifact within the parameters of the modern.

This public reclamation of expertise was part of a larger effort not only to legitimize the Mexican claim to the most reliable scholarship and increase the nation's status among the international scientific community but also to groom home scholars for the vigorous study of their own antiquity. In 1912, professor and ex-director of the museum Jesús

Galindo y Villa advocated strong government support for the Museo by preventing the expropriation of cultural goods and creating guided student investigations from within,

> which by common consent, tend to give an essentially Mexican character to scientific speculation, and with respect to the pre-Colombian civilizations; and so that from us may surge a vigorous and conscientious study of all that belongs to us, of all that is ours, of what is found in our very house, so that we do not have the forced necessity of quenching our thirst in foreign springs.[54]

Judging from the date of the preceding quotation, it may be noted that the concept of *"our* science" is one that proves constant throughout the liberal and scientific regimes and also well into the turbulence of the revolution. In his "Advertencia" to Galindo y Villa's text, Genaro García, who by request of interim revolutionary president Victoriano Huerta had recently resumed the same position of museum director to which he had been originally appointed by Díaz himself, reflects on the continuity between the museum's programs between "then" (1907) and "now" (1913):

> My program of projects will be the same today as that which I formulated in 1907, when Mr. General Porfirio Díaz, then president of the Republic, first entrusted me . . . with this directorship. This program will come down, fundamentally, to endeavor in the best way possible to develop our Archaeology, which is, undoubtedly, the most interesting in America; of our History, destined to spread love to our fatherland; and of our Ethnology, without which the resolution of our most serious national problems would be risky or even pointless.

In addition to constructing a national claim to patrimony while negotiating with a century-long tradition of foreign scholarship, Chavero's emphasis on origins in museum publications and public addresses— which is, as already mentioned, a meaning generator for all collected objects—achieves its persuasive force by marrying the vocabulary of science with the rituals of the sacred. On one hand, museum affiliates and *Anales* contributors Alfredo Chavero, Jesús Galindo y Villa,

Gumesindo Mendoza, and Jesús Sánchez manifest a distinct attempt to unveil the mysterious aura that surrounds pre-Columbian objects to clarify scholarly doubts and complete the unwritten pages of national history. At the same time, however, there are instances of secular ritual around patrimonial objects that supplement the accompanying positivistic rationale with an aura of mysticism that is reminiscent of religious experience (Figure 2.4).

In September 1910, for example, an allegorical procession organized around the transfer of Father Hidalgo's baptismal stone to the Distrito Federal was chosen as the event that would inaugurate the famous Centennial celebrations of that year (Figures 2.5 and 2.6). The procession culminated within the walls of the Museo Nacional, the site chosen to house a symbolic enactment of the secular refoundation of origins of the Mexican nation through the ceremonial placement of Hidalgo's relic:

> The month of the Fatherland began September 2 with the solemn transfer to the Museo Nacional of the baptismal font brought from Cuitzeo de Abasolo . . . in which "the worthy initiator of the emancipation of Mexico was baptized."[55]

The spectral resuscitation of Father Hidalgo is suggested in the form of his granddaughter, doña Guadalupe Hidalgo, whose ceremonial transportation to the Museo and through its doors constituted the culminating moment of the ceremony:

> The captive public of this quasi-religious procession were the scholars, public employees, and the teachers and principals of numerous schools. The granddaughter of the Liberator, doña Guadalupe Hidalgo, played a notable part in the civic homage. The first schools to arrive at the Museo, after crossing the Plaza of the Constitution, crowded with people, formed a kind of military blockade from the entrance of the establishment to the great entrance to the Salon of Archaeology. Hidalgo's granddaughter entered the Temple of the Muses in a car adorned with tri-color ribbons and roses; as she got out of the car, a prolonged and noisy explosion of applause greeted her.[56]

Calling attention in this particular description of the parade is the intentional selection of the Salon of Archaeology as the place that marks

La Expedición á Teotihuacán

Los delegados al Congreso de Americanistas fueron obsequiados con una expedición á las pirámides de Teotihuacán, viaje siempre ameno ó interesante por lo mucho que hay que admirar en la vieja ciudad de los toltecas.

Salió la expedición por el ferrocarril Mexicano, y en el primero de los vagones iba la orquesta típica de Lerdo y en los restantes, hasta el número de cuatro, los excursionistas. Llegados á San Juan Teotihuacán, se apearon los viajeros, tomando el tren de las pirámides que ha sido construido expresamente para las obras arqueológicas que allí se han emprendido.

Este tren se detuvo á 186 metros de la estación de partida, pues se había llegado al primer grupo de edificios, formado por algunos frescos murales, que representan asuntos religiosos y dos escalinatas que, según se dice, servían para subir á las capillas.

Pasado algún tiempo, el tren vuelve á caminar y se descubre la plataforma amplia, cuadrangular, donde se levantan doce montículos de tierra que cubren templos. En el centro de ella, conocida con el nom-

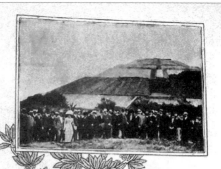

En la pirámide de la Luna

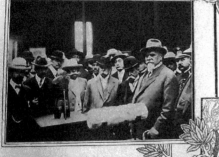

Los excursionistas en el museo de San Juan Teotihuacán

bre de «La Ciudadela», hay una gran plaza que rodea el montículo más alto y grande entre todos los del grupo.

Cuando los expedicionarios llegaron á la pirámide llamada del Sol, el entusiasmo se despertó en todos los ánimos, y no hay para qué decir las frases que se escucharon elogiando lo que era una cosa extraordinaria. Caminando hacia el Norte y atravesado el río de San Juan, se penetró en la Gran Avenida, llamada hoy Vía Sacra; después rieron el Palacio, descubierto por Mr. Desiré Charny, donde hay huellas claras de la alta civilización tolteca, frescos de gran mérito, cuyos colores se conservan aún en magnífico estado.

Terminado todo esto, se visitó el museo, que si bien es pequeño, no por eso deja de ser interesante, pues allí se conservan lápidas de ónix, columnas simbólicas, braseros, piedras, caracoles, gargantillas, navajas, urnas cinerarias, fragmentos de cabezas de tigre, almenas que coronaban la «Casa de los Sacerdotes», cornisas de los cuerpos de las pirámides y otras muchas reliquias no menos interesantes.

Terminado el paseo por en medio de tantas bellezas arqueológicas, tuvo efecto el banquete dentro de la gran gruta, que se adornó de una manera artística, y en la cual estaban colocadas varias mesas, luciéndose banderas tricolores. Dos músicas: la típica de Lerdo y la Banda de Policía

amenizaron la comida tocando las piezas más selectas de su repertorio, las cuales fueron muy celebradas por los comensales.

Hubo, al terminar el banquete, que fué suculento, varios brindis, hablando los señores ministro de Relaciones; el señor Soler, presidente efectivo del Congreso de Americanistas; el señor ministro de Instrucción Pública; el doctor Capitán, sabio arqueólogo francés, y el distinguido maestro español señor Sánchez Moguel.

Todos los discursos fueron muy celebrados por lo profundo de las ideas y por los altos conceptos en que fueron expresados. El regreso tuvo efecto á las cinco de la tarde, hora en que los excursionistas tomaron el tren, y entre ellos recordamos, además de los citados, el señor don Federico Gamboa, el marqués de Polavieja, el ministro chino y el japonés, y todos los delegados al Congreso de Americanistas.

Muchos fueron los elogios que se hicieron de la expedición, por lo perfectamente organizada que estuvo y por las disquisiciones científicas que se escucharon.

En la pirámide del Sol

FIGURE 2.4. Newspaper clip featuring the president's expedition to the ruins of Teotihuacán during the 1910 Centennial celebrations. In *Arte y Letras,* September 18, 1910, 19. Courtesy of the Hemeroteca Nacional de México.

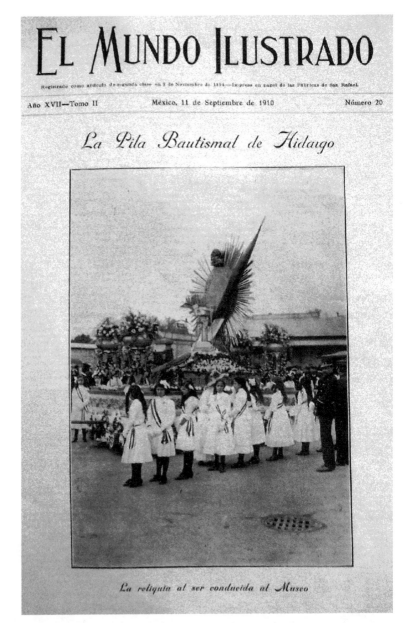

FIGURE 2.5. Cover of *El Mundo Ilustrado*, September 11, 1910, featuring the transfer of Miguel Hidalgo's baptismal stone. Courtesy of the Hemeroteca Nacional de México.

LA PILA BAUTISMAL DE HIDALGO

La niñez ha prestado un hermoso contingente á las fiestas con las que se celebra el centenario de nuestra independencia, y en todas las festividades en que han tomado parte los niños, han sido las más lucidas y las más interesantes.

La primera de ellas fué la conducción de la pila en que fué bautizado el padre de la Patria, de la estación del ferrocarril Central al Museo Nacional de Historia. La dirección de Instrucción primaria pensó, con muy buen acuerdo, que ningún acompañamiento era mejor para tan sagrada reliquia que una parada de niños, ataviados como en los días de fiesta llevando flores y banderas.

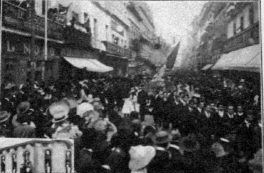

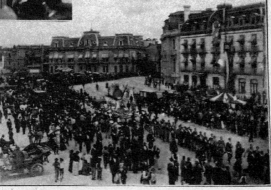

LA MANIFESTACION EN LA CALLE DE SAN FRANCISCO

nos, para que éstos, á su vez y en su tiempo, pasen esta herencia sagrada á sus hijos.

Con placer adornamos esta plana con interesantes fotografías del acto de la traslación, tomadas por nuestros fotógrafos; esperamos que ellas den una buena idea de la ceremonia, y poder coadyuvar en esta forma al fin levantado que persiguieron sus organizadores.

LA PILA AL SER SACADA DE LA ESTACION

Luego que los comisionados por el Museo desembarcaron la pila, los jóvenes de las escuelas primarias superiores empezaron á tirar de la carroza, en que era conducida la pila, para llevarla al lugar que se le había destinado.

Todas las escuelas de la capital, distribuidas en dos grupos, uno adelante de la pila y otros atrás de ella, formaron en la procesión, la que recorrió las principales calles de la ciudad, en medio del entusiasmo popular.

Decimos antes que creemos que la dirección de Instrucción Primaria obró muy cuerdamente al ordenar que las escuelas de niños acompañaran la pila, y nos confirmamos en nuestro dicho, pues es hermoso y grande el cariño hacia el padre de la Patria, y debe inculcarse á los futuros ciudada-

EN LA PLAZA DE LA REFORMA

FIGURE 2.6. Newspaper clip featuring the ceremonial transfer of Miguel Hidalgo's baptismal stone from *El Mundo Ilustrado*, September 11, 1910. Courtesy of the Hemeroteca Nacional de México.

the parade dénouement and initiation of the Centennial celebrations. Leaving aside the practical question of the room's position relative to the scene of the parade, or the accessibility of an exhibit room with more immediate associations with Hidalgo (the Salon of National History, for example), it is important to note that the museum had been closed for a full year in preparation for the Centennial events, during which time it had been reorganized and renamed as the Museo Nacional de Arqueología, Historia y Etnología. That Hidalgo's figurative signature was placed in the Salon of Archaeology in particular points to a correlation in the late nineteenth century between the universal diffusion of the sciences in Western culture, on one hand, and the increasing importance of making a specifically national claim to universal knowledge, on the other. Wrote Gumesindo Mendoza in 1877,

> The general government that has founded this useful establishment has understood that upon doing so, its objective was to popularize scientific knowledge and spread it among all of the classes of our society; therefore, the current Government supports and foments the projects undertaken in this sense. . . . I believe as well that men who are lovers of progress and of the Glory of our country . . . will cooperate . . . by sending objects . . . , referring us to news about the existing ancient ruins, picking up original hieroglyphs, all that which can contribute to beautify and enrich this useful publication, so that it may be appreciated as much by nationals as well as foreigners.[57]

In the conscious pursuit and dissemination of a general economy of knowledge, science and *patria* mutually implicate one another. The objects of antiquity provide not only a unifying standard of cultural capital—and one that transcends social class, as suggested earlier—but also a claim to superiority, kinship, and status with respect to foreign audiences. Tradition unifies or contracts, but then *marketing* that tradition to foreign audiences through such means as publication, world's fair participation, and the hosting of international events at the Museo augments the nation's competitive international status by figuratively "placing" items of worldwide cultural interest within the boundaries of national territory and scholarship. By nationalizing the field of archaeology, Mexican scholars intended not to turn away foreign specialists or other cultural consumers but rather to secure their own position as

producers of their own intellectual traditions and the rightful guardians of Mexican cultural capital.

The Shifting Grounds for Authority

Despite the obvious, strategic maneuvers described earlier that come into play in the elaboration of collections, determining who has authority over them is not as clear-cut as it would seem. It was a rhetorical commonplace in nineteenth-century editorial commentary, for example, to efface oneself as an authority and pretend to allow events to "speak for themselves." In fact, abounding in the periodical commentary of this period are writers' paradoxical apologies for the points of view that they elaborate. As the author denies his own power in conformity with the stylistic trend of the era, the displayed object or artifact likewise becomes its *own* authority in the exhibit context. The agent that collects, assembles, or narrates to a large extent cedes visibility to the display. Likewise, the signature bordering the painting, the monument, the statistical chart, or the reproduced Mayan artifact—which implies both the boundary of the beginning and the finishing touch of an artistic representation—is a deictic device that both indicates and understates the maker.

In *Memory, Myth, and Time in Mexico,* Enrique Florescano refers to a shift in the basis of truth that becomes notable in the enlightened late-eighteenth-century atmosphere of New Spain, where the inventory and the catalog come to replace traditional monarchal authority and religious dogma as the foundations of "arguments, explanations, or judgment."[58] It is in this shift of consensus regarding the basis of truth (and the secularized analytical methods of debating and recording it) that the discourses of science and national history increasingly intersected during the nineteenth-century constructions of modernity. Nowhere does this intersection become more apparent than in the first three epochs of the *Anales del Museo Nacional,* in which the universal language of science and the fragmented grammar of national history reveal themselves to be persistently implicated in one another.

The persuasive force of science as a bolster for nationalistic discourse—a connection also emphasized by Mexican anthropology historian Mechthild Rutsch—is particularly powerful in that it provides rational and secular grounds for a (conversely) transcendent nationalistic

ideology which, grounded in this new source of authority, now becomes essentially "provable."[59] In one 1877 essay published in the *Anales,* for example, Mariano Bárcena, then a professor-affiliate of the Museo, elaborates on the importance of establishing a specifically Mexican paleontology in the search for an origin (*"esa base que buscamos,"* "that base for which we are searching") that would both shed more light on the universal ages of the past and help decipher local regional features in a deepened understanding of *lo nuestro* or "that which is ours."[60] Through the pursuit of "truth" and knowledge of the physical environment, science became an effective marketing tool for the circulation and consumption of national images. Interesting examples of this phenomenon appear in the abundant work in cartography by Mexican geographer, writer, and historian Antonio García Cubas (1832–1912) or, as will be seen in chapter 5, in institutions such as the Instituto Nacional de Geografía y Estadística.

And yet the irreducible foreign legacy and difficulties in securing the resources necessary for funding and supplying nationally sponsored archaeological excavations at home affected the rhetoric of authority available to Mexican experts in a particularly intriguing way. While Mexican scientists were creating a discourse of national origins that was based in the irrefutable terrain of science, repeated references to the "attempt," to improvisation and guessing, surface both in the *Anales* and in the Museo catalog itself. "As a general rule," wrote Galindo y Villa, quoting an anonymous and "vanished" source from within the field of Mexican archaeology, "the archaeologists begin *interpreting, keep guessing, and end up hallucinating."*[61] Likewise, catalog descriptions of archaeological exhibits as published in the Instituto Antropología reveal a consistent lack of consensus with regard to a given object's origins: sources with differing opinions regarding a particular object's undetermined use or origin are paired together, and descriptions are qualified with such phrases as "this is the interpretation of," "we suspect that," "it is our opinion that," "we suppose," and "we still ignore."

In his 1895 publication called *Guide for Visiting the Salons of Mexican History of the Museo Nacional,* museum director Jesús Galindo y Villa introduces his readers to a series of exhibits that are as of yet still imperfectly organized and problematically housed:

For a period of time the salons of Mexican History of this Museo Nacional did not open their doors to the public due to special circumstances; now, enriched with new and valuable acquisitions, they have been given an organization which, if not definitive, is at least in accordance with a methodical and reasoned plan, and secure in the part of the building that is available.[62]

As will be seen in chapter 5, a similar vocabulary of imprecision also occupies a prominent place in the nascent realm of national statistics. Far from detracting from the veracity or reliability of their speakers, however, these overt improvisations and educated guesses collectively build on one another to formulate solid grounds for authority that suspend the promise of "completion" into an indefinite future: "In this way archaeological studies, especially when they can do truly scientific explorations of our ruins and our monuments, will complete and correct our Ancient History, so interesting and so full of teaching." The paradoxically provisional nature of the "permanent" museum exhibit has the inadvertent effect of promising a future for the nation, whose connotations, like the collection and like history itself, are elaborated within the framework of a projected point of completion: "In the end, Archaeology will write all the chapters of that great book, that Bible of history of mankind on the face of the earth."[63]

The rhetorical connection between imprecision and completion in Chavero's words also suggests a metaphysical dimension to the collection that merits further attention. In his quotation given earlier, Chavero imbues archaeological discourse with biblical connotations and, in so doing, confers on its objects the paradoxical status of sacred commodities—sacred because the archeological relic, emptied of all but an approximate guess as to its own particular identity and meaning, becomes associated with a transcendental logic that culminates in a discipline of an official sanction (archaeology) and also in the reification of nation and universal history; commodity because these objects are "circulated" (via publication, exhibition, and public address) as mediums of "education" and "instruction" and are effectively translated into a type of cultural capital used both to negotiate a respectable position within the nations of economic hegemony and to forge a sense of commonality among an irreconcilably heterogeneous body of national citizenry.

Class, Education, and the Production of Citizens

Along with an increased concern for an updated national archaeological inventory during the late nineteenth century, there is a marked effort to create a receptive public base by disseminating information related to archaeological findings. Newspapers such as *El Diario del Hogar, El Universal, El Arte y la Ciencia,* and *El Imparcial* contain regular announcements of archaeological discoveries, which consist of brief descriptions of the locations and dimensions of the finds. Consider, for example, the following announcement, titled "Archaeological Findings" and dated 1900:

> Yesterday morning from the back of the excavations done near the corner of Santa Teresa and the *Reloj,* the second of the important monoliths to which we referred in our past issue was extracted.
>
> It measures two meters 40 centimeters long and ten wide. It is rectangular and [there are] a series of transcriptions bordering the figure. It is believed that this piece belonged to the God of the Air. The stone stairway has not been able to be extracted yet. Two new steps appeared, so well polished, like the first that were seen in the first excavations.[64]

Together with the more subjective and unifying rhetoric that characterizes Chavero's words at the Louisiana Purchase Exhibition quoted earlier, the more objective tone found in announcements such as this one served both to broaden and to consolidate the national public base that bore witness to the nationalization of archaeology and anthropology. Yet despite the effort to forge a common Mexican heritage using exhibited patrimony, the inclusive category of "citizen" (or, for that matter, the frequent use of the first-person plural possessive *nuestro* in association with Mexican patrimony) did not transcend the distinctions inherent to social class. Restrictions of access to the Museo Nacional's exhibits and archives during the late nineteenth century reinforced the material subdivisions of social status. At the apex of the hierarchy stood the professoriate, the scientist, and the academic scholar, and following in descending order were the student, the *público culto* (educated public), and finally, the *público inculto* (uneducated public).

This system of classification was maintained on two levels. The first

was the division of scholarly time and public time; as a result, the Museo opened its doors to the public for only an abbreviated number of hours each week and otherwise dedicated itself exclusively to the pursuit of scholarly investigation. In 1895, for example, the various departments of the Museo were open for an average of two hours per day on two weekdays and three hours on Sunday but closed to the public for the remainder of the time.[65] The second restriction of access to the museum was socioeconomic in nature. In practice, such a restriction meant that the level and depth of explanation to which one had recourse in viewing a given exhibit were regulated both economically and in terms of the educational level of the viewer. For viewers who could both understand more complex explanations and afford to do so, catalogs were available for purchase in each salon: "The Catalogue for this Gallery put together by Galindo y Villa, is for sale at the door of the *Museo* for fifty cents a copy."[66] For those who had lower educational levels and who were not in a position to purchase the catalog, there were guided tours in which verbal explanations were provided, printed exhibit guides that were less detailed than the catalogs, and also the pure experience of visual exposure, which was thought to exercise its impact on the intellect.

This is not to suggest that the less fortunate were intentionally excluded as a target audience. Indeed, quite the opposite is the case, as demonstrated in this excerpt dated 1895:

> Not only the learned find reasons for study and other avenues of investigation in the Museo; all the people, no matter how unlettered they may be, find there the most complete objective instruction, which, by appealing to their senses, awakens their intelligence and exercises their reason, without the need for the fatiguing study of books which are not always available to those visiting the Museo.[67]

In a 1921 analysis of the Museo's pedagogical function, the same author of the catalog mentioned earlier, Jesús Galindo y Villa, places special emphasis on the distinction between *education* and *instruction,* the former pertaining to a more abstract refinement of attention and the senses and the latter relating to the "precepts" that should be followed to realize the aims of *enseñanza*. Education without instruction produces citizens; instruction without education, however, risks producing criminals, as

"criminology statistics have shown."[68] Hence the "moral," "psychological," and "pedagogical" motivations for prioritizing the educational pursuits of the Museo are made apparent.

The particular mechanisms by means of which the museum was to produce law-abiding citizens involved the combined forces of object display, authority, and the act of contemplation. According to the writings of the *Anales*, the theoretical production of a citizenry as exercised through the creation of a common archive of objects occurs in the moment in which those objects acquire a specifically social dimension (a membership) that elicits a type of mimetic response from its viewers (not unlike art critic Felipe Gutiérrez's description of the impact that a painting of a typical Mexican scene has on the viewer who "recognizes" it, as cited in chapter 1). This social dimension of the object does not occur without the discipline of classification or the means by which one object is brought into relation with another. Once gathered into an officially sanctioned abstract membership, however, such as a national archaeology, the objects acquire (metaphorically) a ghostly ability to "speak." Wrote Gumesindo Mendoza, director of the museum in 1877,

Our museum, certainly, now has a well-organized collection of objects pertaining to the various branches of the natural sciences and archaeology; but hieroglyphics, the primary gods . . . , have been there for many years, *mute as the stone or clay from which they are made, because they have not been able to reveal the thoughts which each one holds inside.*[69]

The ghostly speech of the collected object,[70] while translated by the *sano criterio* (sound criteria) of scientific discipline,[71] points beyond itself in a suspended conclusion that can only be effected emotively within the viewer. The visiting public learns how to respond emotively to patrimony by means of repeated exposure and the internal accumulation of viewing experiences that it implies:

We all feel the emotion of patriotism or admiration when standing before the portrait of a hero, or the representation of a glorious feat of arms, or before a memorial monument . . . , and if we multiply the objects and the samples and spend time contemplating them and analyzing them, almost without realizing it we will be educating our

will and our character and will become better citizens and possess the notion of Fatherland, which in some individuals is quite vague, but is still there, latent and capable of coming to the fore at any moment.[72]

According to Galindo y Villa's formulation, there is a metaphorical equivalency to be drawn between the "thoughts" that the collected object encloses and the "notion of fatherland" that lies latently in the viewer. In the same way that the dedicated study of archaeology, anthropology, or ethnography can awaken the "speech" of the object, the repeated viewing of the object within this particular institutional frame reminds the individual that she *already* possesses the notion of a fatherland. In a parallel vein, the aforementioned scholar Rutsch quotes General Vicente Riva Palacio making a claim regarding the transcendent effects produced by the contemplation of historical relics when he writes that "even a simple forelock of hair from a horse" of some national hero would serve to "awaken patriotic sentiments" in people of all social classes.[73] The collective memory is a projected effect not of experience but of a repeated visual homage paid to displayed objects and the naturalized habit of regarding them as meaningful in ways that reach far beyond their original contexts. The fragments, the disjunctions, and the provisional nature of the authority that bridges the gap between the object and the viewing public are all dramatically inverted in the suspended promise of the museum display and its honestly inaccurate or incomplete explanations. By means of repeated exposure to the archaeological exhibit and its binding of secrecy to the promise of transparency, citizens would come to recognize themselves as such.

Archaeology, Memory, and Suppression

In a way that parallels the archaeological object's limited or partial revelation of meanings, the cultural administrations of the museum institution itself can also be studied as much in conjunction with what they hide as with what they disclose. In his investigation of nineteenth-century museum catalogs, Morales Moreno discovers some distinctions that were made between publicly "legitimate" exhibits and private exhibits excluded from public viewing "because they are classified as 'secret' or prohibited."[74] The dialectical tension between display and concealment

that affects the process of creating a modern national patrimony, however, predates the era focused on in this study by approximately one hundred years.

There is the example of the famous *Coatlicue,* the stone monument accidentally discovered in 1790 during the phases of repair being done to the main square in Mexico City. A fusion of precise geometrical forms, of symbolic references to the natural world, of numeric, animal, human, and godly manifestations of the Aztec cosmovision and a symbiotic balance of the static and dynamic forces that describe the *nahua* perception of space and time, the *Coatlicue* statue is one of the most important relics of Mexico's pre-Columbian past. While Justino Fernández's detailed analysis and description of her physical composition places her firmly within the ranks of the superior artworks of Occidental culture of all time, it is the history of the goddess's display—in its peculiar illumination of concealment and secrecy as the undersides of exhibition culture—that concerns this study.

In fact, Antonio León y Gama's famous *Descripción histórica y cronológica de dos piedras* (1792, 1794), which features the *Coatlicue* and the *Piedra del Sol,* begins with an imagined inventory of buried pre-Columbian artifacts that lie hidden from view and await discovery beneath the *zócalo:*

> How many books and paintings did those priests hide . . . , on which, using their own symbols, they had recorded their origin, the advances made by their nation since they left Aztlan to populate the lands of Anahuac; the rites and ceremonies of their religion; the fundamental beginnings of their chronology and astronomy, etc? And how many treasures will never be discovered?[75]

In addition to the deliberate physical concealment of these objects by the colonized indigenous people, continues León y Gama, the deliberate and strategic silencing of their meanings by Spaniards and so-called *indios* alike constituted another, perhaps more insidious way of shielding these objects from the reaches of public and scholarly understanding.[76] In a parallel manner, León y Gama's own voluntary suppression of his work, the result of a published squabble with New Spain scholar José Alzate y Ramírez (1737–99), further obscured the discovered monuments as objects of study and charged the problem of their decoding

with an extra sense of urgency.[77] Finally convinced to break his silence and publish more findings in 1794, the Creole scholar twice links the divulgence of knowledge of this particular subject with the greater good of patriotism:

> Some of these stones already having been destroyed, about which in a few years there will be no one left alive who can make sense of the figures and their meanings, and which by *hiding them* (because those I have are already fragmented) would be a serious affront to my country, and to the people affected by her ancient history; I feel obligated to *break the silence* which I had promised to keep, and *expose* what my limited intelligence has been able to uncover.[78]

The tension between secrecy and transparency that manifests in León y Gama's commentary propels his own journey from a mere curious observer of Mexican antiquities to a well-seasoned expert and also fuels the urgency behind his quest to gain a clearer understanding of pre-Columbian artifacts. In fact, the lack of reliable scholarly sources or translators capable of understanding his collection of sixteenth-century documents drove him to learn *nahua* himself. León y Gama's desire to be "useful" to the *patria* through his investigations also points to the late-eighteenth-century era of Creole scholarship as foundational in terms of the connections established between antique monuments and nationalism.[79] Here the author links the illumination of Mexican antiquities to the overall good of both homeland (the *patria* of New Spain) and kingdom and refers to the "hiding" or obstruction of these objects (via their long history of destruction, the failure to disinter and protect them, and the preponderance of misinformation that has been published about them) as a devastating historical error requiring correction.[80]

That *Coatlicue* was not demolished upon its discovery, a diversion from the usual colonial policy of destroying or incorporating archaeological findings into new constructions, indicates both a positive attitude toward collecting and points to the Creole desire to gain autonomy by differentiating Creole heritage from European antiquity.[81] In a letter addressed to New Spain viceroy Revillagigedo and dated September 5, 1790, chief magistrate Bernardo Bonavía y Zapata recommended that the monument be saved and sent to the Real y Pontificia

Universidad, where scholars could make use of the university's resources to study it and reconstruct its origins.[82] There, indicating a first attempt to categorize it, the monument would rest alongside the Roman and Greek sculpture replicas that had been donated by Charles III of Spain (1759–88).[83] Yet despite the decisiveness and enthusiasm evident in Bonavía y Zapata and Revillagigedo's written exchange, the ambivalence toward "otherness" that is inherent to colonial and postcolonial administration would manifest in several decades of hide-and-seek politics, during which the Coatlicue was alternatively displayed and hidden from view.

Perhaps owing to fear of the Coatlicue's effect on indigenous people, who, according to Bullock, snuck into the university and placed "chaplets of flowers" at her feet, and perhaps considered unworthy of exhibition at the Real y Pontificia Universidad, the cultural administrators at the university ordered that the stone be reburied beneath the institution's courtyard not long after its arrival.[84] On two occasions during this time, the stone was temporarily exhumed at the respective requests of Alexander Humboldt and William Bullock. After special privileges for these official requests were granted, the Coatlicue was reburied.[85]

The difference between Humboldt and Bullock and the general public of New Spain at the time was the formers' firm alignment with an official sanction. That they were permitted to view the stone indicates that the problem was not so much whether the stone should be seen as how it should be regarded. Clashing strongly with the Hellenic ideals of aesthetic beauty and too powerful to be reconciled with the colonial present, the Coatlicue could not be rescripted into public viewing until the postindependence Mexican government arranged for its permanent display in the national museum in the late 1820s. At that point, the goddess's link with contemporary indigenous populations was perhaps no longer perceived as a threat,[86] and the allure of an alternative yet competitive story of origins could be used to help justify the presence of the autonomous nation. Decades later, during the Porfirian promotion of modernity, the increased professionalization of the museum institution and disciplinization of the sciences gave pre-Columbian monuments unprecedented national exposure.

In theoretical terms, the Coatlicue story illustrates the depth of the collection's problem with origins as an extension of its relationship to

concealment. First, we have the concept of collected objects as material entities that have been emptied of their original uses and historical contexts and then supplemented with new meanings. Yet the loss of the collected objects' original historical contexts is, to a certain extent, shielded from perception by their contiguous arrangement, which, as Stewart observes, replaces the lost chronological origin with a synchronous and spatial one.[87] The peculiar thing is that once this severing of the object from its origins is complete, the collector then indulges in a nostalgic, ironic, and impossible gesture of recuperation. In this way, the collected object suffers the paradoxical substitution of its own irretrievable historical moment for a serial logic that banishes time from its equation. It is in this act of substitution that the object is subsumed under the economy of the collected piece and then quite paradoxically reintroduced into history in the most a-historical manner. Because it no longer is what it was, the object turned collected piece embodies a process of historical remembrance that substitutes space for time.[88] The objective point of view is an effect of arrangement, by means of which historically specific and unrelated things become equivalent pieces. And as such, as members of a collective whole, displayed objects come to signify something much bigger than the sum of their parts: history, anthropology, nation.

In addition to the *Coatlicue*'s history of suppression, there is a more revealing example of the inextricable ties between visibility and concealment when it comes to the display of Mexican archeological patrimony. In 1926, Ramón Mena discovered the existence of a *"salón secreto"* in the Museo Nacional:

> From the rich and varied collection of the Department of Archaeology at the Museo Nacional, I have been withdrawing those absolutely phallic examples, and finding myself presently with a good number of objects from almost all the rational groups of the country, I consulted C. Director don Luis Castillo Ledón regarding what I should do with the items, which, some for their nature and some for their number, formed such an interesting collection *for scholars*. And he saw fit to authorize, and even create, a secret Bureau within that very department.[89]

Following this brief introduction is the author's account of a "catalogue in formation" for the former phallic cults of the national territory (Figure 2.7). It becomes apparent from the qualification in the introductory paragraph (that this collection is specifically for the "studious") and from the justification at the end of his brief historical account of the phallic cults (which are important to understand, he claims, the indigenous cosmogony and for the purposes of "comparative science") that such a justification is perceived as needed, even though the article is written well after the establishment of the importance of a "national archaeology" and the creation of a separate department for that specific discipline in the museum.

One significant distinction between the objects described earlier and the similarly "gigantic" objects of the Gallery of Monoliths, which contained such items as the *Coatlicue* and the *Piedra del Sol,* is the difference between part and whole. Measuring from less than one meter to several meters long ("like posts"), the phalluses represented either through objects or photographs in the *Salón secreto* were not only large but also markedly separated from the context of a body referent. Here the "overarticulated" object, to borrow from Susan Stewart's study of the gigantic in *On Longing,* oversteps the boundaries both of its own relevance and also those of taste.

Professor Nicolás León, professor of ethnology of the Museo Nacional who, in a 1903 edition of the *Anales,* published a brief report on the cult of the phallus in pre-Colombian Mexico, tactfully leaves judgment aside and focuses instead on the problem of "clarifying doubts" and "shedding light" on "doubtful facts of controversial meaning" surrounding the "interesting ethnic objects" of pre-Columbian Mexico (Figures 2.8 and 2.9).[90] Inspired by the meter-long *Phallus of Yahualica,* which received public attention in 1890 and was eventually sent by the governor of the state of Hidalgo to the Museo Nacional, León's brief article frames the monolith in such a way that detracts from the sensationalistic reactions that similar objects have inspired and places it firmly on the lower end of a hierarchy of archaeological monuments that merit further investigation to be properly understood.

The gigantic phallus statues were not the only suppressed element of the museum's indigenous display. As Benjamin Keen indicates in *The Aztec Image in Western Thought,* the unspoken component of all

Catálogos del Museo Nacional de Arqueología, Historia y Etnografía

DEPARTAMENTO DE ARQUEOLOGÍA

CATÁLOGO DEL SALÓN SECRETO

(CULTO AL FALO)

POR

RAMÓN MENA

Conservador del Departamento

(2ª edición, corregida y aumentada)

MÉXICO

IMP. DEL MUSEO N. DE ARQUEOLOGÍA, HISTORIA Y ETNOGRAFÍA

1926

FIGURE 2.7. Cover of the second corrected and expanded edition of *Catálogo del Salón secreto (culto al falo)*, 1962, by Ramón Mena, curator of the Department of Archeology. Courtesy of the Instituto Nacional de Antropología e Historia.

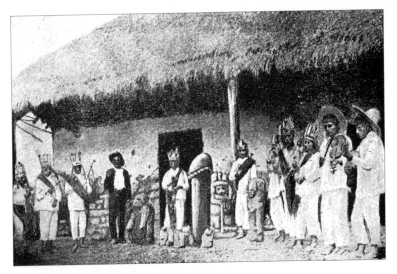

FIGURE 2.8. "Cult to the Phallus. 1890." In Ramón Mena's *Catálogo del Salón secreto (culto al falo)*. Courtesy of the Instituto Nacional de Antropología e Historia.

historical anthropological reflection on Aztec culture, whether favorable or critical, was the status of the contemporary "indian."[91] In fact, references to the contemporary indigenous populations of Mexico do surface within archaeological, anthropological, and ethnographical discourses as both the vestiges of the grandiose empires of antiquity and evidence of an unresolved contemporary socioeconomic national problem. It is in fact because of the need to "resolve" the socioeconomic and cultural difficulties posed by the unproductive and marginalized indigenous populations that archaeology flexed its political edge at this time: witness, for example, the passion-inspired religious rhetoric of museologist Jesús Galindo y Villa, who, in 1914, justified archaeological study by referring to the urgent need for sociological reform within the indigenous communities of Mexico.[92] In addition to this attitude that was common among the Mexican politicocultural elite, however, there was also a nascent respect born amid the museological discourses of the day that predates the postcolonial reflections on marginalized and underrepresented population sectors of the late twentieth and twenty-first centuries.

Though it is true, as indicates Tenorio-Trillo in *Mexico at the World's*

FIGURE 2.9. "The Masturbator." In Ramón Mena's *Catálogo del Salón secreto (culto al falo)*. Courtesy of the Instituto Nacional de Antropología e Historia.

Fairs, that the efforts put toward resurrecting the pre-Colombian past did not translate into any tangible preoccupation for social reforms for indigenous peoples, it is also the case that Mexican archaeologists were acquiring a more sophisticated vocabulary and approach to those populations—one that cut through the simplistic oscillation between their contemporary degeneration, on one hand, and historical superiority, on the other. In renowned anthropologist Manuel Gamio's "The Prejudices in Archaeology and Ethnology" (1913), for example, the inspector of archaeological monuments draws a direct analogy between the prejudices that inhibit both sociological and archaeological approaches to indigenous studies:

> Contemporary civilization has not been able to infiltrate in our indigenous population for two great reasons: first, the natural resistance that this population opposes to cultural change; second, because we know not the reasons for such resistance, we don't know how the Indian thinks, we ignore their true aspirations, we prejudge [them] with our criteria when we should instead submerge ourselves in [theirs] in order to understand [them] and make [sure] that [they] understand us.[93]

In a curious rhetorical parallel, the figurative silence of the (then) contemporary indigenous figure recalls that of the archeological object as described earlier. Where the speech of the archeological object, unleashed through the dedicated work of national scholars and the meticulous arrangement of curators, served ideally to trigger an emotive response in its viewers, the resistance of the living indigenous community posits them firmly outside the ordering, narrating, and collecting efforts of contemporary civilization.

In sum, by comparing the collection and display strategies that were respectively pursued in the arts academy and the national museum as investigated thus far, it is clear that the conjugation of a decidedly national expression with the forces of international diffusion occurs in each. Yet the positions of the two institutions with respect to international influences and the patrimonial base with which each had to work called for different methods. Whereas a significant portion of nineteenth-century canonical paintings that developed along the margins

of academia portray imagery that liberal art critics considered to be national *because* it was marketable, the scholars of the Museo Nacional worked to convince both domestic and foreign scholars and viewing publics that their archeological patrimony was first and foremost a national entity *despite* the strong history of international interest. Despite this difference in dynamic, however, each case confirms the dialectical base of collected objects-cum-patrimony.

Far from a static archive of objects, the museum formed part of a dynamic negotiation that involved the nationalization of universal scientific disciplines; the remapping of authority within a rhetoric of inaccuracy; the ideological pull of transcendent nationalism; the prestige of international exposure; and the powerful narrative potential that drove the categorization, placement, and contemplation of patrimonial objects. Within the scope of the unsettled self-anthropology that describes the museological discourses of the era, Mexican scientific experts complicated the vocabularies that had been inherited from their European and colonial precursors. As a result of their efforts, the nineteenth-century archaeological museum display was geared to appeal to the ideal citizen who, inspired by the transcendent and silent "speech" of patrimony and awed by the revelation of its secrets, would awaken to his or her own latent sense of nationalism.

3

The Hidden Lives of Historical Monuments: Commerce, Fashion, and Memorial

☼ ☼ ☼

If the "unintentional monument," as Alöis Riegl termed the archaeological object in 1903,[1] attracts the spectator's attention based on the historical secrets that it contains, then what of the unabashed exposure represented by the intentional monument? A proliferation in public monument construction in Mexico (and Europe) in the late nineteenth and early twentieth centuries supplements the archaeological object in the pursuit of symbolic capital. The repertoire of heroes that formed in the nation's major cities through monument production encompasses both pre- and postnational Mexican histories, aligning them into a coherent trajectory that implies a thematically unified story. In direct contrast to the semisecretive aura of the archaeological object, however, the monuments that were constructed for the late-nineteenth-century capital city of Mexico were designed to embody liberal interpretations of nationalism as transparently, accessibly, and universally as possible.

In 1867—the year of the liberal triumph—the Secretaría de Fomento was reinstated after its original creation in 1853 to pursue the construction of "public works of utility and adornment" with public funds. The most obvious example of the projects that were undertaken by the secretaría in the Distrito Federal during the era of Porfirio Díaz can be found in the monuments constructed to adorn the Paseo de la Reforma, the principal promenade of the late nineteenth century, where an implicit evolutionary chain of thirty-six monuments, constructed between the years 1889 and 1902, leads from the glorious indigenous past to discovery, independence, and the subsequent liberal reform. On this avenue stand monuments to the last king and martyr of the Aztec empire,

Cuauhtémoc (1887; created by Academia sculptors Gabriel Guerra and Miguel Noreña and engineer Francisco M. Jiménez), to Christopher Columbus (1877; cast by French sculptor Henri Joseph Cardier), and to independence (1910; designed and overseen by architect and engineer Antonio Rivas Mercado). Academia sculptor Jesús F. Contreras (1866–1902) was responsible for twenty of the bronze sculptures that today adorn the Paseo, including those dedicated to Justo Sierra (writer, poet, lawyer, political figure), Luis G. Urbina (poet), José Juan Tablada (poet), and Rubén M. Campos (poet, novelist, composer). Contributing sculptors also include Primitivo Miranda, Epitacio Calvo, Juan Islas, Enrique Alciati, Ernesto Scheleske, and Alejandro Casarín. Following journalist Francisco Sosa's proposal that each state should raise funds and contribute a statue for the adornment of the empty pedestals of the Paseo,[2] the federal government allotted two pedestals per contributing state—all of which, wrote Sosa, for love of the fatherland, could find room in their respectively small budgets to fund two "naturally-sized statues."[3] In addition to the Distrito Federal, contributing states included Veracruz, Yucatán, Hidalgo, Sonora, Nuevo León, and Oaxaca (Botello).

Disagreement and Debate

While the official publications that accompanied the proliferation of monument construction in the capital city of Mexico during the late nineteenth and early twentieth centuries centered largely on questions of beautifying the capital, celebrating the liberal reform, and competing in terms of cultural capital with major European cities, a closer analysis of the notes, written correspondences, and periodicals surrounding these projects reveals a proliferation of often contradictory voices and intentions. In general terms, the publicly debated disagreements on monuments were at times rooted in simple questions of content and taste, such as the case of the nude Venus of the Alameda Park and the moral questions that were raised in periodicals about its appropriateness for children[4] or the aesthetically compromised "Aztec mummies" of the Paseo de la Reforma, as the two monument-sized statues of Aztec warriors cast by Alejandro Casarín were described (now called the *Indios Verdes* and re-placed on the Avenida de los Insurgentes).[5]

Concerns were expressed regarding the selection of a particular material over another, as in Vicente Reyes's lament over the use of concrete

rather than marble for the atrium of the monument to Cuauhtémoc.[6] Another cause for worry was the appropriateness of a certain size of pedestal relative to the monument it supports and its surroundings.[7] At times, larger political tensions between the conservatives and liberals were aroused through debates about which candidates were eligible for the heroic status implied by the intentional monument, such as the fury surrounding the question of a monument to the self-declared former emperor of Mexico Agustín Itúrbide (1822–33) in 1901[8] or Manuel Tolsá's restless statue to Carlos IV (now known as *El Caballito*, "The Little Horse," originally constructed as a personal appeasement to the crown under Viceroy Branciforte at the close of the eighteenth century), which changed locations from its original position in the Zócalo five times before finding its current placement across from the Palacio de Minería.[9]

In short, the Porfirian project of monument building had the productive effect of erecting an official pantheon of heroes to the liberal regime. It also solidified secular and patriotic ritualistic practices, as placements of first monument stones and unveilings of high-profile monuments were often scheduled to coincide with national holidays. In addition, both the monuments themselves and the pomp and circumstance that surrounded them served to reaffirm fraternal ties between nations with a shared dissident past. From a contemporary perspective, and more important for the purposes of this study, however, the national monument provides a less publicized and more intricate lens through which to view the conjugation of nationalism with modernization, the timeless symbolic value systems of patrimony with the whims of temporality and fashion, and the patriotic haze of transcendent nationalism with the discrepancies of social class.

In fact, the politics of monument building in late-nineteenth-century Mexico, which would fall chronologically under what Pierre Nora calls the "classical" era of constructing official memory, reflect a certain anxiousness to fortify the temporality and ephemerality of politics with the atemporal and unifying force of the monument. In the case of Mexico, which, at the time of the death of the *reformista* president Benito Juárez in 1872 had only been politically consolidated for five years, the need to construct and reinforce a cohesive sense of citizenry can be traced through a type of ceremonial frenzy that marked the late nineteenth century, especially surrounding the construction and unveiling of public monuments to fallen national heroes—always attended

by government representatives and often by the president himself.

In the case of the death of Benito Juárez, an 1872 memorandum to the Secretariat of the Constitutional City Hall of Mexico reveals that the idea to construct a monument dedicated to the honor of the deceased leader of the reform movement was first mentioned only within "a few hours after his death."[10] Within two weeks, an official announcement was published, in which artists were invited to submit their proposals within twenty days to a panel of judges consisting of members of the public works commission and various Mexico City engineers. The commission then had eight days to select a project from those submitted. The monument, to be finished by December of the same year, was to be erected in the Plaza de Santo Domingo (renamed the Plaza Juárez) and was not to exceed the cost of thirty thousand pesos.[11]

Despite the precise time frame indicated by the announcement, public disagreements about the details of the project (such as problems with the elected site for the monument, which was vehemently censored by newspapers, and accusations of bias on the part of the judges) led to a series of modifications and adjustments to the original plans. A representative from the panel of judges requested in another memo to the *Secretaría* that the proposed site for the monument be changed from the Plaza de Santo Domingo to the central roundabout of Alameda Park, to be renamed "Juárez" on the September 16 anniversary of the famous shout of Miguel Hidalgo and initiation of the independence movement from Spain. The press, along with all interested citizens, was invited to air its opinions about the newly chosen site as well as to propose alternatives.[12] On August 30, another report from the panel of judges, insisting on the "diligence" and absolute "impartiality" with which the projects were examined, contains a petition for an eight-day extension to submit the final decision, during which time the projects would be exposed to the public in the main room of the city hall, as had been requested by the press.[13]

Notwithstanding these efforts, certain representatives of the press (no specific newspapers were mentioned) remained unconvinced as to the impartiality of the judges, whose invitations to a select number of engineers and artists to give their expert but unofficial opinions about the eight submitted projects were unanimously rejected for reasons unknown. Forced to arrive at a decision on its own, and yet reassured by the

collective effort to lead a fair and semidemocratic process, a representa-
tive of the panel reported with regret that none of the submissions had
successfully fulfilled the criteria for the projected monument. The project
was abandoned for a lack of "activity and insistence" soon thereafter,
until it was undertaken once again with the creation of the National
Commission to Commemorate the Birth of Benito Juárez in 1905.[14]

While the documents contained within the archives of the *Anales
de la Secretaría de Fomento* of 1885 reveal a sense of obligation to follow
European trends of "transmitting to posterity its memories, its glories,
and even its misfortunes through monumental art,"[15] this impulse to
keep up with patrimonial trends that conflicted with the local realities
of symbolically homogenizing a nation renders visible not only the
hidden processes and limitations of official meaning making but also
the irreducible conflict in value systems found in the confrontation of
genealogy and modernity. The selected theme of the monument in
question—Juárez as the founding father of the modern liberal nation—
passes uncontested, yet the gestures behind the drive for an absolutely
democratic process inhibit the actual realization.

Monument Donation: Building Commercial Relationships

The gaps between visible and invisible layers of meaning with which
national monuments were imbued in *fin de siglo* Mexico become more
explicit in the archives of the Secretaría del Ayuntamiento when a given
monument project was introduced in the form of a gift. For the occasion
of the great centennial celebrations of 1910, for example (many details of
which have been documented by Mauricio Tenorio-Trillo), the French
and Italian resident colonies of Mexico offered to fund statues to Louis
Pasteur and Garibaldi (respectively) as both gestures of gratitude for
the generosity of their host nation and also, in more abstract terms, as
transcendent symbols of "the fraternal sympathy that unites the great
Latin republics"[16] (Figures 3.1–3.3).

Much less apparent than the gesture of donation for the sake of fra-
ternity, as described in the archives in which the original proposals were
kept, were the commercial motivations behind the colonies' gestures.
The Colonia francesa had flourished in Mexico during the open-door
policy to foreign industry sustained by Porfirio Díaz. This resident group

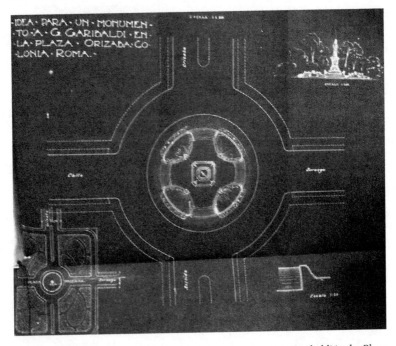

FIGURE 3.1. Translation (upper left): "Idea for a monument to Garibaldi in the Plaza Orizaba, Colonia Roma." In *Memorias de Fomento*, July 1910. Courtesy of the Archivo Histórico del Distrito Federal.

of French capitalists, motivated by the search for new consumer markets for their textiles and initiated by the Arnaud brothers in 1821, had immigrated to Mexico from Barcelonette, France. Despite the internal rules of the colony, which precluded the hiring of Mexicans in their stores, intermarriage, and/or the formation of "lasting relationships" with Mexicans, the colony members saw no contradiction in donating thousands of dollars for the construction of a lasting monument to the Mexican patriotic holiday.

Rather than view these types of donations simply as sublimated commercial transactions presented in the form of gifts, there are two more specific implications that are linked to monuments as studied in this chapter so far. First, it seems that there was tension between the preglobal (social, transnational, and commercial) and the transcendent implications of national patrimony, which manifested in the silences,

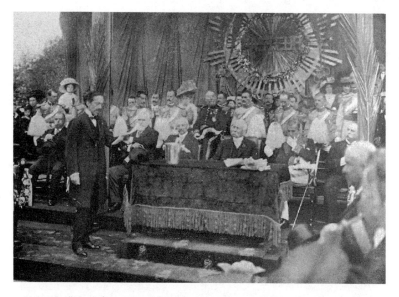

FIGURE 3.2. "Mr. Subsecretary of Public Instruction and Fine Arts [standing to the left] pronouncing the elegy to Pasteur." President Díaz is seated at the table. In *El Mundo Ilustrado*, September 18, 1910. Courtesy of the Hemeroteca Nacional de México.

gaps, and discrepancies between the official documentation surrounding monument donations and the concrete commercial relationships and transactions that sustained them. Second, rather than reading patrimony as commerce, it is more fitting to highlight the ability of these objects to "move in and out of the commodity state," as summarized by Arjun Appadurai with respect to Igor Kopytoff's contribution to *The Social Life of Things*.[17] It's not that patrimony wasn't sacred but rather that it had undeniable connections precisely to those very conditions it was supposed to transcend. Such a realization deepens our understanding of the patrimonial inheritances that pass, metaphorically, from nation to citizen.

In the case of the statue to Isabel the Catholic, originally proposed by the Central Spanish Commission (of the Spanish resident colony) for the Centennial in 1909, the fraternal rhetoric of the proposal is slightly more complex owing to the hints of reconciliation that appear with respect to the colonial past. According to the Spanish Commission's proposal, Mexico is now a spiritual sibling of Spain, and this monument

Monumento á Garibaldi

La colonia italiana, como todas las colonias extranjeras residentes en la ciudad, ha obsequiado á nuestro pueblo con algún recuerdo de las fiestas del centenario de la independencia.

Con un tino muy acertado, Italia escogió á Garibaldi para levantar en su honor el monumento recordatorio, y decimos que con mucho tino, porque Garibaldi representa para Italia algo muy semejante á lo que representa para nosotros el padre Hidalgo.

El Excmo. Sr. Marqués de Bugnano en la tribuna.
El señor Presidente en el lugar de honor

A Garibaldi debe Italia su existencia como nación unida y fuerte: su lugar en el concierto de las naciones europeas y, por lo tanto, podemos decir que su nacionalidad. El símbolo es muy apropiado y seguramente que ninguna figura podría representar mejor la noble idea de libertad que el valiente y noble soldado italiano.

La ceremonia de la colocación de la primera piedra del monumento á Garibaldi se efectuó el martes veinte del actual, bajo la presidencia del señor Presidente de la República y con asistencia del excelentísimo señor embajador extraordinario de Italia y demás enviados de las naciones amigas.

El excelentísimo señor Marqués de Bugnano, embajador especial de Italia, hizo un elogio de Garibaldi y ofreció la estatua en nombre del gobierno de su país y como homenaje al nuestro.

El señor Presidente de la República colocó la primera piedra del monumento, y después los miembros de la colonia italiana formaron una procesión y se dirigieron al monumento á los héroes de la independencia nacional para ofrecer flores.

El señor Presidente de la República colocando la primera piedra del monumento.—Grupo de diplomáticos después de la ceremonia.—Procesión de la colonia italiana.

FIGURE 3.3. Newspaper clip featuring the ceremonial placement of the first stone of the monument to Garibaldi, donated by the Italian resident colony of the Distrito Federal, by President Porfirio Díaz. Following are images of the public procession following the ceremony. In *El Mundo Ilustrado*, September 25, 1910. Courtesy of the Hemeroteca Nacional de México.

project should be accepted, thus, as an incarnation of the two nations' unification in brotherly love and also for the "transcendence in state of mind" that it represents.[18]

What cannot fit within the official rhetoric that frames the Spanish Commission's donation is any reference to the capitalistic endeavors of this resident colony (whose principal base was the Distrito Federal), composed largely of Spanish bankers, business owners, and participants in the agricultural sector during the Díaz regime.[19] These residents created multiple credit institutions and businesses, including the Banco Mercantil in 1882 (precursor to the Banco Nacional de México of 1884), in which Spanish entrepreneurs maintained "a considerable presence," and the Banco Hispano Americano in Madrid in 1900. Far from helping the Mexican economy, however, the activities of these institutions eventually resulted in the loss of forty million pesetas from the Mexican currency flow between 1900 and 1920, an amount that proved "devastating" to the national economy during the first twenty years of the twentieth century.[20]

Of the examples listed thus far, the American colony's proposed donation for the Centennial perhaps most closely approximates the feel of an open investment. In the archive for this particular donation, the theme of the future monument was not significant enough to include it in the initial proposal. Instead, the colony offered the sum of one hundred thousand dollars for the erection of a monument "worthy in subject matter and artistry of perpetuating in part the memory of the event."[21] This is not to suggest that the American colony's proposal contained a specific reference to the commercial enterprises of the group; rather it is the absence of a specific plan, blueprint, or specified location for the monument that suggests the superfluity—almost—of the project content itself. It was not the transcendent piece of art that called attention in this particular file but rather the figurative investment in the American colony's own economic endeavors expressed through the gesture of a (fraternal and patriotic) blind donation.

In addition to the foreign resident colonies of Mexico, whose donations for monument projects were made in homage to the specific event of the Centennial, individual foreign investors also saw opportunities within the general economy of conciliatory diplomacy that describes Mexico's relationship to Europe during the Díaz regime to leave their

marks on Mexican patrimony. Published in 1888 by *El Imparcial,* one brief article demonstrates the intersection of patrimony, homage, and investment in the endeavors of two French capitalists, described quite generally as "in charge of French business in Mexico," who traveled to Puebla to arrange the last details for their donation of a monument to the memory of the French and Mexican soldiers who fell in battle there after the invasion of 1862.[22] When considered in conjunction with Steven Topik's description of the 1880s as a decade in which the plentiful supply of European capital coincided with a renewed interest in Latin America (including Chile, Argentina, Colombia, Uruguay, and Mexico), this particular example of diplomatic investment stands as an interesting example of the less visible transactions that sustain the donated commemorative monument.

Modernization and Commercial Motivations

With respect to those monuments that were conceived by Mexicans for their capital city, the newspaper descriptions that followed the ceremonial unveilings indicate a particular thematic oscillation at the late-nineteenth-century time juncture. The sublimation of the national hero serves the purpose of contributing to the consolidation of a national history. In addition, the public monument provides a reference point for negotiating a position for modernizing Mexico within the circuits of international trade and investment.

If the speeches given at the ceremonies of unveiling functioned to narrate the glorious past deeds of the fallen hero to whom the commemoration was dedicated, the newspaper articles that followed served to situate the monument and the history that it represented clearly within the discourses of progress. Like the concept of the archeological exhibit investigated in the preceding chapter, past and future intersect in the published commentary that surrounds the publicly displayed object, but not necessarily in a cohesive way. The published speech and poem that were composed for the unveiling ceremony for the monument to Christopher Columbus in 1892 by Joaquín Baranda and Justo Sierra (Secretaries of Justice and Public Instruction, respectively), for example, focus on the navigational and political histories of the Old World, the value of scientific accidents, and the laudable visionary qualities of the "martyr father of America":

Martyr father of America! The future
In the fatal hour of justice
Will exhume you from your obscure grave
A hymn will explode from Pole to Pole
And will make then your America
From your martyr's crown, the igneous
Sun of your sovereign apotheosis![23]

Alongside the secular deification of the founding father, however, another type of discourse emerges with this monument and inserts it into an equally powerful yet distinct value system. The writer of a follow-up newspaper article that was published in the *Revista de Sociedad, Arte y Letras* during the same year responds to the Columbus monument as an art object—and thereby indicative of Mexico's international standing with respect to monument building—rather than as an object of transcendent patriotism. Thus the article critiques the monument's material composition, geographical location within the Distrito Federal, and relationship to the educated public.[24] This particular emphasis serves to position the object (and by metonymy, the nation) in an ongoing and implicit dialogue regarding questions of social class, status, and material progress. While the four hundredth anniversary of the so-called discovery of the Americas had prompted a series of honors directed toward the defunct visionary,[25] the writer of the 1892 newspaper article called "The Monument to Columbus" views the fact that paying tribute to the great Columbus had been a project in Mexico since 1875 as indicative of Mexico's progressive vision. The project for the monument to Columbus had been realized thanks to the efforts of Mexican capitalist Antonio Escandón, who had commissioned Parisian sculptor Charles Cordier for that purpose during a visit to France that year.[26]

Despite, as has been argued in this study, the indisputable role that individual Mexican entrepreneurs played in the development of the national arts in Mexico, the newspaper debate that surfaced about the motives of Escandón as the entrepreneurial sponsor of the statue to Columbus indicates that there was indeed a degree of difficulty in reconciling the clashing value systems of sanctified patrimony and commerce. In October 1888, the newspaper *El Partido Liberal* published two articles defending the claim that the monument to Columbus was not, as had been declared in an article and heroic ode published in *El Nacional*

one week prior, due to the magnitude of generosity of the respectable Escandón, who should supposedly be remembered "for the splendid donation that he made to the capital of the Republic."[27] Rather, argued *El Partido Liberal,* the statue to the great visionary Columbus was in fact a compensatory gesture for a failed business transaction in which Escandón had been unable to fulfill his original obligation.

Specifically, it appears that Escandón, concessionaire for the Mexican Railway Company, originally agreed to first demolish the arches of the old aqueduct that ran between San Cosme and Tlaxpana and then install subterranean pipes in their place as payment for a significant piece of land that had been used for the railway. Finding himself, over time, unable to complete the task because of a lack of promised materials, Escandón directed a letter to Mr. Salazar Ilarregui of the Secretaría de Fomento, offering instead to sponsor a work of "public utility and adornment" for the capital city. On receiving Salazar's approval of the idea and suggestion for a monument to Columbus, Escandón wrote to the well-known Mexican author Alejandro Arango y Escandón, who was "versed in history and art," and asked for help in drawing up a project. Arango y Escandón in turn consulted the architect and archaeologist Ramón Rodríguez Arangoiti, who produced the original drawing that was given to and modified by the French sculptor Cordier. Whether the affiliates of *El Nacional* liked it or not, claimed this writer for *El Partido Liberal,* it was an instance of commercial debt rather than inspired patriotism that motivated the creation of this celebrated monument.[28]

The discomfort in the association between the monument to Columbus and the business transactions of Antonio Escandón that appears in the newspaper debate described previously once again points to the broader dynamic in which commercial enterprise and transcendent nationalism intersect. The monuments that were erected to adorn the Paseo de la Reforma during the late nineteenth century were implicated in commercial transactions, discussions about material progress, and debates related to socioeconomic class status in a variety of ways, including the processes of monument casting and production that often took place in European workshops. The giant statues of Hidalgo and Juárez for the *Monument to Independence,* for example, which was first conceived in 1877 and overseen by architect Antonio Rivas Mercado, were cast in the workshop of Italian sculptors Adalberto Cencetti and

FIGURE 3.4. Newspaper clip featuring the inauguration of the *Monument to Independence*. The caption below the image reads: "Monument that the Mexican Nation raised to the heroes of its Independence. Inaugurated the 16th of September." In *Arte y Letras: Semanario Ilustrado*, September 25, 1910. Courtesy of the Hemeroteca Nacional de México.

Giuseppe Trabacchi of Rome between the years 1891 and 1892. Destined to be officially unveiled at the inauguration of the Centennial celebrations on September 16, 1910, and embodiments of the liberal vocabulary of nation, these statues were important pieces of symbolic patrimony (Figure 3.4). However, their insertion into an equally powerful association with commercial progress emerges in a published letter, addressed to *El Partido Liberal* in 1891, in which the Count of Coello describes his visit to the artists' workshop in Italy. In this text, an initial focus on the statue's high quality and the particulars of its material production culminates in ponderings of the possible commercial liaisons to be established between Italy, Spain, and Mexico—all linked in the memory of the voyages of Christopher Columbus—as a result of artistic and commercial collaborations in world's fair projects:

> The imminence during the next year of the centennial of Columbus, who belongs to Spain, Italy, and America, contributes to impulse [this] activity, promising that once the economic conditions of this nation are a bit improved, finally the great idea of a constant line of steamships among the ports of Naples, Geneva, and Mexico will be realized.[29]

Even more important than the "artistic question," continues the writer, the idea of "increasing the communications between Italy and America" is more important than ever, given the need for nations to combine forces to compete with the economic stronghold held by France.[30] Here, then, the association between patrimony and market is rendered explicit as the object in question connects to a range of signification that reaches beyond the traditional scope of patrimonial capital and encompasses the commercial range. Indeed, it is not so much the national monument itself but rather the implications that can be drawn from the conditions of its production that occupy the narrative foreground of this letter: the upcoming year of Columbus's centennial in which two different European cities will host world's fair events; the international cooperation between Mexico and Italy demonstrated by this transaction; and the possibility of greater future commercial arrangements.

Building the Monuments, Building the Nation

Related to the discussion of monuments and their commercial associations is the frequency with which articles and brief snippets of text in late-nineteenth- and early-twentieth-century newspaper articles were dedicated to the processes and phases of national monument production. Common topics included announcements of project themes, brief descriptions of project submissions, plans for a given monument's future placement within the capital city, and subscription announcements. Witness, for example, the following excerpt from an article titled "The Monument to Juárez," published by *El Partido Liberal* in 1890:

> With respect to this monument plan drafted by Dr. Samuel Morales Pereira and drawn up by a section of engineers from the government, we have gathered the following details: . . . Until now we have only been able to see the sketch of this great piece of work, but later on we will publish, once reworked, the definitive plans that will be made in the Engineering Department by order of the honorable General Sánchez Ochoa. . . . As the government has only decreed fifty thousand pesos for said monument and the work will cost half a million at least, it seems to be about opening a national subscription, which we do not doubt will give excellent results.[31]

It is important to note that these monuments were introduced into public discourse not only in celebration of their finished and perfected states but in fact during all phases of their development. The corresponding commentary varies thus from calls to project submissions to descriptions of the selected project's blueprints, calls for monetary contributions, and as seen earlier, the implications of monument construction in terms of international relations. Attention to the phases of development of public monuments during this era forms part of the ongoing dialogue about national development, the construction of modernity, and the hyperconscious fabrication of Mexican *representativity* of which the monuments were part. Production and patrimony intersect in the inspired writings of Mexican entrepreneurs who see literal connections between national monuments and international commerce

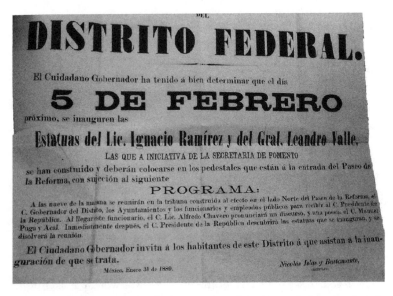

FIGURE 3.5. Poster announcing the inauguration of the statues dedicated to Ignacio Ramírez (secretary of justice and public instruction under President Juárez) and General Leandro Valle (of General Juárez's liberal army). In *Memorias de Fomento*, section "Monumentos," 1887. Courtesy of the Archivo Histórico del Distrito Federal.

and also through the vocabulary of process, assembly, and construction through which these objects systematically entered the public forum.

Fashion: An Intersection of Art and Consumption

Yet another manner in which the published commentary related to monuments flirts with commercial associations is suggested in aesthetic evaluations that appear to be grounded in what strongly approximates fashion criticism. Indeed, there are certain instances in Rodríguez Prampolini's compilation of articles in which critical appraisal of the monuments of the Paseo de la Reforma has to do specifically with the representation of clothing. In an article published by *El Universal* in 1892, for example, in which sculptor Primitivo Miranda's statues of Ignacio Ramírez *(El Nigromante)* and Leandro Valle are criticized for their lack of aesthetic appeal, the author quotes the wife of a distinguished national

writer (also unnamed) who remarks on the artist's lack of attention to wrinkles: "'That sculptor,' she said, 'made a mistake in vocation. He should have been a tailor. Wrinkles in clothing horrify him'"[32] (Figure 3.5).

Along similar lines, the writer of an article called "On the *Paseo de la Reforma*" (1891) bases his descriptive summaries of the statues of Generals D. Ignacio Pesqueira and D. Jesús García Morales (both contributed by the state of Sinaloa) on the clothing in which these generals are portrayed. In fact, clothing appears to be the distinguishing feature between the two:

> That of Pesqueira is more agreeable because, having been covered with a cape of large folds, the sculptor had the chance to impress a certain artistic character upon it, skillfully treating the modeling of the coat; we all know how uncomplimentary modern clothing turns out to be for statuary works of art.[33]

Here there is an intersection between the vocabularies of art criticism and what Appadurai might call the "consumption practices" of the era.[34] The aesthetic criteria of late-nineteenth-century Mexican art, which relied heavily on the criteria of realism, are at the same time touched by specific restrictive temporal referents ("we all know what modern clothing does to statues") and an implicit list of dos and don'ts that evaluates art while pointing in the distance toward consumption habits.

Though organizations such as UNESCO in the late twentieth century may have contributed to the overlap in boundaries between industry and patrimony via strategies of promotion that stimulate various modes of patrimonial consumption, the patrimonial corpus of Mexico has been replete with intersections between patrimonial and commercial value systems from the beginning. Rather than representing an ideological disintegration of sacred heritage values, however, the commercial subtext of Mexican patrimony was integral to the emerging national profile and in fact anticipated the negotiations that regional and national guardians of cultural patrimony would face in the context of globalization in the century to follow.

Gazing and Forgetting: Patriotism as Lack

In addition to inviting the possibility of concrete commercial transactions, the public monuments that served to canonize an official history and promote a sense of citizenry among the national viewing public of the late nineteenth and early twentieth centuries also participated in the dynamics of material progress by contributing to an international index of cultural capital. This idea was approached in nineteenth-century periodicals yet not officially created until 1972 by UNESCO, with the adoption of the international treaty called the Convention Concerning the Protection of the World Cultural and Natural Heritage. Within this economy of meaning that equates progress with artistic production, patrimony as measured against an international repertoire of cultural capital is evaluated first comparatively (in terms of status and membership) and then at the local (or national) level. The synonymity of *progress* and *patriotism* thus leads to both the consideration of monument viewing as an act and affirmation of citizenry and the rhetorical moralization of citizen donations toward monument funding. As will be explained in the sections that follow, looking at monuments somehow conferred the viewing subject's belongingness to a larger group of citizens, and contributions to monument projects became associated with the highest feelings of patriotism.

Inspired patriotism was heavily implicated in the vocabulary that surfaced with respect to public monuments, and particularly so when it came to analyzing, directing, or describing the appropriate or ideal reaction of the national spectator who contemplates the three-dimensional representation of a patriotic figure. In a manner that echoes the descriptions of devotion to the homeland that scholars presumed would be experienced by National Museum visitors, a writer for the *Revista de Sociedad de Arte y Letras* in 1892 describes the statue of Columbus as "awakening in all who see him the mysterious memories of a portentous action and the penetrating and unanimous feeling of love for the homeland and the admiration of genius."[35] As also observed in the museum context, the patriotic gaze in the context of nineteenth-century monuments was closely associated with a future-oriented vocabulary such as one finds on reading one viewer's exposure to the unfinished project for the monument to Cuauhtémoc: "I spent some time in the

contemplation of these works of art and constructing in my imagination the grandiose monument. Afterward I left, full of hope and faith in the future of the fatherland, because, I thought, a community with artists among its sons cannot help but become great."[36]

Here the unfinished monument stands in metonymic relationship with Mexico itself, as the spectator's awed contemplation arouses optimistic visions of the future of the nation as a whole. In a way that parallels the archaeological object's implicit association with future-oriented material progress in the preceding chapter, the use of ancient historic material to create a repertoire of modern representations conjugates the vocabulary of patriotism with the universal, delocalized rhetoric of modernization: "To have confidence in the future," reads an article published by *El Partido Liberal* in 1889, "one needs to have a cult to the past."[37] As will be demonstrated in what follows, the future-oriented discourse of patriotism that surrounds public monuments during this time relies to a significant extent on economic metaphors to define the roles that citizens should play with respect to the nation's march toward greatness.

The elicitation of the citizen's patriotic gaze involves more, however, than the viewer's association of the monument with the nation's future glory. In theoretical terms, Baudrillard writes that consumable objects "are given and received everywhere as force dispensers (happiness, health, security, prestige, etc.)"—as generators of meanings, effects, or values that both exceed the physical, tangible qualities of the physical object and position the viewer or possessor as the recipient of these transformative properties.[38] Transposed into the social context, one could add that through its social accessibility, the collected object is also a dispenser of membership (such as that of citizenry). Modernization was predicated on association and membership and thus inherently fetishistic. To view the displayed object as a dispenser of meaning and status depends on the viewing subject's voluntary forgetting that what is socially sanctified as a universal, objective truth or exact reproduction of something historical is actually an effect of the practical demand for membership. The subject's belonging is confirmed in the object's ability to embody membership through possession of it or association with it, the object being the most accessible vehicle for locating or mapping that abstraction. In fact, this particular act of forgetting, because it entails

the assumption of a shared and socially reiterated perception, is part of the process through which the viewing subject becomes eligible for membership. "Forgetting" in this sense implies, of course, not only the emptying, negative operation that the term initially suggests but also the positive, active assumption of a particular perspective before the commemorative object.

This type of implicitly obedient mode of perception is evident in the form of cultural forgetting that is embodied by the national monument. There the citizen goes to remember what most likely falls outside of lived experience, and it is precisely this lack—shared by all of the monuments' viewers—that opens up a space for a commonality. The absence of lived experience is both acknowledged and supplemented by the monument, which is valid not so much as a marker of history but as a cultural inscription of the present, indeed, an emblem of kinship. Appropriate here is Benedict Anderson's citation of Renan in "Qu'est-ce qu' une nation?": "Therefore the essence of a nation is that all of the individuals have many things in common, and also that all have completely forgotten these things."[39] The long-term goal of the monument is for citizens to remember what was never lived, and to simultaneously forget that they have never lived it. This is the context of the fetish—the "seeing *as*" mode of perception or the social codification that filters the viewer's perception of the publicly accessible *piece*. In the very social accessibility of the displayed object is inscribed this subtle perceptual submission to be evoked in the viewer, a doubled forgetting that passes for collective memory and thereby simulates the "possession" of membership.

There is an interesting relationship between the forgetting that is implied in viewing a public monument or collection and the mode of consumption that Arjun Appadurai associates with the advertising techniques of gift catalogs, which use the simulation of age to sell their products. In a manner parallel to the public monument, the "object with patina," or that "property of goods by which their age becomes a key index of their high status,"[40] refers the possessor to a lost context or way of life that attracts him because of the inherent desire to mitigate this sense of loss. In the context of the true collection, this renders the object difficult to acquire and thus affirms something of the worthiness of the possessor at the same time as it threatens him with the horror of the passage of time.[41]

Although a radical shift in context, the manufacturing of nostalgia that Appadurai locates in the contemporary mass merchandise of objects with patina also applies to the creation of a viewing public via the false or imagined nostalgia of the public historical piece.[42] In the same way that the mass-produced object with patina points to a false sense of loss to create desire in the consumer, the sense of shared history (among nationals of highly heterogeneous backgrounds and completely individual genealogies) imbued in the public historical monument depends on a symmetrical production of "imagined nostalgia." Forgetting is inculcated as a ritualized or semiritualized process of remembering, which offers its membership to citizens in the aesthetic seduction of emotive response.

Monuments, Funding, and Social Class

As symbolic pieces of cultural capital that served, among several other purposes, to inspire and remind Mexican citizens of their national martyrs, the monuments were at times defined from the sociocultural center as transcendent of the vast class differences among Mexico's diverse citizen-public. In the *Annals of the Association of Engineers and Architects of Mexico* (1886), the powerful physical attributes of the monument to Cuauhtémoc, which includes bas-reliefs that narrate the story of the great leader's torture and demise, affect the viewing public in such a way that renders *knowledge* (and therefore any specific education) of the historical context redundant: "[Neither] a great effort nor a vast knowledge of the history and the philosophy of the gesture is important in order to analyze the complicated ideas that translate from the countenance, from the positions or from the groups"[43] (Figure 3.6). However, as was the case for the Museo Nacional, subtle discrepancies related to social class had a way of resisting the homogenizing effects of the most transcendent acts of patriotism.

In addition to the direct correlation between seeing and knowing described previously, the viewing of the public monument was also described as having a powerful visceral effect on the viewer. One article on monument viewing, signed R. Rafael and dated June 1851, points to the fetishization of the image as a properly "Latin" characteristic and one that can be traced to the use of imagery in the Roman Catholic faith.

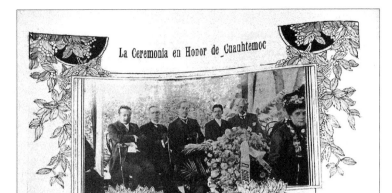

FIGURE 3.6. Newspaper clip featuring the ceremony in honor of Cuauhtémoc. In *Arte y Letras, Semanario Ilustrado,* August 28, 1910. Courtesy of the Hemeroteca Nacional de México.

And much like the ecstatic experience of the saints, the inspirational thoughts that are generated between the monument and the viewer are capable of penetrating the crowd and then "descending" to the level of the uneducated and humble classes, rendering them equivalent if only in terms of their enlightened state: "And in that way, giving a [form] to the abstract [idea] that they symbolize, a path is opened in the hearts of the multitudes; speaking in universal language, it descends to the humble and ignorant ones, stretches their form with action and takes on a body and with that body, life."[44] In this description, the monument is used to reinforce class difference in the very same gesture of reaching beyond it. The rhetoric employed here operates in much the same way as it would if relating to the religious icon in positing the monument as both a unifying agent and a marker of social hierarchy.

Although public monuments in Europe as well as in Mexico were often funded by public subscription, the problem of finding sufficient contributions and amplifying the resources for funding projects occupies a significant amount of the correspondence on public monuments within the annals of the Secretaría de Fomento. In a repetition of the same theme that was implied in Alberto Bribiesca's *Moral Education* painting discussed in chapter 1, one of the consequences of this particular intersection of the private and public sectors was the rhetorical equation of morality with spending. The national martyrs who had lost their lives fighting for the liberal cause were quite often inscribed into public memory using a vocabulary of moral debt, and the need for private sources of funding to homage the memory of the nation's fallen heroes provided an opportunity for the inherited obligation to be fulfilled through monetary contributions.

Written in 1905 by the patriotic committee of Benito Juárez of Chihuahua, one memo sent to the city halls of the Republic asks for monetary contributions for the erection of a monument in honor of the "favorite son" of Mexico in such a way that illustrates this intersection of value systems that equates patriotism with monetary donation:

> In order to complete this artpiece that will perpetuate in bronze and in marble the great memory of the great republican who put on the laurels of glory, battling for the triumph of good with the arms of his privileged spirit, as the favorite son of his fatherland, the Directive

Table of the cited Committee that honored me to preside, agreed that I should send this circular to the City Halls of the Republic so that they serve themselves to contribute the highest quantity possible for them, in name of the towns that they so dignifiedly represent, for the fulfillment of this patriotic idea.[45]

Along similar thematic lines, the newspaper El Globo in 1868 published a brief article of thanks and petition for donations for the construction of a statue to General Vicente Guerrero. Their "poor publication" started the contribution collection with five pesos and the author wished that they had been "able to fund with that amount alone a monument that is worthy of the hero of the Mexican nation." To further contribute to the honorable cause, the newspaper's columns were offered as spaces in which to announce and publish the names of subscribers and the amounts contributed. Foreign subscribers to the publication were invited to send their contributions as well.[46] Another letter, addressed to the City Hall of the Distrito Federal in September 1867, asks for those whose "patriotism" and honor move them to do so to please contribute "what they can and as much as they please" to the fund for a commemorative stone to be placed at the Palace of City Hall. The distribution of the collected funds would be published and any leftover quantity donated to charity.[47]

Within the regular petitions to both nationals and foreigners for their financial contributions to Mexican national monuments, the question of socioeconomic class appears as an obstacle that is figuratively overcome not only by the collective patriotic gaze of the socially diverse crowd but also through concrete participatory means. One memo in particular demonstrates the extent to which class differences could be subject to sublimation through the rhetorical conjugation of patriotism and financial donation. Regarding the announcement for a monument to Isabel the Catholic that was proposed in 1910, a national subscription was to be opened in the hope that those who recognized her importance both for the discovery of America and also for "the humanitarian sentiments that she always held in favor of the naturals of the conquered lands of this continent" would contribute donations. More than large individual donations, it was assured, what was being sought was more of a general assembly of Mexican citizens as a gesture of recognition

and "affection" for the Spanish queen. For the same reason, it reads, "It is hoped that even a small coin can be obtained from the numerous indigenous race, on behalf of whom the aforementioned Sovereign took so much interest."[48] It is through the ethos-driven vocabulary of affection, then, that the notion of debt as a moral obligation—one that is perpetually owed to the dead national martyr or hero whose life in some way exemplified the liberal values that were being celebrated— translates into financial obligation.

Notwithstanding the eloquence with which the effect of class differences on the formation of a cohesive national citizenry could be tempered at the rhetorical level, there were occasions in which the irreducible realities of a socioeconomically diverse population surfaced in conjunction with the topic of national monuments. Given that these were objects of public display that were theoretically accessible to all, the monuments ideally should provide a point of intersection for patriots of all social ranks. There were two areas, however, in which specific needs clashed with the democratic, class-leveling enterprise described earlier.

One had to do with international status. As mentioned at an earlier point, when measured against the international index of cultural patrimony that provided the universal standard toward which individual nations should aspire, the individual monument was used as proof of the artistic savoir faire of the Mexican nation. Wrote Francisco Sosa in 1887, in the same publication in which he proposes that each state contribute its own monument to adorn the remaining empty pedestals of the Paseo de la Reforma,

> The inauguration of the grandiose monument [Cuauhtémoc] with which the federal government has honored the memory of the fatherland in 1521 has come to reveal not only that Mexico never forgets its heroes, but also that amongst its children there are artists capable of producing artworks that are worthy of any cultured nation.[49]

In addition to reinforcing the competitive edge of Mexican artworks on the international scale, the question of status as a measuring medium for patrimonial artworks also surfaces on the local front. If, on one hand, socioeconomic class differences are tempered in the writings that focus on the sublimated or sacred qualities of a given monument,

it is also the case that these monuments were regarded both as objects of patrimony to be associated with a transcendent value system and as examples of national *production*. In this light, the question of status allows for patrimony to be evaluated not only aesthetically and morally but also in terms of its success as national product. One writer for the *Revista de Sociedad, Arte y Letras* in 1892 used the socioeconomic status of the passersby as a means to assess the level of achievement represented by the monument to Columbus: "In Mexico it is one of the principal adornments of the city. It is found, as we said at the beginning, at the most beautiful point of the metropolis, on the most elegant promenade through which the highest-standing and most distinguished members of our society pass."[50]

Within this intersection of value systems that the public monuments of this era embody—as objects that are both transcendent of and subject to the measuring standards of social class—there was some confusion as to whether public monuments were to be treated as public or private property. More specifically, this issue surfaced with problems of vandalism. In September 1910, the general management of public works of the Distrito Federal sent a letter to the secretariat of the superior district government council requesting that a gendarme be sent to stand guard by the recently inaugurated monuments dedicated to independence and to Benito Juárez, respectively, because of the "damage and deterioration" that they had suffered. The letter specifies that it was the "low-standing public" who had "invaded the platforms" and damaged the monuments in question and requests that gendarmes stand permanent vigil over the monuments. This was to be done both to prevent further damage and also so that the authorities could avoid potential criticism for their apathy with respect to public works.

The secretariat responded with a request that a "cord or other object" be placed around the monuments to "impede public access." It should be ensured that this object is both "in harmony with the architecture of the monuments" and at the same time would "radically impede" the public destruction of said monuments. The next document of this file contains the response of the inspector general of police, who points out that there were hardly enough officers to attend to the needs of the public itself, much less to guard monuments. He suggested instead that a group of privately contracted guards be assigned to the task.[51]

This shift from public to private responsibility indicated in the inspector general's response illustrates the limitations of the hegemonic national project represented by these objects. When measured against the practical needs of an understaffed police force, patrimony is regarded more as a luxury item than as a piece of public property with transcendent historic value—an idea that is reinforced by the secretariat's preoccupation with the aesthetic qualities of the cord that would be used to inhibit the crowd's access.

The monuments and monument-building projects of late-nineteenth-century and early-twentieth-century Mexico City embody multiple sets of meanings that, on first glimpse, threaten to contradict one another. If they serve, on one hand, to represent fraternal alliances between nations, they also function at the national level as unifying mechanisms for a vastly heterogeneous population. Though the spiritual influence of national monuments is powerful enough to inspire the citizen to participate in the performance of collective memory by imitating, or at least paying homage (even literally) to, the patriotic hero, they are also pieces of cultural currency used to negotiate, dream, and forge commercial relationships with the nations of economic hegemony. If the monument is transcendent of social class both in the effect generated from its contemplation and in the national subscriptions that offer even the humblest citizen the opportunity to contribute, then it is also one of the keystones through which Mexico represents its high social status on the international scale with respect to the fine arts. Following the intricate maze of meanings that surfaces in the textual recordings of the monument projects illuminates the shifting positions of a nation that straddled diverging value systems as it struggled to contract in the creation of a canon of national patrimony and expand in the competitive arena of capital enterprise.

4

Collections at the World's Fair: Rereading Mexico in Paris, 1889

❋ ❋ ❋

Held approximately every two to four years between the first large international exposition (at the Crystal Palace in England, 1851) and World War I, the late-nineteenth-century world's fair events helped construct a Western paradigm focused on modernity and progress. The most imposing, the most propagated, and the most influential international constructions of the late nineteenth century were the world's fair expositions, which, as precursors to the age of globalization, offered a medium for the creation of commercial relationships among competing nations and also for the international transmission of information and culture. The fairs were spectacular instruments of mass communication, modeling mediums that staged a series of self-conscious displays of nationhood and mobilized the commercial relational matrix that would redefine cultural exposure over the next century. Indeed, as international mediums of transmission in which aesthetic experience, information access, and product purchase occurred in the same venue, the nineteenth-century world's fairs prefigure the global merging of consumption and culture that characterizes the current era.

Mauricio Tenorio-Trillo's exhaustive and groundbreaking study of Mexican participation in world's fairs (with special emphasis on the Exposition Universelle de Paris in 1889) centers on the implicit tensions between image and thing, or form and essence, when he argues that the commissioners in charge of the Mexican exhibit for Paris in 1889 found themselves in the difficult position of representing a nation that did not yet exist. Indeed, the problem of fashioning an image of national selfness that can only be problematically or partially representative of reality is a central characteristic of nineteenth-century exposition culture

as a whole and not just an attribute of Mexico as a developing nation. The Arguments seeking to explain Mexico's "unoriginal" aesthetic (prior to the postrevolutionary muralists), which can be found in Daniel Schávelzon's *La polemica del arte nacional en México* (1850–1950) and Roger Bartra's *La jaula de la melancolía,* have pointed diagnostically toward an inherent sense of Mexican national depression. But a closer glimpse at the circumstances under which the United States and European nations hosted world's fairs suggests a frequent contrast between the semide-pressed or melancholic state of a nation in recovery and the sublime, compensatory events proposed by the fairs. In addition, recognizing that both European and Mexican fair displays played with practices of self-exoticism to attract potential viewers and investors helps collapse the presumed differences between Mexico and the developed world. These realities complicate the commonplace distinctions that privilege the nineteenth-century material self-representations of Europe and the United States over those of the developing world; in fact, trends in world's fair collection building suggest the idea of melancholy as foundational to identity construction in all modern states.

Constructing an Image

Along with the other forms of public exhibition discussed thus far, world's fairs stimulated Mexican national development during the Porfiriato and, in doing so, had a discernible impact on industrial and aesthetic advancement. Witness, for example, the following observations written by Sebastián de Mier in his official account of Mexico's participation in the Paris fair of 1900:

> Very complex are the causes of the material progress observed in Mexico in recent years, revealed by the new enterprises created. . . . There is no denying that one of them is the attendance at the Expositions. After each one of these events, great steps forward for the nation have been achieved, thanks in large part to the publicity associated with them, to the things that have been learned there, and to the fervor and excitement that both constitute and result from the very essence of these tournaments among nations.[1]

World's fairs were venues at which individual nations could perform and, to a certain extent, reinvent themselves. However, the fair commissions of hosting nations firmly held the invited exhibits to specific parameters, standards, and norms. For example, the fair commissions of invited nations submitted blueprints for their pavilion projects to host countries for approval before construction. The spatial layout of the fairgrounds was meticulously determined and organized in such a way that sustained the rigid social and economic hierarchies that describe nineteenth-century Anglo-European hegemony. The hyperconsciousness that surrounded the processes of self-edification inspired by these events led fair commissioners and representatives from all branches of aesthetics (e.g., the plastic arts) to study their competitors' work while still figuring out their own modes and materials of display.

In the Mexican archive for the Exposition Universelle de Paris of 1889, for example, there is a folder containing a drawing and detailed description of the Argentine Pavilion intended for the same fair, indicating the competitive edge against which such sublime articulations of nation were conceived. Along the same lines but on a broader scale, the published guide to the archive of the Academia de San Carlos (with memos dating from 1867 to 1907) contains multiple mentions of the travel stipends used to send artists to study the local practices of European artists at workshops in Rome and Paris. Meanwhile, Academia affiliates, artists, and art critics back home were still working to determine the parameters of a specifically Mexican expression:

> Instructions to C. Emiliano Valadez about the work to which he should dedicate himself during his stay in Europe . . .
>
> To study and practice . . . all that relates to the fabrication of dyes, varnishes and other components used for engravings, [which is] deficient nowadays amongst us.
>
> To study what is new in systems for cooling down steel plates and molds and die and however much you find that is new and good.[2]

The hyperconsciousness, the competitive atmosphere, and indeed, the market mentality that underlay aesthetic practices during the late nineteenth century produced a certain sense of retrospective unease in future scholars. Contemporary writers on the subject have expressed

concern over the construction of a Mexican artistic expression that, precisely because of its exaggerated self-awareness, ultimately compromised its own authenticity:

> The point that has seemed most important to us from the beginning is the attempt to construct a type of art or architecture of *national* characteristics, but as the result of an *a priori* creation; that is, a social group proposes to create a *national art,* and from there give it form, without keeping in mind that this art could only be the result of a complex historical process.[3]

Along the same lines, early-twentieth-century cultural critic Martín Luis Guzmán expresses a similar criticism of Mexican nationalism during the chaos of the revolution, except that he grounds his observations more in the political realm.[4] According to writers like Guzmán, Mexico's error was reversing the organic progression of full self-realization by forging the parameters of a fully edified *patria* (or an "ideal" of *patria* as represented in art and architecture) before "deserving it." In other words, the self-conscious products of a rushed process of self-edification cannot replace the organic, unconscious workings of history. It is the "complex historical process," or, in the words of Guzmán, the spontaneous "feeling of the homeland like a generous impulse," that produces the fully realized and autonomous national polity—not the competitive drive of constant comparison.

One example of market-driven cultural production—as opposed to organic historical process—is the Palacio azteca itself, which was ultimately considered by future architects to be a failed experiment in cultural production owing to its unoriginality (as its blueprints were influenced in part by the notes of foreign explorers and writers), its uselessness, and its failure to become a permanent fixture within the growing repertoire of public places back in the Distrito Federal. Witness the following criticism written during the decade that followed 1889:

> We see, then, that the building is not *useful,* since it has remained disassembled for ten years [and] who knows where . . . without serving any purpose whatsoever; it doesn't express *truth,* as has been proven, nor beauty, since it doesn't correspond to our current tastes, nor to

the principles of absolute beauty. Other writers were more frank and hard, calling the building the great water tank.[5]

To further its multiplicity of meanings, the Palacio was conceptualized and designed as a structure that could be disassembled at the close of the fair and reassembled in Mexico as an archaeological museum, a prospect that was never realized.[6]

A more detailed analysis of Mexico's depressive, market-driven cultural production, found in the writings of journalist and cultural critic Roger Bartra, helps to integrate these criticisms of the Palacio azteca into a broader context of cultural reflection. In "El luto primordial," Bartra reflects on the rhetorical appropriation of melancholy as the definitive Mexican character. Distinguishable in literary and analytical writings as far back as the turn of the nineteenth century, he writes, such melancholy need not be uncritically attributed to the social and political misfortunes that characterize the prototypically "backward" ex-colony, as might be assumed from writings such as Paz's *Postdata* and García Márquez's *Cien años de Soledad*.[7] Basing his observations on postrevolutionary novels, the author focuses on the "myth of the heroic peasant" and the inevitable longing for a better life that converts his existence into a ceremony of mourning, a "body sacrificed on the altar of modernity and progress."[8] Rather than as an originating condition developing organically from a detained economic and political instability, Bartra reads Mexican melancholy in light of the overall hyperconscious process of construction of an autonomous identity in which the Mexican national polity has appropriated and internalized the historical *ideas-tipos* (idea-types) imposed on them by centuries of Eurocentric discourse.[9]

Far from advocating an essentialist and reductive interpretation of *mexicanidad* with this particular reading, melancholy should be understood in this context as a foundational story—one that is put to strategic use in the various institutional articulations of autonomy that accompany the *fin de siglo* juncture and the height of the Porfiriato. From the literary articulations of Mexican romantic poets (including Ignacio Rodríguez Galván and Salvador Díaz Mirón) to the cult of Cuauhtémoc and other tragic heroes (such as Miguel Hidalgo) who have been immortalized in the monuments that adorn the Paseo de la Reforma, there is a link between the institutional leashing and public

reinforcement of sentiment and the experience of political and cultural unity that congeals in the late nineteenth century:

> In this way, the definition of the national character is not a mere problem of descriptive psychology: it is a political necessity of the first order, . . . contributing to the establishment of the bases of a national unity to which the monolithic sovereignty of the Mexican state then corresponds.[10]

This attribute of Mexicanness, however, is not exclusive to Mexico, or even to Latin America in general. If anything, continues Bartra, this melancholic disposition is precisely what brings Mexico to the fore of modern Occidental culture. Citing Lyotard, he routes the notion of a fundamental cultural nostalgia through the disposition that is "peculiar to the modern aesthetic, which finds in the cult to the sublime—the unattainable—a normative unifying consensus."[11] In other words, melancholy does not simply point backward to loss; it also rather contradictorily exercises an *edifying* function in which stories and different embodiments of loneliness and melancholy are used as the foundations for a cohesive political national story to which everyone with that shared history suddenly belongs.

Before elaborating further on the case of Mexico, it would be useful to place Bartra's use of melancholy in dialogue with Freud's 1915 essay "Mourning and Melancholia."[12] According to Freud, what distinguishes the melancholic is the inability to properly distinguish between the self and the lost other. The melancholic disposition refuses to recognize a loss that has occurred and so responds by incorporating some trace of the lost object into its own identity. In contrast with mourning, in which the location of the lost object is external to the self, the melancholic internalizes the lost love-object, converting it into a fundamental component of the ego. The characteristic hatred that would normally accompany the feelings of love for the external love-object is then internalized, causing the ego to turn on itself. The melancholic subject thus convinces itself of its worthlessness, leading to a state of excessive self-torment.

Bartra, however, in positing the melancholic response to the loss of an ideal as constitutive rather then excessive, and in reading the edifying idea of loss as perhaps an essential cultural component of the modern

polity, points to Judith Butler's political reading of Freud in *The Psychic Life of Power*.[13] Not only is melancholia's contraction of the "social" (that which is outside the self) into the self the originating condition for the emergence of the ego, reads Butler, but it is through this occurrence that the Law disappears as an outside object and becomes mistaken for a component of the melancholic's (i.e., citizen's) own conscience. With both Butler and Bartra, then, the melancholic disposition is unleashed from the realm of individual idiosyncrasy and used to decipher social or collective tendencies. In Mexico, it is the coming-of-age conflict in the onset of modernity that pushes the governmental elite to fabricate the symbols of a national identity within the parameters of the universal hegemonic social and scientific discourses of that era. Bartra comments on the historical incorporation of idealized "others" within the Creole articulations of identity, claiming that the internalization of imposed "stereotypes" and "powerful ideas" inevitably influences the behavior of the inhabitants of a nation.[14]

There are two responses to this melancholic internalization of otherness that have a historical presence in Mexican culture, writes Bartra. One is the "tragedy of the fall" and martyrdom. The other, in contrast, points back to the "ecstatic" response derived from Aristotle and the Hippocratic concept of the four humors, "one of which—black bile—had an increasing importance in the definition not just of sickness (melancholy) but also a peculiar state of mind."[15] This would be the state of genius discernible in the philosopher, the artist, or the politician whose contact with the obscure otherness of self and society generates an ecstatic overcoming, "an ecstasy that permits the soul to distance itself from the body, driven by a profound nostalgia for the same earthliness that it abandons." This is also the ecstasy of the visionary whose suffering inspires a resigned profundity of thought that has been celebrated in art, literature, and politics throughout the ages.[16] For Bartra, the heroic dimension to melancholy is undeniable in the political articulations that fashion a given nation's self-justification of autonomy and agency. And owing to its inherently retrospective orientation, the melancholic disposition as studied here further illustrates the fetishism of origins as a major driving force in the creation of a collective canon of displayed objects.

For a concrete example of the necessary relationship between melancholy and the founding stories of nation as suggested by Bartra, one need

not look further than the pavilion exterior of the Palacio azteca itself. As Tenorio-Trillo provides an exhaustive description of the pavilion exterior in his world fair study,[17] I will focus on one significant detail here: the statue and accompanying textual supplement to the representation of the last Aztec king, Cuauhtémoc. The transition of sanctity from deity to polity is epitomized in the sculpted representation of Cuauhtémoc, the last and most tragic of the nation's indigenous leaders, whose dead and tortured body, reads the published *Explication* of the same building, "divided into two bloody pieces," was "the baptism of America."[18]

Through the demise of Cuauhtémoc, the epic of death and loss founds the new political entity. Once again, the modern national collection reproduces an epic story of origins. The transcendent melancholic perspective is one that penetrates the tragic immediacy of ruin and perceives, in the torn fragments of the hero, the newborn *patria*. While the figure of the Aztec hero on the pavilion exterior is solid in its sculpted form, its textual exegesis, published in *Explication de l' edifice mexicain* (Explanation of the Mexican Building) in a trilingual edition written by historian Antonio Peñafiel and distributed to fair visitors, allocates signification not to the depicted whole but rather to the divided pieces of the hero's body. In the play between its fragmentation and reassembly in the exegetical synthesis that is generated between sculpture and text, the body of Cuauhtémoc becomes an emblem of a national story. Like the writers who created the tragic heroes explored in Benjamin's study of the *Trauerspiel,* or German tragic drama,[19] the authors of the written *Explicación* use Cuauhtémoc's martyrdom as a founding national story, thus imposing the physical trials of a single heroic individual onto the breadth of history itself.[20]

Bartra's analysis provides a bridge to connect the idea of a fundamental deficit—a constitutional gap or sense of incompletion that describes, according to this writer, not only those nations with a colonial past—to the huge endeavors of self-representation that mark the nineteenth century. One argument against Mexico's allegedly failed experiment with modernity is that it is precisely this lack of a seamless political and representational topography that characterizes any modern nation. Critical reflections on European or U.S. fairs reveal that one of the fundamental functions of most nineteenth- and early-twentieth-century fairs was to construct a type of bandage to cover an otherwise jagged

seam of destabilizing national catastrophes such as war, economic crisis, and political unrest. For example, in a groundbreaking study on nineteenth-century fairs in the United States, Robert Rydell contrasts the stark historical reality of the 1876 Civil War Reconstruction period with the utopias projected in the U.S. fairs of that era. In his history of great exhibitions, Paul Greenhalgh, in turn, draws attention to the gradual shift in priority, detectable from 1867 on in Europe, from provoking the admiration of the middle and upper classes to educating the impressions of the youth and the lower classes, in direct response to their potentially destabilizing emergence as "socio-political forces."[21] Still along the same lines, Mauricio Tenorio-Trillo points out that the 1889 Paris Centennial fair "helped France persuade itself of its greatness" while it was still recovering from the loss of Alsace and Lorraine to Prussia.[22] In other words, *none* of the identities that were displayed at these great theaters of progress was necessarily organically "felt" before materializing in a concrete actualization. This sense of an inherent and irrecuperable depletion—as mentioned in the introduction with respect to the reduction in Mexican territory following the loss of Texas and the Gadsen purchase—was the mobilizing force that drove the impetus to construct the celebratory inventions of nationalism that were erected for the world's fairs. At the same time, the sense of precarious identity and inherent instability linked to commercial value sustained rather than depleted the sublime national myths that were simultaneously being constructed, written, and disseminated.

Like the world's fair architectural pieces in which myth-sustaining structures were assembled and dissembled in a matter of months, the collections displayed at these fairs also embodied a fundamental ambivalence between presence and dissolution. As seen in the case of the *Coatlicue* statue discussed in chapter 2, which was alternatively placed and pulled from public view according to the perception of social meanings that its display engendered, the official collected piece of the public institution becomes in a sense emptied of its original historical and circumstantial use-functions, only to regain social status and meaning through its immediate appropriation by officially sanctioned disciplines. Yet something is inevitably lost in the complicated processes of assembly and social reconstruction that precede the polished and finished display. It is because of that sense of loss that both the collection and the

"depressed" modern nation that it represents approach the theoretical disposition of mourning.

Despite ingesting the European visual vocabulary of modernity, Mexico nevertheless ventured to produce its own story. Together with the overwhelming anthropological scope of the fairs, there was an awareness that otherness sells, and the strategic practice of self-exoticism with an explicit marketing purpose was not unknown even among the European nations. For example, there appears to be an analogy between the marketing strategies of regional fairs in countries with powerful capital cities, as depicted in Shanny Peer's reading of the use of folklore during the French fair of 1937, where marginal rural economies were boosted by promotion of "the authentic local," and the strategic position taken by Latin American nations relative to the economic hegemony. In other words, the strategic economic use of the status of "otherness" was every bit as powerful, as well as much more overtly maneuverable, as the protagonist's role within the biased anthropological discourses that had for centuries justified European claims of supremacy.

The Persuasiveness of Collections

The Palacio azteca provides a blatant example of Mexico's strategic use of otherness for the purpose of attracting a foreign viewing public. On the outside of the pavilion, which was modeled after an Aztec temple, or *teocalli*, the rise and fall of the Aztec legacy was emblematized through a juxtaposition of abstract symbols and anthropomorphized representations of selected gods and fallen kings from the Aztec pantheon (Figure 4.1). According to Tenorio-Trillo, the building synthesized an array of quotes and images taken from a variety of sources, spanning from Alfredo Chavero's volume 1 of the newly consolidated first exhaustive account of Mexican history (*México a través de los siglos*) to European documentations of travel and archaeological descriptions such as those composed by Lord Kingsborough, Guillaume Dupaix, and Désiré Charnay. Art historian Fausto Ramírez also points out that the gods chosen to represent antiquity conformed to modern values: Centéotl, the protector of agriculture; Xochiquetzal, the deity of the arts; Camaxtli, god of the hunt; and Yacatecuhtli, the god of commerce.[23] Still, the point of the pavilion exterior was to emblematize the rise and fall of the Aztec

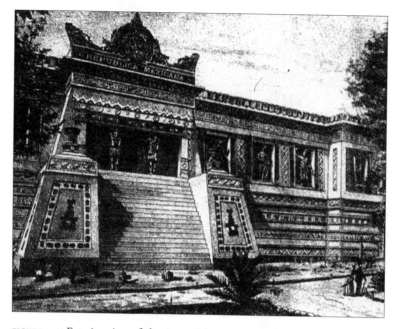

FIGURE 4.1. Exterior view of the Aztec Palace. In José F. Godoy's *Mexico en París*. Courtesy of the Archivo General de la Nación.

empire through a strategic selection of pre-Columbian representations.

In contrast to the eclectic resurrection of the Aztec past displayed on the exterior of the Palacio azteca, the building's interior offered a purely modern display of collections—meticulously divided into the exhibit categories established by the host nation's fair commission—that emphasized raw materials, geography, education, production, and science. In accordance with this totalizing image of raw materials, abundance, and ripeness for commercial exploitation, fair commission member Sebastián de Mier's retrospective observations on the 1889 fair confirm that affirmations of quantity and availability of raw materials took precedence over any pretense of selection or quality of products made from those materials:

The criterion that those favorable conditions imposed on our government in 1889 was to send everything possible to Paris, paying more attention to quantity than quality. The idea was to put on the most

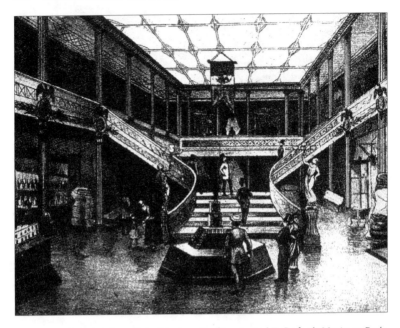

FIGURE 4.2. Interior view of the Mexican Pavilion. In José F. Godoy's *Mexico en París*. Courtesy of the Archivo General de la Nación.

complete and general exhibit possible, and thus show Europe all the natural wealth of the country, all the developed products, and all the products of its manufacturing industries, showing off both provident nature and the intelligence and skill of the workers, so that the Exposition could demonstrate our productive potential.[24]

Not to worry that the products made from the raw materials might have been of secondary quality, continues de Mier. For "countries such as ours, endowed with natural richness and lacking in capital to exploit them," the principal aim was not so much to market its own industries as to attract foreign capital for the foundation of superior ones, "in order to produce better and more cheaply, with secured profits."[25]

This transition from the outside to the inside of the Aztec Palace—from the representation of antiquity to that of modernity—requires further elaboration (Figures 4.2 and 4.3). First, there is the national reappropriation of the indigenous gods represented on the pavilion exterior

FIGURE 4.3. Alternate interior view of the Mexican Pavilion. In José F. Godoy's *Mexico en París*. Courtesy of the Archivo General de la Nación.

and their reassignation of meaning: where they had once represented European scientific hegemony and the exoticism of Mexican antiquity, they now stood for the status of Mexican national production and industry. This ability to withstand a radical shift in meaning, a quality inherent to collected objects, is precisely what enables the theoretically opposed transcendent and commercial realms to intersect. The juxtaposition of old cultural referents on the exterior with new categorizations and ideologies inside reveals the hidden underside of collecting: in the effort to preserve what has been deemed sacred (history), the addition of new contexts and layers of signification (the criteria for collection organization, for example—which will inevitably be more "modern" than the objects collected) enables the nation both to ground its new status in history and to imbue historical referents with a sense of currency and relevance. In addition, it is the capacity of the collected object to shift in meaning (or embody more than one meaning at the same

time) that allows Mexico to use the same objects to represent political consolidation and modern commercialization.

With respect to the pavilion exterior, publicist José F. Godoy reads this particular architectural endeavor as a gesture of nationalism: "If the Commission has fulfilled its commitment, if it has managed to restore in this project the most important relics of ancient Mexican art, it will have performed an act of true patriotism."[26] Indeed, there are within the fair archives several references to the transcendent nationalism represented by this architectural piece with which engineer Luis Salazar proposed to found a new and specifically national architectural style. Ironically, however, the pavilion's exterior more closely mimicked the logic of the market than that of the museum. In other words, by appropriating European renditions of Mexican antiquity, juxtaposing disparate architectural styles, and standing as a temporary structure on the Parisian fair grounds, the exterior of the Palacio azteca embodies the transience, the substitutability, and the instability of commercial value.

Equally contradictorily, the interior of the pavilion, composed largely of manufactured goods and perishable raw materials, appropriated the aura not of a marketplace but of a museum exhibit. In an overwhelming attempt to override the bric-a-brac assembly referred to earlier by Sebastián de Mier with a disciplined and universal legibility, the cataloged exhibit of the interior followed a model of standardization—predetermined and distributed by Paris officials—that divided the objects into groups, subdivided them into classes, and then further subdivided them into the contributions of individual states. The individuality of the items, on which such attention is placed on the building facade, is inside subsumed under the guise of the generic "piece" through the assignment of numbers to each object and their organization into lists. In assigning a number to each object, the viewer's attention is deviated from thing to abstraction—producing what Baudrillard would call the "serial" perspective—which sublimates otherwise unrelated and decontextualized objects into members of a category:

Group II: Education and Teaching—Material and Procedures . . .
Class 8: Organization, Methods and Instruction Material
State of Aguascalientes.
469. 89a. The State of Aguascalientes, by González, 1 vol.
470. 89b. Elements of Chronology, by C. López, 1 vol.

471. 89c. Ethnological Essay of the State, 1 vol.

472. 89d. Code of procedure of the State, 1 vol.

473. 89e. Eulogy of Doctor J. Calero, 9 notebooks.[27]

Furthermore, the meticulous categorization and precise division of produce and material productions into geographically and chronologically organized charts and graphs suggests a stability of meaning that more closely mimics the permanent *museum* exhibits of the era rather than the whims of commercial value. The materials displayed in the pavilion's interior were used both to represent something inherent or essential about the Mexican nation and to point fairgoers toward projections of a future state of "completion" (understood to be a competitive level of national modern development). In this way, this particular world's fair exhibit quite literally exemplifies the ways that the collector's logic can be used to explain Mexico's simultaneous edification of a national patrimony and its flirtations with commercial enterprise.

Competitive Spaces

Despite the intricacy of detail that would allow for exclusive concentration on only the fair pavilion structure, it is essential to consider its strategic placement both within the fairground plans as a whole and with respect to neighboring national pavilions. As in the case of the archaeological objects of the Galería de Monolitos mentioned in chapter 2, space and placement have symbolic as well as practical implications for the exhibit. In fact, the space allotted to the Mexican fair commission is revealed in fair correspondence to be just as important as the overall edification of the national exhibit itself. During the conceptual phase of the Exposition Universelle prior to its opening, certain fair commissioners representing Latin American nations became concerned with the space allotted to the Latin American exhibits. In a written report to the *secretaría* of the Mexican delegation for the 1889 Paris fair, chief commissioner Manuel Díaz Mimiaga writes of a consensual discontent among the invited Latin American nations with respect to the territory to which they were assigned:

Sr. Cristanto Medina had the good will to come to my house to tell me that he and some other General Commissioners from diverse

Hispanic American countries, finding the ground around the Avenue de Suffren to be too narrow to construct their respective pavilions, have agreed to declare to the directors Berger and Alphand that the place is not acceptable, and that they desire to be given the necessary land from the parts designated for gardens in front of the Palace of Liberal Arts and next to the Eiffel Tower.[28]

Besides the narrow land, continues Díaz Mimiaga, the reason for this petition for a new space allotment has to do with augmenting the possibilities of "interest" and "success" of the Latin American exhibits by strategically distancing them from the European and U.S. pavilions and thus reducing the possibility of unfavorable comparisons. There is an irony to the politics of space and presence witnessed here: one argues for representative autonomy when the ultimate object is social membership.

The nature of this agreement—to ensure that the designated territory for the Latin American expositions would constitute a space "of interest" within the international parade of pavilions—implies neither an undifferentiated alliance nor a composed resignation on the part of the Latin American nations to form an unproblematic, seamless equivalency with respect to one another at the fair.[29] The actual physical territory was a point of contention for the Latin American nations, and also, the abstract or conceptual space as initially defined and administered by the French hosts threatened to neutralize any possibility of individual agency for these nations.[30] In his "confidential letter about the next International Exposition of Paris" (1889) to the Mexican fair committee, Crisanto Medina, the member of the Legation of Guatemala cited earlier, expressed great concern over the question of ensuring the creation of individual syndicates for each participating Latin American nation. Referring back to the one Spanish American Syndicate that had been created for the 1878 exposition, also hosted in France, Medina writes:

> You will remember that back then the French *imposed* on us the Hispanic American consortium, and that the syndicate, which to a certain point took away our independence and ability to act, produced results that left much to be desired. Since then I have been opposed to a syndicate of that nature because of the problems that we faced then and that I had foreseen. I think the French administration not only lacks the right to make such a request, but also that it would

breach the rules of courtesy and politics to demand as a condition for participating in the encounter that their Hispanic-American guests form only one body.[31]

This same preoccupation with individual space allotments and autonomous national representations is echoed in the Mexican fair commission's ultimate decline to participate, on the invitation of a Monsieur Millas, in the creation of a "Public Industrial and Commercial Museum, formed especially with natural products from Latin America."[32] Such initiatives, writes Mexican diplomat and chief fair commissioner Manuel Díaz Mimiaga, had already been undertaken in Havre, Liverpool, Amberes, and Hamburg, with few benefits for Mexico because of the bias of the managers, who gave unfair preference to the producing countries that most interested them individually without paying proper attention to the rest of the exhibiting nations. For this reason, continues the fair commissioner, it "doesn't behoove Mexico to confuse its products with those of other countries nor to initiate competition in such limited terrain."[33] Proposed as an alternative was the idea of setting up a series of merchant museums (museos mercantiles) within the Mexican consulates of key cities within various countries considered to be prime targets for initiating or increasing the exportation of Mexican produce: Germany, Belgium, Spain, the United States, France, Great Britain, Italy, Portugal, and Switzerland.[34]

Judging from these observations, it seems that autonomous representation at the fair was considered key for both increasing the interest and attraction to the exhibits offered by individual participating Latin American nations and for the creation of a spirit of fair competition among those nations of similar rank. In this spirit, Mexico acquires a competitor and point of comparison with Argentina, as confirms Díaz Mimiaga:

> It is generally believed, and with good reason, that our country along with Argentina would be the two that will attract the most attention because of the importance, variety, richness, and interest of their natural and industrial products.[35]

As objects of one another's gaze in the spirit of interested competition, Latin American nations justify their respective cultural autonomy to the

international audience by demanding the proper space concessions. In this gesture, individual nations (rather than ex-colonies) assume their respective positions within the scope of the imagined space of the international trade circuits.

On the basis of the stories that have surfaced with respect to the collections studied thus far, it appears that representation itself undergoes a shift from medium to subject in nineteenth-century Mexico. From this perspective, it is not so much the exhibit or the series of products in question that calls for attention as it is the spatial, categorical, and abstract implications of self-representation itself as exercised from within a set of externally and internationally determined standards. The modes, places, spaces, and contexts of display occupied center stage in the debates surrounding the exhibition culture of the late nineteenth century in such a way that implies representation itself as the subject of the Mexican construction of modernization. Though the same may be said indeed with respect to the hosting nations of late-nineteenth-century and early-twentieth-century world's fairs, particular to the case of Mexico was the need to reconcile the colonial past and melancholic symptoms of an underdeveloped nation with the hypercelebratory landmarks constructed for these events. If the subject of national and international scrutiny was indeed the question of representation itself, then the object, in turn, or the language or medium through which the new techniques of representation gathered force and achieved communicability, was the nation. This spectacular form of displacement—the exhibit as subject rather than medium—posits the collection not merely as a set of things organized according to a determined logic but also as a generator of both transcendent and practical, consumable meanings for the Mexico of the Porfirian regime.

5

Collecting Numbers:
Statistics and the Constructive
Force of Deficiency

⚙ ⚙ ⚙

One of the less obvious mediums through which the Mexican Por-
firiato constructed and disseminated an image of nation during the late
nineteenth century, observes Mauricio Tenorio-Trillo in *Mexico at the
World's Fairs,* was through statistical representation. An offspring of the
Enlightenment and the French Revolution, the practice of statistics had
undergone a transition in function from a descriptive role in geographical
studies to a directive one when applied to the social and administrative
realms as informed by disciplines such as criminology, hygiene, mortality,
education, agricultural production, and communications.[1]

Simultaneously descriptive and solicitous, the display of statistical
tables allowed the Porfirian elite not only to demonstrate the administra-
tive mastery necessary to perform visually at a competitive level along-
side the nations of economic hegemony at the late-nineteenth-century
world's fairs but also to "convince Europeans of Mexico's possibilities
for investment and advantages for migration."[2] Contextualized within
a study of Mexican participation in the world's fairs, with emphasis
on the World's Exhibition of Paris in 1889, Mauricio Tenorio-Trillo's
study reveals the dynamic pursuits of the Porfirian *científicos,* who were
driven by the impetus to represent both the nation's real and imagined
(projected) modernizations by participating in the universal diction and
grammar of the sciences—including statistics and all of its products.[3]

In contrast with the impressive statistical data displayed at the world's
fairs, however, the memos and internal governmental correspondences
that surround the emerging statistical compilations of late-nineteenth-
century Mexico reveal multiple references to an obstinate state of national

deficiency. The rhetoric employed in the governmental correspondence between roughly 1880 and 1910 frames modernization through statistical building as a type of compensation for a persistent state of lack—not of resources or potential but of access (to areas in need of statistical representation), consensus (in terms of disseminating the importance of constructing a national statistical representation or how to go about doing so), and representative standardization (with respect to data formatting). Rather than only an exercise of self-deprecation, however, the rhetorical use of deficiency also functions along the same lines as it did in the context of national archaeology in chapter 2 and again in the case of the fallen national martyr in chapter 3: as an essential and constructive component to the persuasive vision in which lists of things and their physical and material referents come to generate transcendent meanings about the nation. In this light, the statistical table became a type of map to progress with blank spaces to be filled—an embodiment of the project of creating a unified (fully inventoried) national territory and, conversely, the product of an irreducibly heterogeneous state and its continuous return to the unfulfilled condition of partial inventory. In the ongoing negotiation between those extremes, statistical representation helped define a way of viewing and displaying the unruly and defiant national landscape as a manageable possession.[4]

Building on Tenorio-Trillo's focus on the projection of national data through international lenses, I have focused here on the proposals and negotiations that surface at the gathering end of Mexico's late-nineteenth-century statistical pursuits as revealed in the archives of the city hall's internal correspondence within the administrative circles of the Porfiriato. This is not to say that the implied and ever-present international lens did not factor into such correspondence—these statistics were by nature comparative and used largely for commercial purposes, as both Tenorio-Trillo and Robert Aguirre (in his observations regarding the European explorers' reduction of the objects, people, and geographic features of the New World to usable "inscriptions" or "flat packages of information") have well explained in their respective studies.[5] Rather, I will explore here how the universal vocabulary of statistics was conjugated within national boundaries and in correspondence geared toward both internal administrative entities and national public sectors connected to print culture.

The Secular State: Guardian of Order

When Mexican positivist Gabino Barreda presented his educational re-
form plan to a commission of the newly triumphant Juárez government
in 1867, he altered the Comptian doctrine of "love, order, and progress" to
a formula more appropriate for post-Reforma Mexico. "Love, order, and
progress" was replaced with "liberty, order, and progress," emphasizing
the idea of an individual and spiritual freedom that would result from
the new, secular role of government. As described in the introduction
to this book, Barreda argued before an audience of both liberal and
conservative persuasions for the state's adoption of scientific knowledge
as the educational ideal as an alternative to ideology. Therefore, argued
Barreda, the government was obligated to release any and all forms
of ideological endorsement. Its sole function was to ensure national
stability by performing its role as a passive "guardian of order," which
would ensure social stability and free the individual to express opinions
and hold particular beliefs.

Leopoldo Zea summarizes this passive, archival role of the liberal–
scientific state in the following terms:

> Material order represents the least noble, that to which the ambitions
> of Mexicans should least extend their efforts. This task was commend-
> ed to the state. The state should not be any other than the *guardian
> of material order,* so that in this way a full spiritual liberty would be
> possible. Every Mexican was free to direct his/her conscience; the
> new education would not try to intervene in the internal order of
> Mexicans, but rather only to make them conscious of the *need that
> a material order should exist,* so that in this way the ordering labor of
> the state should not be inhibited.[6]

In the privileging of "order" as a philosophical and political orientation,
the status of national statistics acquires a powerful discursive force that
places it in direct analogy to ideal governing. Along with the national
painterly canon, the nationalization of archaeology, the erection of a
series of historically themed commemorative monuments, and the ex-
ercises in collecting that fed into world's fair exhibits, statistics emerged
in the political sphere of nineteenth-century Mexico as the solution to a

sociopolitically, geographically, and linguistically fragmented nation. Its apparent lack of ideological association promised to quell tensions between liberals and conservatives and also provided a framework through which to construct the first all-encompassing representations of local, regional, and national territories via the statistical table's juxtaposition of disparate categories, temporal frames, and accompanying explanatory narrations.

A brief overview of statistical and developmental activities in Mexico during the first half of the nineteenth century reveals several key overlaps between the development of statistics and national consolidation and modernization, which also include the drawing of official internal territorial divisions, the standardization of primary school education, and the commercialization of the Mexican Railway. As early as 1833, the year of the creation of the national library, the Dirección de Instrucción Pública,[7] and the Instituto Nacional de Geografía y Estadística, professor and politician Manuel Ortiz de la Torre published the first treatise in which he spelled out the requirements that would be necessary to create a national statistics.[8]

Although rendered in textual format, the strong visual quality to Ortiz de la Torre's work anticipates the impact that statistical production would have on the creation of a powerful series of *conceptual* national images. The suggestion or *idea* of a national image—the collagelike, kaleidoscopic picture that the viewer gleans from statistical graphs and diagrams—is every bit as powerful, given its direct association with scientific truth, as the material forms of national collections viewed thus far. Ortiz de la Torre's report or "analytical note" *(nota analítica)* consisted of a sixty-five-point plan that distributed the data solicitations into three broad categories: raw nature, civil society, and political administration. While the *nota* reads in a straightforward and linear manner for "ease of comprehension," the author included an alternate, graphlike outline in the margins of the report in a first effort to address the issue of how to visually configure large amounts of information into a standardized, meaningful, and transmitable format.[9] The text itself is also laden with a rich and suggestive visual appeal; witness, for example, point 4 on the checklist, which contains a guide for describing Mexican soil:

In terms of its *appearance*: the following will be described: 1. The *ground* in general, going through all of its points, and manifesting all

of the varieties that present within these: concerning the material of which it is composed, which will be professionally classified, if possible, and if not, presented in lay terms: rock or stone, *tepetate,* mud, lime, sand, *tequesquite* etc., the color of these materials, the smell and particular flavor for those which have it; the hardness, weight, viscosity and all other sensitive qualities: concerning the plane or inclination that presents, that is, where the ground stays level, where it declines and where it rises: and in terms of the objects that cover it: namely, settlements or farmhouses, waters, forests or groves, weeds, grasses, planted fields and all sorts of labors.[10]

In 1850, the Sociedad Mexicana de Geografía y Estadística was created through the merging of the Comisión de Estadística Militar (created 1839) and the Instituto Nacional de Geografía y Estadística to further the pursuit of national statistics and also to complete the first general map of the republic. In 1853, the year of the first International Congress of Statistics in Brussels, organized by the famous Belgian statistician Adolphe Quetelet, the Secretaría de Fomento was formed in Mexico with a branch created specifically for the purposes of creating a national statistics.[11]

A series of publications ensued in the decades leading up to the 1880s such as geographer Jesús Hermosa's *Manual de Geografía y Estadística,* which coincided with the constitution of 1857 and declared that the unified territory of Mexico was composed of twenty-four states. In 1874, one year after the liberal reform laws were merged with the constitution and commercial services on the Mexican Railway (which ran from the capital city to the port of Veracruz) were initiated, the first elementary course in statistics was published by author José María Pérez Hernández in an effort to encourage the incorporation of the discipline into the mandatory primary school curriculum.[12] Similar developmental parallels between statistics and national infrastructural development describe the 1880s; among the more important coincidences, as observed in the *Cronología de la estadística en México,* would be the Mexican Telephone Company and the Dirección General de Estadística, both of which were created in 1882.[13]

Incomplete Data

Paralleling the published advocacy for a renewed pursuit of the national arts as seen in chapter 1, it appears from certain newspaper publications that despite both the tremendous efforts made toward the pursuit of Mexican statistics and the enthusiasm espoused by believers in the mid- to late nineteenth century, local and regional Mexican governments (along with much of the general public) had yet to be convinced of the direct correlation between statistical gathering and public welfare. In fact, the lack of a unified and coherent national effort behind statistical gathering was producing a perpetually incomplete and faulty set of data that could not be used to calculate more than an approximate idea of the branch of national resources or infrastructural category in question, much less for administrative purposes.

The persistently inaccurate census, claims one writer in a newspaper article published in 1878, produces a domino effect in which the gaps in the inventory of businesses, goods, and resources lead to uneven taxation and distributions of wealth, thus ultimately impeding both fair governing and national progress. The initiation to compose a national census had begun in 1862, when a military official by the name of Rafael Durán was commissioned for the project, the results of which were published in the bulletin of the Sociedad Mexicana de Geografía y Estadística that same year.[14] An effort was reinitiated in 1868 after the liberal triumph under Benito Juárez, which produced "scarce results."[15] Notwithstanding the efforts of over a decade to compile and archive accurate information, then, the need for a consistent and unified effort to produce an exhaustive and standardized system of statistical representation had not yet been met:

> Among us, the attempts made until today have been quite imperfect. Some states have tried to make their efforts, and truly important facts are to be found disseminated in the archives of local governments, works which are not circulated amongst the hands of all [but rather] which are only seen by the curious, to whom more often than not is applied the name of fanatics.[16]

The point is not to produce a perfect product, continues this writer— "because that just cannot be done"—but rather to commit as a nation to

continually cultivate this discipline and rectify errors "every time [one] is discovered." With respect to this particular national collection, then, it was necessary to make the collective transition from the pursuit of statistics as an idiosyncratic pastime to a systematic discipline. If a perfected product was not yet possible, then it was through of a type of cultivated balance between data accumulation and systematic error correction that Mexico could claim a viable position within the march of progress.

In yet another manifestation of the collection's strong concern for placement, the need for format standardization in the gathering and recording of statistical information was of primary concern (Figure 5.1). Like the privileging of object arrangement as a generator of meaning in the context of the Museo Nacional, much of the correspondence that accompanies the administrative pursuit of statistics during the Porfiriato is geared toward figuring out the proper formula for compiling, arranging, and ultimately ensuring the availability, legibility, and usability of the gathered data.

In an 1885 memo addressed to the Ayuntamiento of the Distrito Federal,[17] Ramón de Prida y Arteaga of Prida, Navarro, and Company announced the formation of the Commercial Agency of the Mexican Republic, composed of *científicos* Alfonso Lancaster Jones (lawyer, diplomat, and politician), José Yves Limantour (future secretary of finance in Mexico from 1893 to 1911), Feliciano Navarro, and the author himself. The principal aim of this company was to organize the data produced by the Secretarías de Hacienda y de Fomento and other governmental agencies, "to form and follow in its constant movement the general Statistics of all of the branches that constitute the national resources, whose statistics will be the foundation and guide of its endeavors."[18]

In an effort to fulfill this task, the new agency invented several serial publications, including the annual *Dictionary of Statistics of the Mexican Republic* (with a nearly exhaustive span of coverage from geography to natural resources to transportation infrastructure), a monthly memorandum to cover the movement and fluctuations of the resources included in the preceding, and a weekly bulletin covering issues related to economy and administration, which was to be published in Spanish, English, and French.[19] The finished works would be regularly distributed to the archives of the Ayuntamiento, the Secretaría Municipal, the administration of Rentas Municipales, and the Dirección de Obras Públicas, where they could be accessed publicly.[20]

DIRECCION GENERAL DE ESTADISTICA

DE LA

REPUBLICA MEXICANA.

C. Ingeniero Manuel Fernández Leal, Secretario de Fomento.

Tengo la honra de presentar á vd. el segundo Anuario Estadístico
correspondiente al año de 1894.

El presente Anuario comprende las materias siguientes:

Situacion, límites y superficie del territorio.

Coordenadas geográficas de varias poblaciones.

Poblacion aproximada de la República.

Movimiento de poblacion en el año de 1893.

Defunciones ocasionadas por las enfermedades de tifo y viruela en el
o de 1894.

Resúmen de la mortalidad habida en la Municipalidad de México
rante los años de 1868 á 1894.

Movimiento de enfermos habido en los hospitales de la República.

Marcas de fábrica y de comercio registradas durante el año de 1894.

Patentes de privilegio expedidas durante el mismo año.

Introduccion de efectos nacionales y extranjeros á la Capital en el
quinquenio de 1889 á 1894.

Importacion en los años fiscales de 1892 á 1893 y de 1893 á 1894.

Exportacion en el quinquenio de 1889 á 1894.

Reses, carneros y cerdos sacrificados para el abasto de la Capital
durante los años de 1878 á 1894.

FIGURE 5.1. Photograph of the index page of the *Anuario Estadística*, corresponding
to the year 1894. Listed here are such details as territorial divisions, geographical
coordinates of various populations, an approximate census of the republic, and im-
ports and exports from 1893 to 1894. Courtesy of the Archivo General de la Nación.

Read together, those memos of the *Memorias de Fomento* that emphasize the need both to standardize the tables through which the statistical reports were submitted and to generate a working system for data collection draw attention to the categories through which the status of the nation was assessed during the closing years of the nineteenth century. The *boletas* or data reports that were distributed to local and regional governments determined a priori the groups and sets of things that would be classified together and deemed representative of local (and national) resources and infrastructures. Because of the large number of questionnaires and statistical "skeletons" (blank numerical reports that, when filled, would be used to generate the statistical reports) in circulation, which, according to the *Memorias de Fomento,* ranged in topic from flower production to criminal reports, it was difficult to create a working system for data collection. Owing to this issue and to illustrate the need for a revised plan for data collection, one handwritten memo from the Sala de comisiones from the year 1897 lists the number of separate petitions for data in circulation at the state level:

No. 1: Urban railways: width and extension of the tracks and places in which they are established

No. 2: Telegraphs: Number of offices, extension of the cables and classification; telephones—the same data

No. 3: Industries: Classes, Primary Materials, headquarters and summary of the establishments

No. 4: Day wages and Salaries: in Agriculture and Mining as well as the Arts and Trades

No. 5: Livestock in their diverse species: Cattle, horses. Mules and donkeys; pigs and sheep

No. 6: Fiscal Value of Urban and Rustic Properties

No. 7: Public Rents of the State and its Municipalities

No. 8: Libraries: Number of works that they have, as well as the number of volumes, number of visitors, etc., funds upon which they subsist

No. 9: Museums: Object to which they are destined; funds upon which they subsist

No. 10: Hospitals: Movement—of men and women and news of recoveries and deaths

No. 11: Scientific and Literary Societies
No. 13 [sic]: Scientific Professions—Number of people who practice with and without a legal title
No. 14: Movement of the [population of] offenders in the jails—
No. 15: Public officials who practice civil and military justice
No. 16: Deaths caused by syphilis and smallpox and the number of people vaccinated.[21]

These categories illuminate not only the classifications that granted a selection of professions, products, and infrastructures national and international public visibility but also the implication of additional dimensions of meaning when the displayed series is intended to mean more than the sum of its parts. In fact, it is because of the discrepancies in attitudes about what system of meaning to assign to it in nineteenth-century Europe and Mexico—the descriptive or the deterministic—that statistics remained a controversial topic.[22]

Stories Statistics Tell

As lawyer Roberto A. Esteva Ruiz (member of the Sociedad Mexicana de Geografía Estadística) explained in a speech prepared for the president and high associates of the Boletín de la Sociedad Mexicana de Geografía y Estadística in 1900, opponents of the statistical claim to truth viewed statistics not as a science but as a method—a brute material accumulation that excludes the possibility of (nonfictitious) interpretation unless appropriated by another science. For its advocates, however, statistical data provided the material through which social phenomena could be clarified and remedied. Both parties, argues Esteva Ruiz, are mistaken in their reductive conceptions of statistics. A science in itself as well as an indispensable methodical instrument for other disciplines, statistics is not limited to a descriptive function but exercises an explanatory one as well. The influence of statistics, far from restricted to social phenomena, extends to all scientific disciplines through the provision of "quantitative explanations" for diverse phenomena.[23]

For Esteva Ruiz, the transition from number to explanation occurs in the process of placement or arrangement of statistical data—an observation that not only routes through much of this study but also

anticipates Edward Tufte's work on the visual display of quantitative information that would be published in the United States nearly a century later. In a manner that recalls Mieke Bal's connection between collections and narratives, Ruiz argued that it is through decipherable patterns of numerical data over a period of time that quantification acquires its explanatory dimension. In the statistical display, the arrangement or placement of numbers alongside one another acquires a significance that renders the individual element meaningless on its own and yet saturated with value when placed into a series. In other words, unlike the other genres of collections investigated thus far, the fragment of statistical data was an a priori serial entity from its conception—meaningless on its own, yet potentially powerful enough to shape policies on the national scale when properly arranged and displayed. The statistician extracts meaning, or, using Ruiz's words, "the profound knowledge of society," from the negotiation between accumulation and arrangement.

In addition to the transposition of statistical data into specific instances of meaning, there were also perceptual implications that emerged from the format of the statistical chart during this time, when various social and geographical features were finding representation for the first time. For the viewer, the power of this mode of display—which found its way into national newspapers as well as the larger exhibits put together for world's fairs—resides in its conceptual collapse of the gigantic and the miniature. Here the gigantic can be understood as the represented geographical or sociological feature and the miniature as its conversion into numerical symbol. In this transition of thing to number and its subsequent visual consumption, the boundaries of the viewing self are extended in a type of figurative vacillation between the miniature, concise chart of numerical tables and the "infinite reverie" of the gigantic landscape.[24] In this figurative swing in perspective, the viewing subject occupies both a transcendent perspective—one that assembles, inductively, a specific vision of the nation or part of the nation—and the perspective of the floating observer, who is in turn swallowed by an imagined expansive landscape scene (such as one of José María Velasco's many representations of the Valle de México, as referenced in chapter 1). In statistical displays, the nation reveals itself as both a consumable entity and a sublime, extended territory. Its ability to encompass both of

these extreme perceptual boundaries made this form of representation quite powerful at a time when concrete and totalizing visual images of the nation were still quite new.

Thus far, it seems that the argumentative pull of the statistical representation is generated from two fundamental beliefs. First, there is the idea, as Mary Poovey also observes with respect to the bookkeeping ledger in early modern Britain, that the number is a direct embodiment of truth.[25] Second, there is the association that emerges between the twin processes of data accumulation and arrangement and the assumption that they together constitute a valid system of generating knowledge. On the international scale, Mexico was positioned in such a way that the *científicos* sought to introduce the nation into the global commercial agenda neither as a colony nor as a newly autonomous and warring state—both of which reflected the nation's not-too-distant history—but rather as a possible peer. On the local front, the snippets of statistical tables and general reflections on statistics that were published in such newspapers as *El siglo XIX* and *El Monitor* (such as "Report on Animal Sicknesses" published in *El siglo XIX* in June 1878 or "Approximate Calculation of the Manufactured Production of the Republic" in *El Siglo XIX* in September 1878) had to be persuasive enough to convince a heterogeneous general public of the legitimacy and importance of contributing to this national project (Figure 5.2). In both cases, the liminal position of a recently consolidated and modernizing nation-state is mitigated through its assumption of a type of narrative that is particularly suited to collections of things.

Applying Mieke Bal's ideas as expressed in her essay on the "narrative perspective on collecting," it seems that the story into which the systematization of collecting fits—with the shift in perspective that it enacts from part to whole, from incompletion to completion, and from the individual to the serially related object—is especially accommodating to the Mexican nation during this time.[26] Straddling the poles of what it no longer was (a state that had not stabilized politically since independence) and what it was yet to become (for the Porfirian project, a fully consolidated and modernized sovereignty with its own ascending position within the international economic hegemony), Mexico's politics of ordering material things at this time allowed for stories of origins and future projections to write over the deficiencies of the present state.[27]

ENFERMEDADES REGIONALES.						
ESTADOS						
Aguascalientes		24	8		4	1
Baja California		96			1	8
Campeche		178	2		1	1
Coahuila		184	45	43	12	39
Colima		76	166	29	49	31
Chiapas	3	88	28,072	10	173	55
Chihuahua		149	7	2	65	31
Distrito Federal		187	4	20	1	1
Durango		297	68	73	336	101
Guanajuato		419	100	218	8	49
Guerrero	9	155	90,976	104	693	267
Hidalgo		447	76	43	614	74
Jalisco		266	881	823	824	324
Michoacán		727	20,947	200	1,262	868
México		466	61	22	7	12
Morelos	32	137	8,087	11	28	9
Nuevo León	4	394	74	36	191	45
Oaxaca	149	640	2,821	74	449	263
Puebla		703	3,250	35	909	24
Querétaro		241	6	30		11
San Luis Potosí		688	85	58	98	21
Sinaloa		228	120	144	424	122
Sonora		38	27	2	43	25
Tabasco	4	127	1,747	12	91	15
Tamaulipas		198	4	1		2
Tlaxcala		29	8	8	6	4
Tepic		161	225	82	39	38
Veracruz	150	1,086	1,588	24	935	23
Yucatán	10	529	12	13	3	16
Zacatecas		327	72	75	6	21
TOTALES	361	9,234	158,489	1,656	6,672	1,999

NOTA.—Estos datos podrán completarse para el próximo *Anuario*.

FIGURE 5.2. Statistical table of deaths related to disease (tuberculosis, hookworm, leprosy, goiter, hypothyroidism) organized by state, 1895. The note at the bottom of the graph reads, "These data will be able to be completed by the next *Anuario*." In the third *Anuario Estadístico* of 1895. Courtesy of the Archivo General de la Nación.

A quasi-religious belief in the healing powers of statistics and the sciences in general (as explored in chapter 2 with respect to archeology) was embodied and ritualized in the late-nineteenth-century collection and display of numbers and objects. The point here is to realize the power of the inventory—the acts of cataloging, listing, and surveying that, despite holes and inaccuracies, constitute concrete practices that fortified the persuasive power and status of the nation.

The Problem of Inaccuracy

Despite the great efforts made to gather, compile, report, and file data in a methodological way during this time, the problem of standardizing a homogeneous format for the multiple (and steadily growing) divisions that together sustained the national project of statistical gathering proved difficult. As a result, the administrative correspondence of the last twenty years of the nineteenth century repeatedly addresses the problems caused by this consistent lack of cohesion. In the *Dirección General de Estadística,* director Antonio Peñafiel's annual report on the agricultural production of 1894, for example, the diverse formats through which some states persisted in submitting their information had produced results that were not entirely useful:

> It is lamentable that the majority of the tables are deficient; this depends on whether or not the data are provided, or that they are received late and it's no longer possible to make them figure in the respective tables; furthermore, some data are submitted in a different format from that which was made available from the Secretaría and without adherence to the models of this Administration, which you will see in the branch titled Movement of the Population, which emphasizes the lack of uniformity that is required in statistical works, so that the data can be comparable and used in the diverse studies to which they may be applied.[28]

Already in 1880, this question of formatting was addressed in a memo directed to the Secretaría de Fomento, where the difficulties of compiling an accurate census were linked to the inadequate format of the municipal registers that were circulated. "Lots" of money was spent each year on the development, printing, and distribution of the official register, and this effort had failed to produce accurate data. Information regarding the "age, sex, and gender, and other conditions that the register attributed to the individuals in many cases are not true, and from there [arises] the confusion and disorder in this particular branch."[29] Each year, wrote the author of this memorandum, despite the fact that the official tables were regularly sent out, the problems of accuracy resurfaced on a daily basis.[30] Special commissions were created in an effort to address

this problem, and a report filed two years later indicates that "insurmountable difficulties" prevented the collection of accurate information, including the "heterogeneous character" of the branches relating to national population and wealth and the "multiplicity of the offices to which one must turn in order to pick up the data that are needed."[31] Indeed, the problem of information inaccuracies was enough to provoke an invitation to the general public to participate in remedying the problem. Antonio Peñafiel laments the "great portion of inexactitudes" and "absolute lack of precise details" that he confronts on glimpsing the General Statistics of the Republic. The difficult work required to compile these data, he wrote, would be made much easier if citizen travelers would simply record their findings while otherwise pursuing their journeys:

> Great are, certainly, the difficulties that the acquisition of these facts presents, and very long the time that is needed in order to gather them; but this job would be made much easier if all travelers took the time to take some notes upon crossing the populations and ranches of their path. It is very simple, in fact, to take down the general aspect of a population, its orographic situation, the distinctive character of its inhabitants. It's very easy, equally, to approach the markets, and see the class of fruits that are expended, to ask their prices and origin, etc., and if to those notes are added some data taken from the *curatos,* from the city halls and from the mouths of the doctors of the place, enough will be gathered to advance the Statistics of the country.[32]

As a result of the insurmountable difficulties that presented themselves when it came to gathering data, wrote Antonio Peñafiel (director of the Dirección General de Estadística) in his preface to the first *Annual Statistical Report* of 1893, including time constraints, reprinted data, and confusion caused by the juxtaposition of data pertaining to different year calculations (the fiscal and the natural), the president of the republic had consented to replacing the monthly bulletins for yearly reports.[33] Even those, however, were often incomplete or disorganized, with data either missing or submitted according to the wrong formats, the yearly report thus serving only to give an "approximate notion" of such high-priority categories as agricultural production and the national census.[34]

Publications such as the famous geographer Antonio García Cubas's *Cuadro Geográfico y Estadístico* (1884) offered firm support of statistics and its ability to steer the Mexican nation through obstacles inherited from the colonial past and onward to achieve the goal of prosperity. However, as far as more widely circulated public endorsements and criticisms of statistical administration were concerned, attention was also drawn to the problems of information accuracy and the question of whether politics or statistics held the upper hand when it came to claiming a truth. In 1883, "Junius," a pseudonym for the *modernista* poet and frequent periodical columnist Manuel Gutiérrez Nájera, attempted to shed light on the blind spot of what constituted statistical authority. In a debate with Ignacio Altamirano over the question of mandating a system of public education, Junius draws the question of authority away from the collection of numbers intended to "speak for itself" back to the subjective position of the beholder.

The interpretive exercise behind any statistic, argues Junius, hinges favorably on administration, to the detriment of accuracy. The power of authority and the "right to interpret" result not in numbers generated from observing nature but rather an a priori interpretational bias. Junius recalls the famous anecdote of a well-known (unnamed) statistician who worked with his father on the geography and census of the state of Guanajuato:

> How many inhabitants does Guanajuato have, son?
> —Seven hundred thousand, Papa.
> That calculation seems exaggerated to me: I think that there aren't more than three hundred thousand.
> —No, Papa, seven hundred thousand.
> Well, look, son, let's split the difference: neither you nor I, eh? We'll put four hundred fifty thousand.[35]

Despite the critical aim of this anecdote, however, which not only portrays statistical reporting as frivolous, speculative, and inaccurate but also draws attention to its central place in the formation of an idea of nation as a knowable, representable entity, it is also the case that the open acknowledgment of imperfections and flaws was hardly new to the introductory comments and narratives that accompanied statistical

publications. Reaching back to Jesús Hermosa's *Manual de geografía y estadística* in 1857, for example, the geographer grounds his preface in a partial apology for the "errors and defects" of the manual in such a way that anticipates and contests reader criticisms while creating space for the contribution to national development that his publication represents: "We have undertaken the task from the beginning, endeavoring to give an idea, although in compendium form, of the country and all its parts: for which reason we hope that the public may forgive the errors and defects of the Manual."[36] While the missing components and the question of standardization may be unresolved, the indispensability of statistics—based on its presumably transparent relationship to knowledge (a subject that was also debated)—is firmly planted here.

Opportunities in the Gaps

As Mary Poovey observes in her study of the development of the modern fact in Britain between the sixteenth and early nineteenth centuries, the type of knowledge in question here is no longer so uniformly that of irrefutable universal principle but rather one that incorporates inductive principles of empirical observation into a claim to higher truth. As in the case of the exaggerated phallic objects of the National Museum's *Salón secreto,* the part becomes empowered when it replaces the whole in its relationship to signification. And whereas in some cases (such as the example just mentioned), this redistribution of visual power can lead to the suppression of the "part," in others, like the incomplete statistical table, the missing pieces actually reinforce the quasi-religious belief in the whole and invigorate the efforts to complete it. This provability or claim to honesty via the direct association of numbers and unbiased truth is what creates space for the errors for which Hermosa apologizes and which further solidify a claim to transparency. As nothing inspires confidence more than the confession of error (along with the implicit promise to remedy), the rhetorical demonstration of honesty such as that expressed in the cited passage constitutes its ideological slant.[37] At the same time, the promise to complete the nation's inventory and thereby ensure a future with a new and heightened sense of cohesion makes space for acceptance and even faith in an imperfect statistics, just as the future-oriented rhetoric associated with both ancient and

modern pieces of nineteenth-century patrimony has sustained each of the collections discussed so far.

Even three decades after Hermosa's publication, the idea of defects, informational gaps, or logistical obstacles, far from detracting from the veracity of statistical representation, served as a testament to the credibility of the information gatherer. Furthermore, those errors or blank spaces in statistical information regarding national resources, for example, could be used as propaganda. In late-nineteenth-century publications destined for both national and international reading publics, such informational gaps presented opportunities to remind potential investors that despite the correlation that relates geographical feature to number, the former always exceeds the latter: "So vast is the field that the territory of the Republic offers, with respect to its fauna, that it is impossible to extend [the following list] without exceeding the proper limits of this work."[38]

In this case, inaccuracy favors the image of bounty and thus serves as incentive for further exploration. Vague numerical descriptions of nature, such as the words *multitudes* and *infinity*, supplement the absence of a detailed count. Though in these cases, inaccuracy pushes the question of potential to the superlative, the problem of inaccuracy becomes tempered through the marking of certain data as "nonofficial," with the explanation that, though promising, the available information fails to fit the proper criteria of the statistic. Here the confession makes space for the mention of *non*-official data that would otherwise remain excluded from the statistical manual such as the variety of still-undocumented products made from the maguey tree: "The government is currently trying to rectify all the defects which our nascent statistics contain," writes García Cubas with respect to the *Cuadro geográfico y estadístico* in 1884.[39] The inclusion of a section called *Erratas notables* at the back of this work further quells the issue of inaccuracy with evidence of the fulfillment of this promise to rectify. In the economy of balance of the statistical description, the gaps in precision are counterbalanced with the evidence of honesty.

The implication is that fragmented information produces the impression of a whole, which ultimately supplants the need for the whole itself. This idea is akin to the "infinite reverie" of which Stewart writes with respect to Noah's Ark, in which "a finite number of elements create,

by their virtue of their combination, an infinite reverie."[40] In this context, the gaps in information that preclude the totalizing account fortify that impression of wholeness not only by placing extra emphasis on the information that *is* available but also by creating space for belief where there is none.

In his deconstructive analysis of the Freud museum of London, Jacques Derrida also approaches the concept of the "impression" and its oft-overlooked capacity as a generator of meaning. First, there is the typographical impression of the inscription, which, for purposes of this book, could also be interpreted as the museum display catalog or the interpretive text that accompanies a set of statistical data—in short, the "instructions for perception" of the work.[41] In that case, there is a text that inscribes meaning, leaving its mark on the page in an ambitious attempt to record truth in words that would be more accurately described as a set of "graphic illustrations" that are ambiguous at best.[42] Second, there is the provisional notion of impression in which "a concept in the process of being formed always remains inadequate relative to what it ought to be."[43] Applied to the context studied here, and understanding the potential equivalence, in Derrida's words, between *collection* and *concept*, the perpetual status of incompletion of any given collection is what sustains its vitality and drives the collector's desire to continue the exercise of providing order to some aspect of the past. Here fits the notion of the indefatigable search for origins and its simultaneous dependency on the implicit promise of completion—a phenomenon that has proven consistent through each of the genres of collections investigated in this book and culminates most vividly in the example of national statistics.

In his "Report on the Projects of the Society during the Year of 1900," for example, Secretary Trinidad Sánchez Santos enthusiastically cites the work of a statistician who developed a study not only of all the existing industries of the nation but also of all the possible ones: "But this great glimpse into the future," he writes, ". . . is not the arid forecast of the astronomer . . . nor the authoritarian forecast of the prophet; it is the voice of truth, sung in chorus by the mouths of the sciences."[44] Baudrillard's "serial point of view"—the perspective that is invoked by the displayed series—is actualized here in its fullest capacity.[45] In this type of visual economy, two perceptual shifts occur: first, the

individual element that is present or represented (such as the number and types of existing Mexican industries) cedes visibility to the series in which it is placed. Second, there is a shift in the scale of value assigned to the objects that compose a series—the individual element starts to mean more than itself, as the Mexican industries come to represent not only themselves but the future industries as well. In this way, statistics both stand for the objects that they represent on the chart and, in the case of Trinidad Sánchez's calculation of yet nonexistent industries, transcend the object altogether. If science were to replace ideology in Gabino Barreda's original prescription for governing, in other words, it would do so by reclaiming belief as a by-product. The ghosts of what *will* exist, the errors and the gaps together solidify the statistical claim to transparency.

If statistical data manage to straddle the gap that separates thing from meaning, they do so in part by creating a space for belief within what has come to be regarded as calculable fact. Perhaps the most direct example of this intersection of faith and fact can be found in *Estadística de la República,* a yearly publication of national statistical information dating from 1877, in which Mexican statistician Emiliano Busto prefaces three volumes of categorized statistical data with a lengthy justification of their social value using a Roman Catholic metaphor.

In Busto's preface to volume I, the power attributed to statistics is expressed through a rhetorical deification of the nation and secured by the government in its ability to execute the "will" of the numbers:

> [Statistics] mark clearly and distinctly the prosperity or decadence of the sources of public wealth; they indicate the saving and healthy means to remedy the social necessities of the Territory, the Population, and the State, which is *the statistical trinity to which the great governmental machine is subject,* . . . and it will make known to what ends the energetic and saving action of the Government of the Republic should direct itself so that agriculture, mining and industry, commerce, navigation, the arts, the sciences and the population may prosper, so as to give life, progressive movement and wealth to a vast territory such as that of the Mexican soil.

Notice the shift in locus of power that is made explicit in Busto's logic: authority is worked in such a way as to posit its traditional association

(the ruler, the government) at the ultimate service of statistics, rather than the contrary. The metaphysical power of statistics lies in its apparent *transcendence* of narrative (i.e., of meaning, of the "story" or interpretation that is generated by the displayed statistical table) altogether. The narrative (interpretation) is both rendered redundant and recuperated as a mysteriously hidden quality that reveals itself through the numerical arrangement or the comparative statistical table. The immediacy of the numerical claim to truth, which surpasses even that of the collected object by both encompassing and going beyond materiality, obfuscates the slower narrative or interpretive gesture. In this way, statistics appears both to replace and to transcend narrative in the direct embodiment of truth that it enacts.

It is in fact this underplaying of the interpretive processes that precedes the elaboration of statistical fact that sparks the skepticism of critics such as Junius. What belief hides in the end are the very processes of negotiation that pave their way to the public forum while masked as facts. Junius's account of the aforementioned incident between father and son reveals the concept of fact to be ultimately defined not only by flippant arbitrariness but also by calculated negotiation.

In his current study on impersonality and objectivity in number-based calculations, Alan Megill elaborates on this idea. Far from leading to "a Babel of incomprehension and disagreement," observes this writer, the negotiations that underlie what becomes accepted as fact simply indicate that "what will count as true is worked out through the bargaining, debating, cajoling that takes place within a relatively closed community of disciplinary specialists."[46] The idea that what becomes commonly accepted as fact hides the very subtext of bargaining that sustains it likens the process of meaning making described here to the marketing strategies and compromises that provide the basis for a specialized commercial agreement. The exchange that is negotiated among the experts is that of thing for meaning, a transaction that is represented symbolically through the substitution of the object for its numerical representation. What the historical investigation of statistics helps to reveal in the case of late-nineteenth-century Mexico, then, is precisely that this notion of bargaining as the hidden subtext of truthful or accurate representation describes the underlying current of both national consolidation and modernization. In other words, these processes are only apparently contradictory in their opposing investments in the

respectively centripetal and centrifugal forces of nation and market.

In the conscious pursuit and dissemination of a general economy of knowledge, science and *patria* mutually implicate one another. The statistical table provides a type of general equivalent through which the gaps between social classes and ranks of nations may be measured and compared. In this system, the principles by which statistics moralizes a system of knowledge are implicitly economic. Like the double bookkeeping system analyzed by Poovey, the statistical system hinges on the concept of an all-encompassing *balance*. This balance—of gathered information to informational gaps, of accuracy to inaccuracy, of number to interpretation, of status to possibility—links statistics to ideological claims such as the implication of "goodness" or virtue. In García Cubas's *Cuadro estadístico* of 1884, Alfonso Lancaster Jones writes,

> None of the cultured nations . . . is less known and with less precision judged by others than ours. . . .
>
> Because of this ignorance of the physical and social conditions of the country, a certain spirit of prejudice was born, which tends to qualify its [people] and its things as always bad, without examination, and which has contributed to maintaining us in an isolation that was damaging not only to our own interests, but to those of the entire human family.[47]

The statistical table thus not only moralizes a national profile by rectifying prior ethical judgments made against it but also promises to rectify the years of isolation that the nation and world have suffered because of ignorance about Mexico. In fact, Lancaster Jones's description of statistics as a form of radical networking provides a precursor to the language of globalism that would surface over one hundred years later. Here the information dissemination that occurs through the publication of statistical data approaches the ethical realm through its association with morality, honesty, and human–family values.

The authority of statistics in nineteenth-century Mexico resides in its transferal of value from thing to meaning and its claim to noninterpretive immediacy in relation to the elements that it represents. As a direct and absolute expression, statistics naturalizes the transferability of value between thing and symbol, and it is through such recodification

that the raw geographical feature becomes indicative of a yet non-existent industry or that several different populations of indigenous people become (theoretically) integrated citizens. Indeed, the logic of the collection into which the practice of statistics feeds announces the mass conversion of the individual object into an undifferentiated member of something bigger under the signifying economies of order and homogenization. In the realm of statistics, the highest realization of the collection is actualized in the shift from an assembly of things to one of numbers: through the conversion of thing to number and the subsequent placement of that number within a displayed series, the collection becomes an absolute expression of truth.

In sum, the practice and systematization of statistical gathering in nineteenth-century Mexico fold the activities of national consolidation and modernization into one. Territorial divisions and maps were drawn, production and natural resources were named and calculated, and matters pertaining to populations and languages were documented for the first time. Within national boundaries, such data contributed to the process of unifying a disparate population by displaying a series of symbolic and imagistic associations for theretofore unrepresented components of the national territory. Not only did statistical data lead to the production of knowledge as the unification of disparate elements into a legible narrative but they also promised to reveal the causalities, patterns, and relationships that linked them. Despite the difficulties that obstructed the implementation of an accurate system of numerical representation, the cartographers and statisticians who dedicated themselves to developing and nationalizing this branch of science managed to use the disparities and gaps in information to celebrate both the honesty of an administration dedicated to rectifying its quantitative errors and the abundance of a territory of natural resources that exceeded representation altogether.

Conclusion

※ ※ ※

This book is the product of a set of questions that occurred to me as a graduate student in Latin American literature after taking seminars on the processes of Latin American modernization. Material references abounded in the *modernista* poetry and prose that we read. Particularly interesting to me was the figure of the fictional collector that surfaces in *modernista* literature, such as José Fernández in José Asunción Silva's *De sobremesa,* whose exquisite collections embodied the intersection of (internationally) traversed and (locally) inhabited spaces within the domestic setting of late-nineteenth-century *fin de siglo* culture.

When I turned to real collectors and collections, the museum institution seemed the obvious place to start. Inquiry led me to further questions: what invisible efforts preface the finished display? What hosts of factors converge behind the theaters of national representation that displayed objects embodied? How do objects—or more specifically, collections of objects—come to mean more than the sum of their parts? Flora S. Kaplan's *Museums and the Making of "Ourselves"* not only led me to Mexico as a case study for what would become this project but also made clear that far from representing the eternal and intransient values with which nineteenth-century national displays seem to be imbued in civic ceremonies and popular propagandistic literature, there are layers of transactions, negotiations, and ambiguities that all provide access to the far less visible and less stable processes that together enact the effects of meaning making.

The dialectical embrace of patrimony and market that lies at the core of nineteenth-century exhibition culture forms the backbone of this study. In the field of the national arts, the tension plays out not only within the Academia as a venue for both the selling and display of

Mexican works but also in the struggles between the traditional and the more liberal perspectives on what would indeed constitute specifically national painterly themes. One hundred years later, Banamex's significant collection of nineteenth-century *costumbrista* paintings further blurs the boundary between public and private. In the museum context, the practice of archeology involved a theatrical staging of ownership in which ancient patrimony was reintroduced into commercial contexts (such as the St. Louis Exhibition of 1904 or the Congreso de Americanistas of 1910) as a product of Mexican scholarship. While contemplation of the individual piece was thought to invigorate latent patriotic feelings, the museum as a whole—through both the contribution to and hosting of international events—continued to provide the grounds for commercial negotiations throughout the nineteenth century. Several of Mexico's key nineteenth- and early-twentieth-century national monuments, as seen in chapter 3, were direct embodiments of commercial relationships or transactions. Furthermore, the newspaper commentary that circulated around several of these pieces linked them to market interests through their emphasis on process and commercial agendas. The Palacio azteca, as analyzed in chapter 4, was probably the most obvious and direct embodiment of the irreducible mutual dependency of national exhibit and commercial display. Last, the field of national statistics simultaneously presented Mexican cultural consumers with the charts and tables necessary for them to imagine a series of composite visions of the *patria* and, conversely, enticed foreign investors with suggestions of bounty and abundance that exceeded the gesture of representation altogether.

Though each of the venues and institutions investigated here embodies a unique and dynamic connection between national patrimony and the international market, certain general patterns link them. In the example of statistics, archaeology, and world's fairs, the heavy precedent of foreign scholarship and exhibition culture required that the new collections be rhetorically grounded within a national conceptual framework. A national vocabulary and body of scholarship was thus built within the perimeters of international scholarship, creating a dialectical mode of defining selfness that anticipated the future dialogues that would shape local cultural administration in the era of globalization one hundred years later. Conversely, in the creation of collections

with little or no national precedent, such as the privately commissioned paintings studied in chapter 1 and the national monuments studied in chapter 3, references to commerce and market possibilities helped cultural critics and administrators reinforce a sense of legitimacy and validation for national cultural expression. In both dynamics, the myths of national patrimony intersect with the exchange values determined by international commercial networks within which the liberal and Porfirian governments negotiated for a position.

Currently the intersections between cultural administration and open markets continue to shape the contexts in which national "things" (collections, imagery, artifacts, spaces) become publicly accessible. In his contribution to *Mexican Art in the Age of Globalization,* the late art critic Olivier Debroise argues that starting largely in the 1960s, the Mexican government bargained for diplomatic and economic status throughout the latter half of the twentieth century in part by fostering art exhibitions abroad or for international audiences at home. In 1968, for example, the Exposición Solar exhibit, sponsored by the Instituto Nacional de Bellas Artes, was "the most ambitious cultural event of the XIX Olympic Games" held in Mexico City that year.[1] In a similar vein, the Mexico: Splendors for 30 Centuries exhibit, held at the Metropolitan Museum of Art in 1990 and organized collaboratively by the late Mexican archeologist Felipe Solís Olguín, marked the beginning of the North American Free Trade Agreement debates under the presidency of Carlos Salinas.[2] In terms of the impact of globalization on individual artists, the present-day culture of international art bienniels and fairs—which take place in developed and developing countries alike—has made it possible for local artists to receive international acclaim before their works have been deemed worthy of merit within their own countries of origin. Far from creating a facile opposition between the "evil" global and the "heroic" local expressions, observes Debroise, current art culture recognizes the *necessity* of "global interaction" in the "new circuits of exchange" that shape the practices and policies of local and national cultural administrations.[3]

In terms of current aesthetic trends in displaying the national, Debroise observes that Mexican exhibition culture in the global era has led to the prominence of the "blockbuster" exhibit, which, displayed at home and/or abroad, tries to "show everything" at once in a long

and linear trajectory that connects the distant past to the most recent present. A product of a combination of factors (including institutional sponsorship, the focus on tourists as target audiences, and a strong legacy of interpreting Mexican selfness through an anthropocultural focus), the blockbuster exhibit creates a somewhat limited and repetitive repertoire in terms of what gets circulated as distinctively Mexican art. In an interesting reversal of Altamirano's criticisms of the Academia artists' insistent repetition of European classical themes over a century earlier, Debroise observes that now it is the Mexican canon itself that threatens to yolk the development of a more nuanced and varied inventory of Mexican artists and artistic expressions.

Countering this tendency, although still adhering to the blockbuster habit of "staging dramatic narratives of national identity," there are artists and curators who address the question of origins and essence through Mexican artistic expression in a nonlinear, mosaic-like fashion.[4] The recent Imágenes del mexicano exhibit at the Bozar Centre for Fine Arts in Brussels (February 11–April 25, 2010), for example, put together in honor of the Bicentennial celebrations and organized by Conaculta (Consejo Nacional para la Cultura y las Artes), featured works from several prominent Mexican national museums as well as private collections. The goal of the project, which incorporated works from national and international artists alike, was to display the conceptualization and materialization of Mexicanness as it had evolved historically, yet in a multifaceted and kaleidoscopic manner—not reducible to any common denominator or single and cohesive vision. For another example of this expansion of the national narrative to include more marginal artistic expressions, there is the Facturas y manufacturas de la identidad exhibit at the Museo de Arte Moderno, which features a celebration of the popular arts and their role in developing a postrevolutionary Mexican aesthetic. In other words, judging from the titles of the exhibitions (with reference to "images" in the plural and "manufactured" objects), state museums still showcase and export images of the nation, but they now reflect a more self-reflexive and pluralistic vision of selfness than has perhaps been explored at the large institutional level before.

Far from a new phenomenon, there are links that bind the exhibition of Mexicanness with commercial interests that can be traced to the very

core of nineteenth-century national representative canons. Throughout this study, I have argued for the need to deconstruct the privileged spaces of national hegemony by unveiling their hidden transactions and flirtations with commercial enterprise. Nonetheless, it is neither my intention to negate the contributions of centralized, institutionally sanctioned culture nor to criticize the fundamental need to posit a stable sense of meaning during this critical time of national consolidation and modernization; rather, I have advocated for a more nuanced understanding of patrimony through a deeper look into the mobile, transient, and disjunctive dynamics that route through these public collections. The constitutional dialectic between past and future, the emptying and refilling of objects with serial meanings, the habitualization of the fetishistic and melancholic modes of perception, the intersections with narrative, the displacement of authority, and the strategic use of the rhetoric of error or defeat all complicate the immediate presumption of patrimony as a collective inheritance.

In pointing this out, my intention is not to suggest that the kinship of citizenry is a false or overdetermined concept or to argue that Mexico's cultural administration was somehow less authentic than others' during this time period. My point is twofold: first, that the collected piece that defined nineteenth-century patrimony was dialectically linked to the market value system, and second, that to gain a fuller vision of the brand of patriotism that was created along with public collections, it is necessary to look into the ways in which the collecting attitude linked Mexicanness to specific *practices,* that is, to strategic forms of cultural and commodity consumption such as those investigated here.

What the collection can offer us in the examples studied here is an illustration of the idea that the cultural coming-of-age of a nation relies on a consuming public that both affirms and transcends the national boundary. And those very *things* on which the identity of a nation sustains itself ultimately shift in meaning—become something else or someone else's, quite literally—when read from within the parameters of that other value system, the commercial, that it inevitably and paradoxically also represents. Perhaps this is the nature of the persuasive force that the nation acquires through its own object pageantry—by remaining elusive and unfixed (as the collection ultimately does), the

story of the nation guarantees its own reiteration. Its own retelling must be continually affirmed and displayed before the desiring gaze of the viewer. By unraveling the circumstances that lie hidden beneath displayed or exhibited pieces of cultural capital, the parameters of national identity begin to emerge not only as monumental inheritances but also as the complex and dynamic components of a continuously changing and mobile social network.

Acknowledgments

꽃 꽃 꽃

I am grateful to many for their assistance in making this book possible. My department chair, Ruth Gross, provided me with a great deal of support. I am also indebted to a number of people for their invaluable constructive feedback on the manuscript as it evolved from the dissertation project, including Sylvia Molloy, Richard Rosa, Jens Andermann, Hans Kellner, Fausto Ramírez, William J. Acree Jr., Juan Carlos González Espitia, Álvaro Fernández Bravo, and David Rieder. Professors Mary Sheriff, Daniel Sherman, Eduardo Douglas, Neil McWilliam, and Kim Rorschach were immensely helpful in suggesting art history resources for chapter 1. To my colleagues in the Department of Foreign Languages and Literatures at North Carolina State University, I am thankful for the generous collegial support that enabled this project. My copy editor, Kara West, was of immense assistance in refining the writing. My father, William Garrigan, translated all the important quotations from Spanish to English. Marsha Ostroff and Walther Boelsterly Urrutia helped me with many tasks that I could not have done on my own, including the securing of copyright permissions for the images. I also express my appreciation for access to archives of various important cultural institutions of Mexico, including the Archivo General de la Nación, the Banco Nacional de México, the Hemeroteca Nacional and the Biblioteca Nacional, the Archivo Histórico del Distrito Federal, the Instituto Nacional de Antropología e Historia, and the Instituto Nacional de Bellas Artes y Literatura.

I thank the editorial director of the University of Minnesota Press, Richard Morrison, and his assistant, Erin Warholm.

To my family and friends—too numerous to name individually—who have lived this project with me, I am grateful. To my parents, William and Marcia Garrigan, I dedicate this book.

Notes

☼ ☼ ☼

Introduction

1 "Even after Maximilian's death, Mexico could not even attempt to re-establish diplomatic relations with France until Napoleon III died in 1870. Not until the Porfirian regime achieved a certain domestic political balance did the international arena regain importance for the Mexican government and did Emilio Velasco successfully negotiate the reestablishment of Mexican diplomatic relations with France. Mexico's attendance at the Paris World's Fair of 1889 thus appeared to be a way of promoting internationally both Mexico's republicanism and its socioeconomic maturity. It also meant the final symbolic act of reconciliation with the ever-admired French nation." Tenorio-Trillo, *Mexico at the World's Fairs,* 47.

2 The idea of the gift exchange as sharing the same "commonality of spirit" as commodity exchange is first elaborated by Pierre Bourdieu and Marcel Maus, both quoted by Arjun Appadurai in his own formulation of the idea in *The Social Life of Things:* "I propose that the commodity situation in the social life of any 'thing' be defined as the situation in which its exchangeability (past, present, future) for some other thing is its socially relevant feature" (13). Also, Tenorio-Trillo, *Mexico at the World's Fairs,* 37, mentions the symbiotic relationship between the "pragmatic"–economic goals and the "allegorical"–nationalistic claims made by Mexico in the context of world's fairs.

3 The term *patrimony* here refers to the staged assembly of publicly displayed objects that are marketed to the public sphere as an organic community inheritance. As a result, these objects become strategically linked to group identity formation and reinforcement.

4 Andermann, *Optic of the State,* 2007.

5 Meyer and Sherman, *Course of Mexican History,* 313.

6 Ibid., 314.

7 Ibid., 324.

8 Wasserman, *Everyday Life and Politics*, 33.

9 Ibid., 46–47.

10 Meyer and Sherman, *Course of Mexican History*, 321.

11 Ibid., 320–21.

12 Ibid., 329.

13 Ibid., 337.

14 Ibid., 352.

15 As Camp, *Politics in Mexico*, 33, describes, liberal politics drew on the ideas of the Enlightenment movements of Europe and the United States, the secularization of social administration, an active citizen voice in government, and economic liberalism, defined in this context as "the encouragement of individual initiative and the protection of individual property rights." The conservatives, conversely, affiliated more closely with the progressive Bourbon monarchy that preceded independence, supporting the strong role of the church in property and administration and a stronger central government—more appropriate, from their perspective, for a new nation accustomed to the authoritarian administration of the colonial era.

16 Meyer and Sherman, *Course of Mexican History*, 390.

17 Ibid., 399.

18 On Benito Juárez's death in 1872, the liberal party had divided into what would later become three separate factions: the *juaristas*, also referred to as the *puros* or *jacobinos*, who advocated radical liberal politics and an absolute adherence to the 1857 constitution; the *lerdistas*, or the "economic and political elite," concerned with "order and the status quo"; and the *porfiristas*, who were at first the "radicals and progressives and spoke as the party of 'the people,'" although they would later adopt a more moderate and conservative stance. Garner, *Porfirio Díaz*, 50.

19 Meyer and Sherman, *Course of Mexican History*, 404–5.

20 Zea, *El positivismo en México*, 55.

21 Barreda, "Oración cívica," http://www.ensayistas.org/antologia/XIXA/barreda/.

22 Zea, *El positivismo en México*, 398.

23 On the international scale, the nations of the North Atlantic formed the international network into which Latin American raw materials became "progressively integrated" as the demographic, capital, and technological changes of the Industrial Revolution took effect. Garner, *Porfirio Díaz*, 164.

24 Taussig, *Magic of the State*, 9.

25 Bal, "Telling Objects," 99.

26 Widdifield, *Embodiment of the National*, 40–42. In *Mexico at the World's Fairs*,

30, Tenorio-Trillo also makes reference to the rhetoric of reconciliation during the Porfirian era.

27 Barros and Barros, *Justo Sierra*, 160.

28 Bal, "Telling Objects," 100–1.

29 Ibid., 101.

30 Baudrillard, *System of Objects*, 90–91, 97, 103–5.

31 Zea, *El positivismo en México*, 43.

32 Barros, *Justo Sierra*, 168.

33 Ibid., 190.

34 Marichal, "Obstacles to the Development of Capital Markets," 118.

35 Meyer and Sherman, *Course of Mexican History*.

36 Ibid., 319.

37 Marichal, "Obstacles to the Development of Capital Markets," 17, 118–31.

38 Wasserman, *Everyday Life and Politics*, 69–70.

39 Cárdenas, "A Macroeconomic Interpretation of Nineteenth-century Mexico," 65–117.

40 Bortz and Haber, *Mexican Economy*, 325.

41 Díaz-Andreu, *A World History of Nineteenth-century Archaeology*, 5–6. See Margaret Díaz-Andreu's summary of the distinction (made by various scholars, including Eric Hobsbawm) between "civic or political" nationalism and "cultural or ethnic" nationalism. Whereas the former has been defined in conjunction with individual rights and the empowerment of the people, the latter refers to the sense of shared inheritance, ethnicity, language, and cultural attributes.

42 Fernández, *Historia de los museos de México*.

43 Kaplan, *Museums and the Making of "Ourselves,"* 183.

44 Aching, *Politics of Spanish American Modernismo*, 10, discusses a parallel phenomenon (of cultural negotiation between the Americas and Europe) in terms of the institutionalization of the Spanish American language: "Hence, faced with the enigma of a literature that defined its brand of Americanness by actively reclaiming a European heritage, observers found it difficult to reconcile the modernistas' declaration of cultural independence with a cosmopolitan penchant for literature from former colonizers."

45 Rodríguez Prampolini, *La crítica de arte en México en el siglo XIX*, 38–39, 41.

46 Alonso, *Burden of Modernity*, 157.

47 Berman, *All That Is Solid Melts into Air*, 16–17.

48 Ibid., 99.

49 Díaz-Andreu, *A World History of Nineteenth-century Archaeology*, 87–94.

50 Gielbelhausen, *Architecture of the Museum*, 185.

51 Mexico, "Exposition Universelle Internacionale de Paris 1889," vol. 1, exp. 7, 71–72.

52 Díaz-Andreu, *A World History of Nineteenth-century Archaeology*, 9.
53 Tenorio-Trillo, *Mexico at the World's Fairs*.
54 Ibid., 125–30.

1. Fine Art and Demand

1 The Academia de San Carlos (Academy of San Carlos), originally established between 1781 and 1785 by the collaborative efforts of Viceroy Martín de Mayorga and coining factory superintendent Fernando Mangino, was reorganized under the Juárez restoration and renamed the National School of Fine Arts in 1867. For purposes of clarity, I will refer to the school as the Academia.

2 Rodríguez Prampolini, *La crítica de arte en México en el siglo XIX*, 3:320.

3 While reflecting on the same experience of art as merchandise at the Exposition de Paris of 1900, modernist poet Rubén Darío reacts with a celebratory attitude. Accordingly, Julio Ramos's interpretation of Latin American *modernismo* separates the movement chronologically into respective phases of rejection, followed by acceptance and embrace, of the emerging market of luxurious goods. Ramos, *Desencuentros de la modernidad en América Latina*, 116.

4 In both her introduction and the first essay (titled "Los principios de la crítica de arte") of volume 1 of *La crítica de arte en México en el siglo XIX*, Rodríguez Prampolini offers a brief and illuminating discussion of the nineteenth-century Mexican art critic. The author identifies who these critics were, what broad influences helped shape their discussions, the distinction between art "critic" and art lover at the time, and the role and responsibilities of the critic with respect to Mexican society. In brief, she defines the critics as "generally writers, authors, poets and even politicians who, out of love for the fine arts, wrote, with all good faith and modesty, their impressions" (16).

5 Velázquez Guadarrama, *La colección de pintura del Banco Nacional de México*, 1:27–28.

6 Soler and Acevedo, *Los pinceles de la historia*, 35–52.

7 Ibid., 60.

8 Paris, 1889; Madrid, 1892; Chicago, 1893; Paris, 1900; Buffalo, 1901; St. Louis, 1904.

9 Debroise, *La era de la discrepancia*, 21–22.

10 The hierarchical hegemony of the historical genre, observes Angélica Velázquez Guadarrama in her introduction to the Banamex catalog of nineteenth-century Mexican paintings, stems from the inheritance of the French–European hierarchy of values in which the highest function

of art was that not only of pleasing but also of instructing the spectator in terms of moral standards. Also, the historical genre was viewed as a respectable intellectual undertaking (requiring a vast repertoire of knowledge in various different disciplines) and a respectable challenge with regard to technique. Velázquez Guadarrama, *La colección de pintura del Banco Nacional de México*, 1:28–29.

11 Ramírez, "El proyecto artístico en la Restauración de la República," 58. These paintings were *The Discovery of Pulque* by José Obregón, *The Sad Night* by Francisco de P. Mendoza, and *Allegory of the Constitution of 1857* by Petronilo Monroy.

12 Curiously, however, when it came to compiling a Mexican national representation at the World's Fair events, such as at the Philadelphia Fair of 1876 (the first of its kind in which Mexico participated), the selected paintings did contain a moderate representation of the modern genres. Soler and Acevedo, *Los pinceles de la historia*, 64. That the proportion of modern to older genres (and national to universal biblical or classical themes) sent by Mexico to the world's fair events would only increase as the century progressed is testament to the nineteenth-century dynamic under investigation here, in which the international marketing context informs modern expressions of the individual nation.

13 When the Academia opened its doors after having undergone renovations in 1847, the curriculum for painting, under the instruction of Pelegrín Clavé, drew largely on Old Testament themes for subject matter. After the Restoration in 1867 and the naming of Ramón Álcaraz to the position of director, the pursuit of national themes began to gain the momentum that was to continue under the future direction of Román Lascuráin (1876–1902) and Antonio Rivas Mercado (1902–11). Despite the slow and deliberate modernization that the Academia was to undergo, the art and literary critics of a liberal persuasion (such as Ignacio Altamirano and José Martí) filled the late-nineteenth-century newspapers with complaints around the conservatism, the lack of attention paid to national and modern themes, and the overall lack of artistic innovation. Sánchez Arreola, *Catálogo del archivo de la Escuela Nacional de Bellas Artes 1857–1920*, xx.

14 Flora Elena Sánchez Arreola points out that after a suggestion published in the newspaper *La Libertad* in 1884, President Díaz agreed to open the Academia's doors to the public on Sundays between the hours of 9:00 A.M. and 1:00 P.M., with the caveat that the number of visitors not exceed five hundred. Ibid., xxiv.

15 Altamirano and Martínez, *Escritos de literatura y arte*, 183, 192.

16 Altshuler, *Salon to Biennial*, 13.

17 Solkin, *Art on the Line*, 2, 12.

18 Waterfield, *Palaces of Art*, 37.
19 Ibid.
20 Ibid., 54.
21 Ibid., 56.
22 Ibid., 103.
23 Ibid., 107.
24 Ibid., 108.
25 Ibid., 125.
26 Ibid., 127.
27 Ibid., 132.
28 Rodríguez Prampolini, *La crítica de arte en México en el siglo XIX*, 1:141.
29 Ibid., 1:137.
30 Ibid., 73.
31 Rodríguez Prampolini, *La crítica de arte en México en el siglo XIX*, 2:349.
32 For a brief and thorough introduction to the arts patron Felipe Sánchez Solís, see Soler and Acevedo, *Los pinceles de la historia*, 66–72. As for examples of other types of public exhibits, *El Eco Universal* published an announcement of a painting exhibit to be held in the Hotel del Jardín in July 1888, and *El Siglo XIX* published the Spanish-born Mexican resident painter José Escudero y Espronceda's intention to hang his portraits of Mexican national heroes on the facade of his house to commemorate the Mexican Independence Day on September 16, 1884. Rodríguez Prampolini, *La crítica de arte en México en el siglo XIX*, 3:170, 230.
33 Velázquez Guadarrama, *La colección de pintura del Banco Nacional de México*, 2:382. Ángela Velásquez Guadarrama observes that the attribution to Ibarrarán y Ponce is unlikely given the artist's solid dedication to biblical–historical themes.
34 Ibid., 1:108. For yet one more example of the ways in which the activities of the middle classes became common artistic subjects in the nineteenth century, the Spanish architect–Mexican resident and art patron Lorenzo de la Hidalga's watercolor painting titled *Interior of the National Theater* (completed between 1844 and 1901) highlights a particular scene of Mexican cultural consumption in such a way that, unlike the Italian painter and Mexican resident Pedro Güaldi's rendition of the same theme, foregrounds the viewing public rather than the edifice and renders a rather intimate portrayal of the middle-class crowd depicted in a moment of contemplation. Velázquez Guadarrama, *La colección de pintura del Banco Nacional de México*, 2:376–79.
35 García Barragán and Arrieta, *José Agustín Arrieta*, 70.
36 Ibid., 72.
37 Ibid.

38 Ibid., 20.
39 Ibid., 26.
40 Ibid., 57–58.
41 Ibid., 31.
42 Ibid., 100.
43 Widdifield, *Hacia otra historia del arte en México*, 269; Velázquez Guadarrama, *La colección de pintura del Banco Nacional de México*, 1:28, 137. During the conservative Academia leadership of Pelegrín Clavé (1846–68), genre painting began to flourish in Puebla and Guadalajara and then subsequently appeared in the Academia's exhibitions with more frequency under the direction of Ramón Álcaraz (1868–77) and Román Lascurain (1877–1902). Velázquez Guadarrama, *La colección de pintura del Banco Nacional de México*, 1:138. While acquiring popularity primarily as products of private commission rather than official Academia endorsement, genre paintings appear in the catalog lists of the Academia's annual exhibitions and enter into public discourse through newspaper commentary with a frequency that highlights their importance as a modern genre. Though genre paintings appeared as early as the 1840s in Guadalajara and Puebla, that painterly tradition did not figure regularly within the walls of the Academia until after the Restored Republic in 1867. Widdifield, *Hacia otra historia del arte en México*, 141.
44 Witness the following observation, made by Ignacio Altamirano, which was published in 1883–84: "For us the Mexican school is being born, and it will grow and progress if our artists, understanding the true tendencies of art and studying nature, abandon the traditions of that ascetic art from whose rigors [the talents of painters such as Daniel Cabrera] has hardly been able to escape." Rodríguez Prampolini, *La crítica de arte en México en el siglo XIX*, 3:147.
45 Ibid., 3:110; translation mine.
46 This painting is not listed in the official catalog for the exhibition, but it does appear in Gutiérrez's published review of the exhibition. Ibid.
47 Writes Luis Ma. Cabello y Lapiedra, an architect who published this commentary in *El arte y la ciencia* in 1899, "So it is sad, very sad that history and religious painting have disappeared or are tending to disappear from the dominion of painting; but it is necessary that art . . . reflect the era in which it lives, and it's fair to confess that in these times of decadent society, those are not themes on which the artist fixes [his] attention." Ibid., 3:475.
48 Ibid., 3:351.
49 About Librado Suárez's painting titled *After the Party*, which was hung at the Twentieth Exhibition of the Academia in 1880, Ignacio Altamirano

writes, "The indigenous types which are difficult to represent because of their color and their sweet, melancholy character that modifies in part their racial ugliness are well, very well manifested." Ibid., 3:55.

50 Regarding Manuel Ocaranza's *A Parishioner,* also hung at the Twentieth Exhibition of the Academia in 1880, Altamirano writes, "This painting has called attention, has attracted a great number of curious visitors and has been the object of praise." Ibid., 3:42.

51 Ibid., 3:155.

52 About Alejandro Casarín (author of such paintings as *The Quijote, Sancho, The Reading, The Breakfast, Charity,* and *Paternal Love*), for example, Ignacio Altamirano writes, "Casarín is another cultivator of genre painting. About him we said in our study *The Salon in 1879–80,* published in this past year, the following: 'Sr. Casarín enjoys now in Mexico a notable reputation as a genre painter and his paintings are well appreciated; some have sold well here and in the U.S.'" Ibid., 3:155. Artist and art critic Felipe Gutiérrez articulates similar praise for José María Obregón in the XXII Exposition of 1881: "May Sr. Obregón receive our most sincere encouragement to execute another thousand episodes of this class, which are still virgins amongst us and have the stamp of novelty for the foreigner." Ibid., 3:110.

53 Ibid., 2:188.

54 Ibid., 3:129.

55 Acevedo, *Arte e imagen,* 126.

56 By *fetishism,* I mean the excessive attachment to specific material things that are also associated with magical-like powers (here the power of representation). I see patrimony as operating in a similar manner as Marx does the commodity: his definition of commodity fetishism emphasizes the confusion of subjective assessments of value for objective properties.

57 Stewart, *On Longing,* 163.

58 Ibid., 158–59.

59 Ibid., 164–65.

60 Rodríguez Prampolini, *La crítica de arte en México en el siglo XIX,* 3:129.

61 For an example of this debate, see the article called "El artista ante el tribunal de la Inquisición" in Ibid., 2:227–31.

62 Ibid., 1:138.

63 Ibid., 1.142.

64 Ibid., 1.144.

65 Velázquez Guadarrama, *La colección de pintura del Banco Nacional de México,* 1:26.

66 Ibid., 1.28.

67 Ibid., 1.112.

68 Altamirano and Martínez, *Escritos de literatura y arte,* 143.

69 A student of Pelegrín Clavé and pensioned to study in Italy and France, Parra Hernández became a professor of the Academia in 1882. He was best known for his paintings of historical themes such as *Fray Bartolomé de las Casas* (1875) and *La matanza de Cholula* (1877). For more information, see Debora Dorotinsky Alperstein's critical introduction of the artist in the Banamex catalog of Velázquez Guadarrama, *La colección de pintura del Banco Nacional de México*, 2:436.

70 Ibid., 2:442.

71 Fausto Ramírez writes of a parallel tension in this painting, reminiscent of a baroque sensibility, that distinguishes thing from image and also separates different levels of dimensionality in the transition from real to first painted and then embroidered flowers. Ibid., 2:334.

72 Ibid., 2:336. *Criollismo*, or the exaltation of the local, permeated all branches of artistic expression in early-twentieth-century Mexico, despite its predominant understanding as a literary phenomenon. For painterly examples from the first two decades of the twentieth century, see Saturnino Herrán's *La cosecha* (1909), *Nuestros dioses antiguos* (1916), and *Mujer con calabaza* (1917) from the Andrés Blaistén collection. The Mexican poet Ramón López Velarde approached the theme of artistic *criollismo* in his essay on the poet Enrique Fernández Ledesma as far back as 1916 and again in "Melodía Criolla," in reference to the Zacatecan musician Manuel M. Ponce (1882–1948). Martínez, *Ramón López Velarde*, 351–52, 369.

73 The following is a select list of names that appear regularly within the indexes of the exhibitions of the Academia as patrons who loaned artworks from their private collections for public exhibitions: Alfredo Chavero (archaeologist), Felipe Sánchez Solís (lawyer, writer, and liberal politician), Wenceslao Quintana, P. Martínez Arana, Fernando del Valle, Telésforo García, José Barradas, Ignacio Alcérreca Comonfort (architect), José de Teresa Miranda (senator), Luis García Pimentel, Francisco Arce, and Francisco Hernández Rivas.

74 Rodríguez Prampolini, *La crítica de arte en México en el siglo XIX*, 2:221.

75 Not all images of consumption that were depicted in genre paintings were favorable, as demonstrated in works such as Manuel Ocaranza's *Café de la Concordia* (shown at the Academia's Exhibition of 1871). In this piece, a clear denunciation of social inequalities, a young, poorly dressed boy from the lower class looks through a side window of the Café de la Concordia at the middle- to high-class clientele. Here the visibility provided by the side window reveals its dark side: if, for the empowered social classes, the display window generates a reverie that revolves around fantasies of possession and acquisition, that same transparency that represents an opening or offering for the privileged only emphasizes the barriers that

divide the rich from the poor when viewed from the other perspective. The point that interests me here is the implication that there is a correct and an incorrect way to spend money, as suggested in the comparison between this painting and Bribiesca's *Moral Education*. For a closer analysis of *Café de la Concordia*, see Ángela Velásquez Guadarrama's analysis in Widdifield, *Hacia otra historia del arte en México*, 155.

76 Rodríguez Prampolini, *La crítica de arte en México en el siglo XIX*, 1:381.

77 In the introduction to their anthology on the Mexican economy during the late nineteenth and early twentieth centuries, Jeffrey L. Bortz and Stephen Haber locate the new middle class in the "nascent bankers and manufacturers" that were incorporated into the rents distributions under the Díaz government. The inclusion of this component of the private sector served the double purpose of promoting internal economic growth and providing further support for the dictatorship. Bortz and Haber, *Mexican Economy*, 16.

78 Rodríguez Prampolini, *La crítica de arte en México en el siglo XIX*, 3:88; emphasis added.

79 Stewart, *On Longing*, 137.

80 This reading is indebted to Stewart's discussion of the postcard in *On Longing*, 137–38.

2. Our Archaeology

1 Keen, *Aztec Image in Western Thought*, 418.

2 First published in 1877 after museum director Gumesindo Mendoza observed the lack of legitimate, scholarly, and consistent publications generated by the institution, the *Anales del Museo Nacional de México* bore the fruit of the careful investigations of such scholars as Manuel Orozco y Berra and Alfredo Chavero (both professor affiliates of the museum), naturalist Dr. Manuel M. Villada, and geologist–paleontologist Mariano de la Bárcena. The publication of the *Anales* marks a seminal moment in museum scholarship for the museum, which became an increasingly productive study center until 1940, when the Instituto Nacional de Antropología e Historia was founded.

3 Instituto Nacional de Antropología e Historia de México, *Anales del Museo Nacional de México*, epochs 1–3.

4 Mexican lawyer, writer, historian, and archeologist and one-time director of the Museo Nacional Alfredo Chavero (1841–1906) collaborated with Vicente Riva Palacio to author the first volume of *México a través de los siglos*, published in 1880. Tenorio-Trillo, *Mexico at the World's Fairs*, 256.

5 A pharmaceutical chemist by trade, Mendoza served as director of the

Museo Nacional between 1876 and 1883. In the first issue of the *Anales del Museo Nacional* in 1877, Mendoza and liberal historian Manuel Orozco y Berra composed a series of articles in which they defended the superiority of the Aztec civilization and advocated for governmental intervention on behalf of contemporary indigenous people. Bernal, *A History of Mexican Archeology*, 416.

6 Employee of the Museo Nacional between 1884 and 1888, anthropologist-archeologist Leopoldo Batres (1852–1926) realized excavations in several Mexican archeological sites during the Porfiriato, including Teotihuacán, Monte Albán, and Mitla. Owing to inaccuracies, his reconstruction of the Pyramid of the Sun later proved controversial.

7 A contemporary and colleague of Gumesindo Mendoza, Dr. Jesus Sánchez began his career as a professor in the Museo Nacional, where he investigated a variety of topics related to ancient Mexican history that ranged from botany and zoology to archaeology and linguistics. He served as director of the museum first between 1883 and 1889 and then again between 1909 and 1911. Ortega et al., *Relación histórica de los antecedentes*, 48. One of his founding essays in Mexican archaeology, published in 1877 in the first volume of the *Anales*, was titled "Reseña Histórica del Museo Nacional de México."

8 Mexican writer, historian, and engineer Jesús Galindo y Villa (1867–1937), who held the first chair position in archaeology at the Museo Nacional, was the author of several books related to Mexican history. In 1895, he published the *Guía para visitar los salones de historia de México del Museo Nacional*. The *Breve noticia histórico-descriptiva del Museo Nacional de México* was published in 1896.

9 An early- to mid-twentieth-century Mexican anthropologist, Manuel Gamio, was well known in part for the archaeological research that he conducted in Teotihuacán between 1918 and 1920. His work contributed to the postrevolutionary valorization of Mexico's indigenous inheritance and effectively "reinstated Indian civilization as the foundation of Mexican history." Brading, "Manuel Gamio and the Official Indigenismo in Mexico," 78.

10 Bernal, *A History of Mexican Archeology*, 130.

11 Instituto Nacional de Antropología e Historia de México, *Anales del Museo Nacional de México*, epoch 1a, tome 2, 486.

12 Comas, *Cien años de Congresos Americanistas*, 14.

13 Aguirre, *Informal Empire*, 67.

14 Morales-Moreno, "History and Patriotism in the National Museum of Mexico," 181.

15 Mitchell, *Iconology*, 193.

16 Ibid.

17 Bernal, *A History of Mexican Archeology*, 103–39.

18 Bortz and Haber, *Mexican Economy*, 95, 163.

19 Aguirre, *Informal Empire*, xxix.

20 Ibid., 125.

21 Harrison, "Projections of the Revolutionary Nation," 34.

22 Williams, "Collecting and Exhibiting Pre-Columbiana in France and England," 123–37.

23 Ibid., 128. For a detailed summary of twentieth-century foreign aesthetic evaluations of pre-Columbian art, see section C.1 ("Críticos e historiadores extranjeros") of Justino Fernández's study of the *Coatlicue* in *Estética del arte mexicano*.

24 Aguirre, *Informal Empire*, 67.

25 Benson, "Robert Woods Bliss Collection of Pre-Columbian Art," 16–17.

26 Evans, *Romancing the Maya*, 3.

27 Davis, *Désiré Charnay, Expeditionary Photographer*, 11–12.

28 Graham, *Alfred Maudslay and the Maya*, 101; Davis, *Désiré Charnay, Expeditionary Photographer*, 35, 104.

29 Davis, *Désiré Charnay, Expeditionary Photographer*, 17, 35, 104.

30 Ibid., 201–2.

31 Graham, *Alfred Maudslay and the Maya*, 226.

32 Ibid., 228, 233–34.

33 Ibid., 150.

34 Ibid., 150, 159–65.

35 Davis, *Désiré Charnay, Expeditionary Photographer*, 25.

36 Instituto Nacional de Antropología e Historia de México, *Anales del Museo Nacional de México*, 40.

37 Graham, *Alfred Maudslay and the Maya*, 103.

38 Ibid., 110.

39 Ibid., 221.

40 Tenorio-Trillo, *Mexico at the World's Fairs*, 73.

41 This particular transfer of documents corresponds with Derrida's later theoretical formulation of the archive in *Archive Fever*. In this metaphorical reading of the archive, to which I will refer in this chapter, the first step in the creation of a public archive involves a transfer from private to public and necessitates a change in domiciliation: "It is thus, in this domiciliation, in this house arrest, that archives take place. The dwelling, this place where they dwell permanently, marks this institutional passage from the private to the public, which does not always mean from the secret to the nonsecret" (2–3).

42 Florescano, *Memory, Myth, and Time in Mexico*, 186–205; Keen, *Aztec Image in Western Thought*, chapters 13 and 14.

43 Galindo y Villa, *Guía para visitor los salones de historia de México del Museo Nacional*, 15.

44 Instituto Nacional de Antropología e Historia de México, *Anales del Museo Nacional de México*, epoch 1, tome 4, 3.

45 Báez Macías, *Guía del archivo de la Antigua Academia de San Carlos*, section 2.2, 706.

46 Rodríguez Prampolini, *La crítica de arte en México en el siglo XIX*, 3:390–91. See, e.g., Demetrio Mejía's report to the secretary of justice and public instruction on an 1887 excavation at Tenguiengajó in the state of Oaxaca. This law was far from the first motion of its kind. In theory, archaeological monuments had been declared exempt from trade since 1575. Throughout the centuries, several governmental decrees geared toward the protection of archaeological monuments were issued but rarely enforced. In 1825, with the founding of the National Museum, the expropriation of cultural artifacts was prohibited. In 1829, Mexican statesman Carlos María de Bustamente introduced further legislation seeking the protection of national antiquities. In 1859, the Sociedad de Geografía y Estadística proposed that archaeological monuments be claimed as state property, a plan that was revised in 1862. In 1875, an inspector y conservador de monumentos arqueológicos de la República was created for purposes of archaeological site surveillance. Bernal, *A History of Mexican Archeology*, 140.

47 This observation was made by Timothy Webmoor in an unpublished paper titled "An Archaeology of Mexican Nationalism: Cultural Politics and Archaeological Knowledge," 17.

48 To name just a few of these key scholars, there are art patrons Alfredo Chavero and Felipe Sánchez Solís and museum scholars Jesús Sánchez, Manuel Urbina, Jesús Galindo y Villa, Manuel Orozco y Berra, and Gumesindo Mendoza (the first director of the Museo following the Reforma).

49 Mendoza and Sánchez, *Catálogo de las colecciones, histórica y arqueológica del Museo Nacional de México*, section 1.2, 111.

50 Chavero mentions F. W. Putnam (a late-nineteenth-century scholar of Harvard), William H. Holmes (of the Smithsonian Institution), Edward J. Payne (British scholar and author of *History of the New World Called America*), the Count of Charencey, Seler and Förstman, Cyrus Thomas, and several more names in his "Discurso Pronunciado el 24 de Septiembre de 1904." See Bernal, *A History of Mexican Archeology*, chapters 5–7, for a more exhaustive list of foreign historians and archaeologists who led expeditions on Mexican soil during the nineteenth century.

51 Chavero, "Discurso pronunciado el 24 de septiembre de 1904 en el Congreso de Artes y Ciencias," epoch 2, tome 2, 396.

52 Ibid., 395.

53 Ibid., 388.

54 Galindo y Villa, "Exposición general sobre la arqueología mexicana," 190.

55 Morales-Moreno, *Orígenes de la museología mexicana*, 44.

56 Ibid., 44–45.

57 Instituto Nacional de Antropología e Historia de México, *Anales del Museo Nacional de México*, epoch 1, tome 1, prologue.

58 Florescano, *Memory, Myth, and Time in Mexico*, 198.

59 Rutsch, "Natural History, National Museum, and Anthropology in Mexico," 99.

60 Bárcena, "Introducción al estudio de la paleontología Mexicana," 13. The inclusiveness of the term *lo nuestro* in this context is questionable in practice as an important aspect of the scientific nationalization of the Mexican past was the production and consumption of "objective" knowledge among the middle class and urban elites. Tenorio-Trillo, *Mexico at the World's Fairs*, 173.

61 Instituto Nacional de Antropología e Historia de México, *Anales del Museo Nacional de México*, epoch 3, tome 5, 187.

62 Galindo y Villa, *Guía para visitor los salones de historia de México del Museo Nacional*, iii.

63 Chavero, "Discurso pronunciado el 24 de septiembre de 1904 en el Congreso de Artes y Ciencias."

64 Rodríguez Prampolini, *La crítica de arte en México en el siglo XIX*, 3:501.

65 Statistical information with respect to the number of national and foreign visitors to the museum is sporadically included in the *Anales*. In 1902, for example, 275,350 visitors were documented, including 10,284 foreigners and 265,066 Mexican nationals.

66 Galindo y Villa, *Breve noticia histórico-descriptiva del Museo Nacional de México*, 10.

67 Morales-Moreno, *Orígenes de la museología mexicana*, 124.

68 Ibid., 123.

69 Instituto Nacional de Antropología e Historia de México, *Anales del Museo Nacional de México*, epoch 1, tome 1, prologue; emphasis added.

70 For an interesting exposition on the parallels between displayed objects and speech or narrative in the context of late-nineteenth-century U.S. museum culture, see chapter 1 of Conn, *Museums and American Intellectual Life*.

71 Examples of this *sano criterio* would be the *leyenda*, or legend–caption accompanying the exhibited pieces in the salon, or the "names, dates, places, anecdotes" that Galindo y Villa enthusiastically offers his readers in the form of the published guide.

72 Morales-Moreno, *Orígenes de la museología mexicana*, 126.
73 Rutsch, "Natural History, National Museum, and Anthropology in Mexico," 99.
74 Morales-Moreno, *Orígenes de la museología mexicana*, 138.
75 León y Gama, *Descripción histórica y cronológica de las dos piedras*, 2.
76 Ibid., 5.
77 In addition to the *Coatlicue* and the *Piedra del Sol*, León y Gama also refers to a tomb containing the skeleton of an unidentified quadropedic animal that was buried with various pots and elaborately decorated clay objects, metal *cascabeles* (bells or rattles), and other objects. The collection was in the possession of a Captain D. Antonio Pineda of Guanajuato, for which reason the author had not been able to see or study all of the objects. Ibid., 11.
78 Ibid., 3, 4; emphasis added.
79 Fausto Ramírez has pointed out to me that the term *patria* as employed by León y Gama, Alzate, and in general by Mexican Creole intellectuals of the eighteenth and nineteenth centuries could mean either "New Spain" or "Spain," or both, as these scholars felt to be at the same time "españoles y novohispanos." Pérez Vejo, *Nación, identidad nacional y otros mitos nacionalistas*, is a useful source for this subject.
80 León y Gama, *Descripción histórica y cronológica de las dos piedras*, 4.
81 Ibid., 8; Schreffler, "Making of an Aztec Goddess," 9.
82 León y Gama, *Descripción histórica y cronológica de las dos piedras*, 10.
83 Schreffler, "Making of an Aztec Goddess," 16.
84 Bullock, *Six Months' Residence and Travels in Mexico*, 342; Schreffler, "Making of an Aztec Goddess," 21.
85 Writes Schreffler, "Making of an Aztec Goddess," 23, "while there exists some uncertainty about what happened to the sculpture after Bullock's visit, it either remained above ground from 1824 to the present, or it was reburied for a short time, having been displayed in the courtyard in 1826."
86 Ibid., 23.
87 Stewart, *On Longing*, 153.
88 Ibid.; Baudrillard, *System of Objects*, 95.
89 Morales-Moreno, *Orígenes de la museología mexicana*, 159; emphasis added.
90 Instituto Nacional de Antropología e Historia de México, *Anales del Museo Nacional de México*, epoch 2, tome 1, 278.
91 Keen, *Aztec Image in Western Thought*, 435.
92 "The profound study of those races reveals to us [the need for] their urgent redemption, beginning with their education integral and worthy of a civilized culture, in order to say afterward to each and every one,

like the Savior to Lázaro: Rise up and walk!" Galindo y Villa, "Exposición general sobre la arqueología mexicana."

93 Gamio, "Prejudices in Archaeology and Ethnography," 153.

3. The Hidden Lives of Historical Monuments

1 Riegl, "El culto moderno a los monumentos," 28.

2 Sosa's proposal was published in *El Partido Liberal* on September 2, 1887.

3 Rodríguez Prampolini, *La crítica de arte en México en el siglo XIX*, 3:216.

4 Ibid., 270–72.

5 Ibid., 340.

6 Ibid., 197.

7 Ibid., 247.

8 Ibid., 246.

9 Ibid., 556–57. For a complete account of the history of the statue and its multiple locations, see Manuel Aguirre Botello's Web page titled "El Caballito: historia y sitios que ocupó," http://www.mexicomaxico.org/Caballito/caballito.htm.

10 Secretaría del Ayuntamiento Constitucional de México, "Historia-monumentos," exp. 20, section 1a, number 3, 14.

11 Ibid., 12.

12 Ibid., 17–18.

13 Ibid., 19.

14 Rodríguez Prampolini, *La crítica de arte en México en el siglo XIX*, 3:453.

15 Secretaría de Fomento de México, *Anales de la Secretaría de Fomento 1857–1910*, 3:319.

16 Secretaría del Ayuntamiento Constitucional de México, "Historia-monumentos," exp. 1096, section 2. An interesting dimension to the question of visibility and invisibility with respect to national monuments can be found as well in descriptions of the objects that were formally buried within the first stones of these monuments. In the case of the monument to Garibaldi, for example, for which the first stone was placed by President Díaz and the Italian ambassador Marquis Alfredo Capece Minutolo di Bugnano in a solemn ceremony on September 17, 1910, a collection of small objects was buried in a hollowed area in the interior of the stone: a sampling of "newspaper clippings of the day," some newly minted coins, and a small poster board inscribed with a brief summary of the ceremony. For the purposes of this chapter, the presence of the coins in particular calls attention: symbolically "planted" within the hidden interior of the stone in a manner analogous to seeds, they imbue the monument's foundation with monetary value while also metaphorically

promising their own future reproduction. García, *Crónica oficial de las fiestas del primer Centenario*, 54.

17 Appadurai, *Social Life of Things*, 17.

18 Secretaría del Ayuntamiento Constitucional de México, "Historia-monumentos," exp. 1097.

19 In her article titled "Empresarios y banqueros: entre el Porfiriato y la Revolución," Leonor Ludlow names several of the key Spanish financial entrepreneurs residing in Mexico during the late nineteenth century. The Cámara de Comercio y de Industria Española was the central meeting place of the Spanish entrepreneurs of this period. While Mexico is not an immigrant nation, observes Ludlow, Spanish immigration did account for the largest influx of immigrants during the last two decades of the nineteenth century. Lida, *Una immigración privilegiada*, 144–45.

20 Ibid., 155, 161.

21 Secretaría del Ayuntamiento Constitucional de México, "Historia-monumentos," exp. 1051. Soon after this proposal was issued, although I have not found documentation specifying how, when, or by whom, General Washington was chosen for the monument's theme. According to García, *Crónica oficial de las fiestas del Primer Centenario*, the subscription that was opened among the U.S. resident colony of Mexico City to fund the project was filled within a month. On September 11, 1910, a small ceremony commemorating the U.S. hero occurred at the chosen site for the monument, in the Plaza de la Dinamarca of the Colonia Juárez (59–60).

22 Rodríguez Prampolini, *La crítica de arte en México en el siglo XIX*, 3:227.

23 Chavero and Baranda, *Homenaje á Cristóbal Colón*, 20.

24 Rodríguez Prampolini, *La crítica de arte en México en el siglo XIX*, 3:358–62.

25 These include two world's fair events held respectively in Madrid and Chicago—the Historic American Exposition of 1892 and the World's Columbian Exposition of 1893.

26 Rodríguez Prampolini, *La crítica de arte en México en el siglo XIX*, 3:359.

27 Ibid., 240.

28 Ibid., 242.

29 Ibid., 315.

30 Ibid., 316.

31 Ibid., 309.

32 Ibid., 340.

33 Ibid., 317.

34 Appadurai, *Modernity at Large*, 68.

35 Rodríguez Prampolini, *La crítica de arte en México en el siglo XIX*, 3:359.

36 Ibid., 187.

37 Ibid., 246.

38 Baudrillard, *System of Objects*, 94.
39 Anderson, *Imagined Communities*, 6.
40 Appadurai, *Modernity at Large*, 75.
41 Ibid., 76.
42 Ibid., 77.
43 Rodríguez Prampolini, *La crítica de arte en México en el siglo XIX*, 3:200.
44 Ibid., 246.
45 Secretaría del Ayuntamiento Constitucional de México, "Historia-monumentos," exp. 1095, number 1, 230.
46 Ibid., exp. 14, section 2a.
47 Ibid., exp. 12, section 1a.
48 Ibid., exp. 60, number 1013.
49 Rodríguez Prampolini, *La crítica de arte en México en el siglo XIX*, 3:216.
50 Ibid., 362.
51 Secretaría del Ayuntamiento Constitucional de México, "Historia-monumentos," exp. 1099.

4. Collections at the World's Fair

1 De Mier, *México en la Exposición*, 8.
2 Báez Macías, *Guía del archivo de la Antigua Academia de San Carlos*, 182.
3 Schávelzon, *La polémica del arte nacional en México*, 11.
4 Vásquez de Knauth, *Nacionalismo y educatión en México*, 129.
5 Schávelzon, *La polémica del arte nacional en México*, 152.
6 Ramírez, "Dioses, heroes y reyes mexicanos en Paris," 210.
7 Bartra, *La jaula de la melancolía*, 58.
8 Ibid., 47.
9 Ibid., 51.
10 Ibid., 226.
11 Ibid., 58.
12 Sigmund Freud, "Mourning and Melancholia," *Standard Edition* 14 (1953): 243–58.
13 Judith Butler, *The Psychic Life of Power: Theories in Subjection* (Stanford, Calif.: Stanford University Press, 1997).
14 Bartra, *La jaula de la melancolía*, 51.
15 Ibid., 55.
16 Ibid., 57.
17 Tenorio-Trillo, *Mexico at the World's Fairs*, 96–112.
18 Ramírez, "Dioses, heroes y reyes mexicanos en Paris," 231.
19 Buck-Morss, *Dialectics of Seeing*, distinguishes between the opposing worldviews of allegory and myth as proposed by Benjamin: allegory

privileges the "fragment of reality," a "montage-like" construction in which the association between thing and meaning is questioned (225). Similarly, the eclectic individual components of the Aztec Pavilion exterior, which were drawn from several different sources and cosmologies, stood out individually in a way that compromised the (critical) viewer's ability to synthesize meaning from the whole. Conversely, the mythic worldview, which Benjamin perceived as prevalent wherever industrialization occurs, stakes a claim to transcendent, lasting truth (226). By pairing these contrasting perspectives, I found a useful conceptual lens for interpreting the opposing logics that manifest when comparing the outside to the inside of the Palacio azteca.

20 Benjamin, *Origin of German Tragic Drama*, 91.

21 Rydell, *All the World's a Fair*, 22.

22 Tenorio-Trillo, *Mexico at the World's Fairs*, 22.

23 Ramírez, "Dioses, heroes y reyes mexicanos en Paris," 225; translation mine.

24 De Mier, *México en la Exposición Universal Internacional de Paris*, 22. On visiting the Mexican Pavilion, Aurelia Castillo de González wrote of her disappointment that the abundant raw materials exhibited by Mexico at the fair had not been supplemented with equal attention to artistic products and innovations, which "contribute to the prosperity of nations and refinement of customs." She attributed this gap in the Mexican exhibit in part to "indolence." Tenorio-Trillo, *Mexico at the World's Fairs*, 24–25.

25 De Mier, *México en la Exposición Universal Internacional de Paris*, 22.

26 Godoy, *México en Paris*, 68.

27 Mexico, "Exposition Universelle Internacionale de Paris 1889," 25.

28 Ibid., box 1, exp. 3.

29 Confirming the French administration's territorial concession to the Latin American nations, Díaz Mimiaga writes, "It is a pleasure for me to report that, this matter having been considered, it has been resolved that only those Hispanic American nations that propose to give great importance to their exhibition and therefore to the building that contains it will be located at the indicated site. Until now this includes only the Argentine Republic, which is going to erect a spacious and beautiful construction, Bolivia, Venezuela, and Mexico, which, following my indications, will also have reserved a place in the middle of a garden." Ibid., box 1, exp. 3.

30 In *La edad de oro*, José Martí's account of the Exposition Universelle de Paris of 1889 that was written for children, the juxtaposition of absolute otherness (such as the Habitaciones del hombre exhibit, in which the ages of humanity from prehistoric to contemporary times are displayed in forty-three pavilions, including Persian, Egyptian, and Latin American

exhibits) and the celebratory landmarks of Occidental hegemony, such as the Eiffel Tower, ultimately balance one another in an overall democratic equivalency of value. In Aurelia Castillo de González's travel account of the 1889 fair, the fairgoer's individual capacity to undermine intentional hierarchies takes center stage as the author's recording of her first "rapid glimpse" of the fair barely touches on the Eiffel Tower and the famous Machines Gallery, only to rest on the Argentine and Mexican pavilions and elaborate her impressions of those structures. Castillo de González, *Un paseo por Europa.*

31 Mexico, "Exposition Universelle Internacionale de Paris 1889," box 11, exp. 1.

32 Ibid., vol. 11, exp. 12, 9.

33 Ibid., 10.

34 Ibid.

35 Ibid., box 1, exp. 3.

5. Collecting Numbers

1 Tenorio-Trillo, *Mexico at the World's Fairs,* 128–29.

2 Ibid., 126.

3 Tenorio-Trillo, ibid., 127, uses statistics, maps, and numbering to illustrate how Mexico represented its "proficiency in the lingua franca of late nineteenth-century Europe: science in its diverse forms." Cartography, patenting, and general public administration were all connected to statistics within the administrative circles of Western nations at this time (136).

4 The perceptual transition from space (piece of landscape or geographical feature) to number not only allows for an acceleration of the rate of change to take effect via the construction of instruments of transportation and communication but also exercises a type of metaphorical discipline on that landscape that helps define what James Clifford calls the "collecting attitude"—which means, in sum, to see something as something else (landscape as possession, thing as number, individual as part of a series)—as a core perceptual mode with respect to Mexican modernization. Elsner and Cardinal, *Cultures of Collecting,* 104.

5 Tenorio-Trillo, *Mexico at the World's Fairs,* xxiv.

6 Zea, *El positivismo en México,* 107; translation mine.

7 The Dirección de Instrucción Pública was founded as a key administrative entity for public education following its official secularization.

8 Instituto Nacional de Estadística, Geografía e Informática de Mexico, *Cronología de la estadística en México,* 28.

9 Ortiz de la Torre, *Instruction sobre los datos ó noticias,* 197.
10 Ibid., 199.
11 Ibid., 33.
12 Ibid., 38.
13 Instituto Nacional de Estadística, Geografía e Informática de Mexico, *Cronología de la estadística en México,* 4, 40.
14 Ibid., 36.
15 Ibid., 37.
16 *El Siglo XIX,* tome 73, number 11872.
17 The memo was dated December 1, 1885, which was three years after the creation of the Dirección General de Estadística by interim president Manual González.
18 Secretaría del Ayuntamiento Constitucional de México, "Estadística," exp. 42, section 1a, number 3; translation mine.
19 Ibid., exp. 43, section 4a, number 1.
20 Ibid., exp. 43, section 1a, number 3, 3.
21 Ibid., exp. 71, section 2a, number 4.
22 Tenorio-Trillo, *Mexico at the World's Fairs,* 128.
23 Esteva Ruiz, "La antropogeografía y la estadística," 548–57.
24 Stewart, *On Longing,* 152.
25 Poovey, *A History of the Modern Fact,* 33.
26 Bal, "Telling Objects," 97–115.
27 Bal, ibid., describes this dynamic from a theoretical perspective.
28 Secretaría de Fomento de México, *Anuario Estadístico de la República Mexicana 1894,* xviii.
29 Secretaría del Ayuntamiento Constitucional de México, "Estadística," exp. 42, section 4a, number 6.
30 Ibid., exp. 60, section 2a, number 1.
31 Ibid., exp. 71, section 2a, number 4.
32 Secretaría de Fomento de México, *Anales de la Secretaría de Fomento 1857–1910,* 1:367.
33 Secretaría de Fomento de México, *Anuario Estadístico de la República Mexicana 1893,* iii.
34 Ibid., xix; Secretaría de Fomento de México, *Anuario Estadístico de la República Mexicana 1895,* i.
35 Altamirano and Monsiváis, *Crónicas,* tome 1, 300.
36 Hermosa, *Manual de geografía y estadistica de la República Mexicana,* "Advertencia."
37 Poovey, *A History of the Modern Fact,* 58.
38 García Cubas, *Cuadro geográfico,* 163.
39 Ibid., 150.

40 Stewart, *On Longing,* 152.
41 Ibid., 90.
42 Derrida, *Archive Fever,* 27.
43 Ibid., 29.
44 Sánchez Santos, "Reseña de los trabajos de la Sociedad durante el año de 1900," 467.
45 Baudrillard, *System of Objects,* 90.
46 Megill, *Rethinking Objectivity,* 198.
47 García Cubas, *Cuadro geográfico,* v.

Conclusion

1 García de Germenos, "Salón Independiente," 49.
2 Ibid., 30.
3 Debroise, *La era de la discrepancia,* 25.
4 Ibid., 26.

Bibliography

❀ ❀ ❀

Acevedo, Esther, ed. *Arte e imagen*. Mexico City: Conaculta, 2001.

Aching, Gerard. *The Politics of Spanish American Modernismo*. Cambridge: Cambridge University Press, 1997.

Aguirre, Robert. *Informal Empire: Mexico and Central America in Victorian Culture*. Minneapolis: University of Minnesota Press, 2005.

Alonso, Carlos. *The Burden of Modernity: The Rhetoric of Cultural Discourse in Spanish America*. New York: Oxford University Press, 1998.

Altamirano, Ignacio Manuel, and José Luis Martínez. *Escritos de literatura y arte*. Mexico City: Consejo Nacional para la Cultura y las Artes, 1989.

Altamirano, Ignacio Manuel, and Carlos Monsiváis. *Crónicas*. Mexico City: Secretaría de Educación Pública, 1987.

Altshuler, Bruce. *Salon to Biennial: Exhibitions That Made Art History*. London: Phaidon, 2008.

Andermann, Jens. *The Optic of the State: Visuality and Power in Argentina and Brazil*. Pittsburgh, Penn.: University of Pittsburgh Press, 2007.

Andermann, Jens, and Beatriz González Stéphan. *Galerías del progreso: Museos, exposiciones y cultural visual en América Latina*. Buenos Aires: Beatriz Viterbo, 2006.

Anderson, Benedict. *Imagined Communities: Reflections of the Origin and Spread of Nationalism*. London: Verso, 1983.

Appadurai, Arjun. *Modernity at Large: Cultural Dimensions of Globalization*. Minneapolis: University of Minnesota Press, 1996.

———, ed. *The Social Life of Things: Commodities in Cultural Perspective*. Cambridge: Cambridge University Press, 1986.

Asunción Silva, José. *De sobremesa*. Buenos Aires: Editorial Losada, 1992.

Báez Macías, Eduardo, ed. *Guía del archivo de la Antigua Academia de San Carlos 1867–1907*. 3 vols. Mexico City: Universidad Nacional Autónoma de México, 1993.

Bal, Mieke. "Telling Objects: A Narrative Perspective on Collecting." In *The Cultures of Collecting*, edited by John Elsner and Roger Cardinal, 97–115. Cambridge, Mass.: Harvard University Press, 1994.

Bárcena, Mariano. "Introducción al estudio de la paleontología mexicana." In *Anales del Museo Nacional de México*, vol. 1, edited by the Instituto Nacional de Antropología e Historia de México, 43–46. Mexico City: Museo Nacional de Antropología.

Barreda, Gabino. "Oración cívica." Antología del Ensayo. http://www.ensayistas.org/antologia/XIXA/barreda/.

Barros, Catalina, and Cristina Barros, eds. *Justo Sierra: Antología General.* Mexico City: Universidad Nacional Autónoma de México, 1982.

Bartra, Roger. *La jaula de la melancolía: identidad y metamorphosis del mexicano.* Mexico City: Editorial Grijalbo, 1987.

Baudrillard, Jean. *The System of Objects.* Translated by James Benedict. London: Verso, 1996.

Benjamin, Walter. *The Origin of German Tragic Drama.* London: New Left Books, 1977.

Benson, Elizabeth P. "The Robert Woods Bliss Collection of Pre-Columbian Art." In *Collecting the Pre-Columbian Past,* edited by Elizabeth Hill Boone, 123–40. Washington, D.C.: Dumbarton Oaks, 1993.

Berman, Marshall. *All That Is Solid Melts into Air: The Experience of Modernity.* New York: Simon and Schuster, 1982.

Bernal, Ignacio. *A History of Mexican Archeology: The Vanquished Civilizations of Middle America.* London: Thames and Hudson, 1980.

Bortz, Jeff, and Stephen H. Haber. *The Mexican Economy, 1870–1930: Essays on the Economic History of Institutions, Revolution, and Growth.* Palo Alto, Calif.: Stanford University Press, 2002.

Botello, Manuel Aguirre. "El Caballito: historia y sitios que ocupó." http://www.mexicomaxico.org/Caballito/caballito.htm.

———. "Estatuas del Paseo de la Reforma." http://www.mexicomaxico.org/Reforma/reformaEstatuas.htm.

Brading, David A. "Manuel Gamio and the Official Indigenismo in Mexico." *Bulletin of Latin American Research* 7, no. 1 (1988): 75–89.

Buck-Morss, Susan. *The Dialectics of Seeing.* Cambridge, Mass.: MIT Press, 1989.

Bullock, W. *Six Months' Residence and Travels in Mexico: Containing Remarks on the Present State of New Spain, Its Natural Productions, State of Society, Manufactures, Trade, Agriculture, and Antiquities, &C.* Port Washington, NY: Kennikat Press, 1971.

Busto, Emiliano. *Estadística de la República Mexicana.* 3 vols. Mexico City: I. Cumplido, 1880.

Camp, Roderic Ai. *Politics in Mexico.* New York: Oxford University Press, 1996.

Cárdenas, Enrique. "A Macroeconomic Interpretation of Nineteenth-century Mexico." In *How Latin America Fell Behind: Essays on the Economic Histories of Brazil and Mexico, 1900–1914,* edited by Stephen Haber, 65–92. Palo Alto, Calif.: Stanford University Press, 1997.

Castillo de González, Aurelia. *Un paseo por Europa: cartas de Francia (Exposición de 1889), de Italia Y de Suiza.* Habana: La Propoganda Literaria, 1891.

Charnay, Désiré, J. Gonino, and Helen S. Conant. *The Ancient Cities of the New World: Being Voyages and Explorations in Mexico and Central America from 1857–1882.* New York: Harper, 1887.

Chavero, Alfredo. "Discurso pronunciado el 24 de septiembre de 1904 en el Congreso de Artes y Ciencias de la Exposición Universal de San Luis, Missouri." 1905. In *Anales del Museo Nacional de México,* edited by the Instituto Nacional de Antropología e Historia de México. Mexico City: Museo Nacional de Antropología.

Chavero, Alfredo, and Joaquín Baranda. *Homenaje á Cristóbal Colón: antigüedades mexicanas.* Mexico City: Oficina Tipográfica de la Secretaría de Fomento, 1892.

Comas, Juan. *Cien años de Congresos Americanistas: ensayo histórico, crítico y bibliográfico.* Mexico City: Instituto de Investigaciones Históricas, 1974.

Conn, Steven. *Museums and American Intellectual Life: 1876–1926.* Chicago: University of Chicago Press, 1998.

Davis, Keith F., ed. *Désiré Charnay, Expeditionary Photographer.* Albuquerque: University of New Mexico Press, 1981.

Debroise, Olivier. *La era de la discrepancia: arte y cultural visual en México, 1968–1997.* Mexico City: Universidad Nacional Autónoma de México, 2006.

de Mier, Sebastian B. *México en la Exposición Universal Internacional de Paris—1900.* Mexico City: Secretaria de Fomento, 1901.

Derrida, Jacques. *Archive Fever: A Freudian Impression.* Translated by Eric Prenowitz. Chicago: University of Chicago Press, 1995.

Díaz-Andreu, Margaret. *A World History of Nineteenth-century Archaeology: Nationalism, Colonialism, and the Past.* New York: Oxford University Press, 2007.

Elsner, John, and Roger Cardinal, eds. *The Cultures of Collecting.* Cambridge, Mass.: Harvard University Press, 1994.

Esteva Ruiz, Roberto A. "La antropogeografía y la estadística." *Boletín de la Sociedad Mexicana de Geografía y Estadística* 4, no. 4 (1897): 545–57.

Evans, R. Tripp. *Romancing the Maya: Mexican Antiquity in the American Imagination 1820–1915.* Austin: University of Texas Press, 2004.

Fernández, Justino. *Estética del arte mexicano: Coatlicue. El retablo de los reyes. El hombre.* Mexico City: Universidad Nacional Autónomade México, Instituto de Investigaciones Estéticas, 1990.

Fernández, Miguel Ángel. *Historia de los museos de México.* Mexico City: Promotora de Comercialización Directa, 1988.

Florescano, Enrique. *Memory, Myth, and Time in Mexico: From the Aztecs to Independence.* Translated by Albert G. Bork. Austin: University of Texas Press, 1994.

Galindo y Villa, Jesús. *Breve noticia histórico-descriptiva del Museo Nacional de México*. Mexico City: Museo Nacional, 1901.

———. "Exposición general sobre la arqueología mexicana." 1914. In *Anales del Museo Nacional de México*, edited by the Instituto Nacional de Antropología e Historia de México. Mexico City: Museo Nacional de Antropología.

———. *Guía para visitar los salones de historia de México del Museo Nacional*. Mexico City: Museo Nacional, 1896.

Gamio, Manuel. "The Prejudices in Archaeology and Ethnography." In *Anales del Museo Nacional de México*, vol. 5, epoch 3a, edited by the Instituto Nacional de Antropología e Historia de México, 153–60. Mexico City: Museo Nacional de Antropología.

García, Genaro. "Advertencia." In *Anales del Museo Nacional de México*, edited by the Instituto Nacional de Antropología e Historia de México. Mexico City: Museo Nacional de Antropología.

———. *Crónica oficial de las fiestas del primer Centenario de la Independencia de México*. Mexico City: Museo Nacional, 1911.

García Barragán, Elisa, and Agustín Arrieta. *José Agustín Arrieta: lumbres de lo cotidiano*. Mexico City: Fondo Editorial de la Plástica Mexicana, 1998.

García Cubas, Antonio. *Cuadro geográfico, estadístico, descriptivo é histórico de los Estados Unidos Mexicanos*. Mexico City: Oficina Tipográfica de la Secretaría de Fomento, 1884.

García Cubas, Antonio, and Casimiro Castro. *Album of the Mexican Railway: A Collection of Views*. Mexico City: Editorial Innovación, 1981.

García de Germenos, Pilar. "Salón Independiente: Una relectura." In *La era de la discrepancia: arte y cultural visual en México, 1968–1997*, 40–57. Mexico City: Universidad Nacional Autónoma de México, 2006.

Garner, Paul. *Porfirio Díaz: Profiles in Power*. London: Pearson Education, 2001.

Gielbelhausen, Michaela, ed. *The Architecture of the Museum: Symbolic Structures, Urban Contexts*. Critical Perspectives in Art History. Manchester, U.K.: Manchester University Press, 2003.

Godoy, José Francisco. *México en París: reseña de la participación de la República mexicana en La Exposición de París en 1889*. Mexico City: Tipografía de Alfonso E. López, 1890.

González-Stephan, Beatriz, and Jens Andermann, eds. *Galerías del progreso: museos, exposiciones y cultura visual en América Latina*. Buenos Aires: Beatriz Viterbo, 2006.

Good, Carl, and John V. Waldron. *The Effects of the Nation: Mexican Art in an Age of Globalization*. Philadelphia: Temple University Press, 2001.

Graham, Ian. *Alfred Maudslay and the Maya: A Biography*. Norman: University of Oklahoma Press, 2002.

Greenhalgh, Paul. *Ephemeral Vistas: The Expositions Universelles, Great Exhibitions, and World's Fairs, 1851–1939*. Manchester, U.K.: Manchester University Press, 1988.

Gutiérrez Abascal, R. *El paisajista José María Velasco (1840–1912)*. Mexico City: Fond de Cultura Económica, 1943.

Harrison, Carol E. "Projections of the Revolutionary Nation: French Expeditions in the Pacific, 1791–1803." *Osiris* 24, no. 1 (2009): 33–52.

Hermosa, Jesús. *Manual de geografía y estadística de la República Mexicana*. Paris, 1857.

Huysmans, Joris-Karl. *Against Nature*. Translated by Robert Baldick. New York: Penguin Books, 1959.

Instituto Nacional de Antropología e Historia de México. *Anales del Museo Nacional de México: Colección completa 1877–1977*. 1st ed. Epochs 1–3. CD-ROM. Mexico City: Fundación MAPFRE TAVERA, 2002.

Instituto Nacional de Estadística, Geografía e Informática de México. *Cronología de la estadística en México (1521–2003)*. Mexico City: Instituto Nacional de Estadística, Geografía e Informática, 2005.

Kaplan, Flora S. *Museums and the Making of "Ourselves": The Role of Objects in National Identity*. London: Leicester University Press, 1994.

Keen, Benjamin. *The Aztec Image in Western Thought*. New Brunswick, N.J.: Rutgers University Press, 1971.

León, Aurora. *El museo: Teoría, praxis y utopia*. Madrid: Ediciones Cátedra, 1978.

León y Gama, Antonio de. *Descripción histórica y cronológica de las dos piedras, que con ocasión del nuevo empedrado que se está formando en la plaza principal de México, se hallaron en ella el año de 1790*. Mexico City: Don F. de Zúñiga y Ontiveros, 1792.

Lida, Clara E., ed. *Una inmigración privilegiada: comerciantes, empresarios y profesionales españoles en México en los siglos XIX y XX*. Madrid: Alianza, 1994.

Marichal, Carlos. "Obstacles to the Development of Capital Markets in Nineteenth-century Mexico." In *How Latin America Fell Behind: Essays on the Economic Histories of Brazil and Mexico, 1900–1914*, edited by Stephen Haber, 118–45. Palo Alto, Calif.: Stanford University Press, 1997.

Martí, José. *Le edad de oro*. Miami, Fla.: Ediciones Universal, 2001.

Martínez, José Luis, ed. *Ramón López Velarde: Obra poética*. Paris: Signatarios del Acuerdo Archivos, 1998.

Marx, Karl, and David McLellan. *Capital: An Abridged Edition*. Oxford: Oxford University Press, 1995.

Megill, Allan, ed. *Rethinking Objectivity*. Durham, N.C.: Duke University Press, 1994.

Mejía, Demetrio. "Report to the Secretary of Justice and Public Instruction." In *Anales del Museo Nacional de México*, edited by the Instituto Nacional de

Antropología e Historia de México, vol. 4, epoch 1, 17–24. Mexico City: Museo Nacional de Antropología.

Mendoza, Gumesindo, and Jésus Sánchez. *Catálogo de las colecciones, histórica y arqueológica del Museo Nacional de México.* Mexico City: I. Escalante, 1882.

Mexico. "Exposition Universelle Internacionale de París 1889." *Catalogue officielle de l'Exposition de la République Mexicaine.* Paris: Générale Lahure, 1889.

Meyer, Michael C., and William L. Sherman. *The Course of Mexican History.* New York: Oxford University Press, 1991.

Mitchell, W. J. Thomas. *Iconology: Image, Text, Ideology.* Chicago: University of Chicago Press, 1986.

Morales-Moreno, Luis Gerardo. "History and Patriotism in the National Museum of Mexico." In *Museums and the Making of Ourselves: The Role of Objects in National Identity,* edited by Peggy Phelan, 171–91. London: Leicester University Press, 1994.

———. *Orígenes de la museología mexicana: Fuentes para el estudio histórico Del Museo Nacional, 1780–1940.* Mexico: Universidad Iberoamericana, Departamento de Historia, 1994.

Nora, Pierre, and Lawrence D. Kritzman. *Realms of Memory: Rethinking the French Past.* New York: Columbia University Press, 1996.

Ortega, Martha M., José Luis Godínez, and Gloria Vilaclara. *Relación histórica de los antecedentes y origen del Instituto de Biología.* Mexico City: El Instituto, 1996.

Ortiz de la Torre, Manuel. *Instruccion sobre los datos o noticias que se necesitan para la formación de la estadística de la república.* 1833.

Peer, Shanny. *France on Display.* Albany: State University of New York Press, 1998.

Peñafiel, Antonio. *Explication de l'edifice Mexicain a l'Exposition Internationale de París en 1889.* Barcelona: d'Espase et Compagnie, 1889.

Pérez Vejo, Tomás. *Nación, identidad nacional y otros mitos nacionalistas.* Oviedo, Spain: Nobel, 1999.

Poovey, Mary. *A History of the Modern Fact: Problems of Knowledge in the Sciences of Wealth and Society.* Chicago: University of Chicago Press, 1992.

Ramírez, Fausto. "Dioses, heroes y reyes mexicanos en París, 1889." In *Historia, leyendas y mitos de México: su expresión en el arte (XI Coloquio Internacional de Historia del Arte),* 201–53. Mexico City: Universidad Nacional Autónoma de México, 1988.

———. "El proyecto artístico en la Restauración de la República." In *Los pinceles de la historia: La fabricación del estado 1864–1910,* edited by Jaime Soler and Esther Acevedo, 54–89. Mexico City: Instituto Nacional de Bellas Artes, 2003.

Ramírez, José. Letter to Carlos Pacheco. March 28, 1890. Exposition 28 of

Exposiciones, vol. 11. Mexico City: Archivo General de la Nación.

Ramos, Julio. *Desencuentros de la modernidad en América Latina: literatura y política en el siglo XIX*. Mexico City: Fondo de Cultura Económica, 1989.

Riegl, Aloïs. "El culto moderno a los monumentos: carácteres y origen." *La balsa de la Medusa 7* (1903): 9–99.

Rodríguez Prampolini, Ida, ed. *La crítica de arte en México en el siglo XIX*. 2nd ed. 3 vols. Coyoacán, Mexico: Instituto de Investigaciones Estéticas, 1997.

Romero de Terreros, Manuel. *Paisajistas mexicanos del siglo XIX*. Mexico City: Universitaria, 1943.

Rutsch, Mechthild. "Natural History, National Museum, and Anthropology in Mexico: Some Reference Points on the Forging and Re-forging of National Identity." *Perspectivas Latinoamericanas* 1 (2004): 89–122.

Rydell, Robert. *All the World's a Fair: Visions of Empire at American International Expositions, 1876–1916*. Chicago: University of Chicago Press, 1984.

Sánchez, Jesús. "Informe al Secretario de Justicia e Instrucción Pública." In *Anales del Museo Nacional de México*, edited by the Instituto Nacional de Antropología e Historia de México, vol. 4, epoch 1, 3–4. Mexico City: Museo Nacional de Antropología.

Sánchez Arreola, Flora Elena. *Catálogo del archivo de la Escuela Nacional de Bellas Artes 1857–1920*. Mexico City: Instituto de Investigaciones Estéticas, 1996.

Sánchez Santos, Trinidad. "Reseña de los trabajos de la Sociedad durante el año de 1900." *Boletín de la Sociedad Mexicana de Geografía y Estadística* 4, no. 4 (1897): 466–67.

Schávelzon, Daniel, ed. *La polémica del arte nacional en México, 1850–1910*. Mexico City: Fondo de Cultura Económica, 1988.

Schreffler, Michael J. "The Making of an Aztec Goddess: A Historiographic Study of the Coatlicue." M.A. thesis, Arizona State University, 1994.

Secretaría de Fomento de México. *Anales de la Secretaría de Fomento 1857–1910*. 11 vols. Mexico City: Oficina Tipográfica de la Secretaría de Fomento.

———. *Anuario Estadístico de la República Mexicana*. Numbers 1–3. Mexico City: Oficina Tipográfica de la Secretaría de Fomento, 1894–96.

———. *Memorias de Fomento, 1857–1910*. Mexico City: Biblioteca del Archivo General de la Nación, 1900.

Secretaría del Ayuntamiento Constitucional de México. "Estadística." Government typescripts and manuscripts, 1880–1899. Expedients 41–77. Mexico City: Archivo del Antiguo Ayuntamiento de México.

Secretaría del Ayuntamiento Constitucional de México. "Historia-monumentos." Government correspondence, 1867–1910. Expedients 12–1098. Mexico City: Archivo del Antiguo Ayuntamiento de México.

Soler, Jaime, and Esther Acevedo, eds. *Los pinceles de la historia: La fabricación del estado 1864–1910*. Mexico: Instituto Nacional de Bellas Artes, 2003.

Solkin, David H. *Art on the Line: The Royal Academy Exhibitions at Somerset House, 1780–1836.* New Haven, Conn.: Yale University Press, 2001.

Sosa, Francisco. "A la prensa nacional." 1887. In *La crítica del arte en México en el siglo,* vol. 3, edited by Ida Rodríguez Prampolini, 215–18. Mexico City: Instituto de Investigaciones Estéticas, 1997.

Stewart, Susan. *On Longing.* Durham, N.C.: Duke University Press, 1993.

Taussig, Michael. *The Magic of the State.* New York: Routledge, 1997.

Tenorio-Trillo, Mauricio. "1910 Mexico City: Space and Nation in the City of the *Centenario.*" *Journal of Latin American Studies* 28, no. 1 (1996): 75–104.

———. *Mexico at the World's Fairs: Crafting a Modern Nation.* Berkeley: University of California Press, 1996.

Topik, Steven C. "When Mexico Had the Blues: A Transatlantic Tale of Bonds, Bankers, and Nationalists, 1862–1910." *American Historical Review* 105, no. 3 (2000), http://www.historycooperative.org/journals/ahr/105.3/ahoo0714.html.

Tufte, Edward R. *The Visual Display of Quantitative Information.* Cheshire, Conn.: Graphics Press, 2001.

Vásquez de Knauth, Josefina. *Nacionalismo y educatión en México.* Mexico City: Dentro de Estudios Históricos, 1970.

Velázquez Guadarrama, Angélica. *La colección de pintura del Banco Nacional de México: Catálogo siglo XIX.* 2 vols. Mexico City: Fomento Cultura Banamex, 2004.

Wasserman, Mark. *Everyday Life and Politics in Nineteenth-century Mexico: Men, Women and War.* Albuquerque: University of New Mexico Press, 2000.

Waterfield, Giles. *Palaces of Art: Art Galleries in Britain, 1790–1990.* London: Dulwich Picture Gallery, 1991.

Webmoor, Timothy. "An Archaeology of Mexican Nationalism: Cultural Politics and Archaeological Knowledge." Unpublished paper, Stanford University, 2003.

Weiner, Richard. *Race, Nation, and Market: Economic Culture in Porfirian Mexico.* Tucson: University of Arizona Press, 2004.

Widdifield, Stacie G. *The Embodiment of the National in Late Nineteenth-century Mexican Painting.* Tucson: University of Arizona Press, 1996.

———, ed. *Hacia otra historia del arte en México: La amplitud del modernismo y la modernidad (1861–1920).* Vol. 2. Mexico City: Conaculta, 2004.

Williams, Elizabeth. "Collecting and Exhibiting Pre-Columbiana in France and England, 1870–1930." In *Collecting the Pre-Columbian Past,* edited by Elizabeth Hill Boone, 123–40. Washington, D.C.: Dumbarton Oaks, 1993.

Zea, Leopoldo. *El positivismo en México: Nacimiento, apogeo y decadencia.* Mexico City: Fondo de Cultura Económica, 1993.

Index

✼ ✼ ✼

Meyer, Michael: *The Course of Mexican History*, 15–16
middle class, Mexican: artistic commissions for, 44; as artistic subjects, 190n34; cultivation of taste, 60; viewers, 49
Mier, Sebastián de, 136, 145–46, 148
military, Mexican, 11–12, 13, 14
Millas, Monsieur, 151
Miranda, Primitivo, 122
Mirzoeff, Nicolas, 2
Mitchell, W. J. T., 71
Moctezuma, gift to Cortés, 67
modernity: construction through art, 63; European, 20–21, 144; Latin American, 188n3; role of science in, 73; universal discourses of, 82
modernity, Mexican: construction of, 152; cultural capital in, 78, 80; failure in, 142; genre painting in, 45; national history in, 89; Porfirian promotion, 98; relationship to antiquity, 146; scientific discourse of, 89
modernization: bargaining in, 173; destructive aspects of, 20–21; fetishistic, 125; as phenomenon, 21
modernization, Latin American, 177; European models for, 21–22; global perspectives on, 20; local issues in, 20
modernization, Mexican, 19–27; commercial motivations for, 116–20; hierarchical values in, 21; patriotic rhetoric of, 125; role of international market in, 19; role of patrimony in, 21; role of public monuments in, 109, 116–20, 121; through statistics,

154, 156, 204n4
El Monitor (newspaper), statistical reports of, 164
El Monitor Republicano, on protection of monuments, 80
Monroy, Petronilo: *Allegory of the Constitution of 1857*, 189n11
monuments, unintentional, 107. *See also* pre-Columbian monuments; public monuments, Mexican
Monument to Independence (Mexico City), 119; casting of, 118, 120
Morales-Morena, Luis Gerardo, 17–18, 23–24; on Museo Nacional, 70; on viewer restrictions, 95
Morelos, José María, 33
MUNAL art exposition (1984), 56
muralist paintings, Mexican, 31
Museo Nacional (Mexico), 3; access to, 92–93; collective memory at, 25, 66; commercial links of, 70; consolidation of, 18; disciplinary spaces of, 5; establishment of national patrimony, 10; Gallery of Monoliths, 77, 78–79, 79, 100; international influences on, 104; Maximilian and, 72; participation in world's fairs, 70; patrimonial base of, 104; pedagogical function of, 93–94; political autonomy through, 77–78; production of citizens, 94; recovery of national loss, 65–66; role in state formation, 17; Salon of Archaeology, 84, 88; *salón secreto* of, 99–100, 169; transformations to, 77; visitors to, 198n65

manufacturing of, 127; and
melancholy, 141
numbers: embodiment of truth,
164; perceptual transitions to,
204n4; shift from objects to, 175.
See also statistics

objects: classification of, 94;
generation of meaning, 99, 125,
147–48, 159; of Porfiriato, 2–3;
social dimensions of, 94. *See also*
collected objects
Obregón, José, 192n52; *The
Discovery of Pulque,* 189n11
Ocaranza, Manuel, 46; *Café de la
Concordia,* 193n75; *A Parishioner,*
192n50
Olympic games (Mexico City,
1968), 179
order, Mexican: quest for, 6–10;
role of national statistics in, 26,
155–57; state guardianship of,
155–56
origins, Mexican national:
disagreements concerning,
90; establishment of, 10–15,
63–64; fetishism of, 49, 141;
improvisations on, 91; in
national collections, 51, 63–64;
and ordering of objects, 164;
refoundation of, 84, 86; scientific
discourse of, 90
Orozco y Berra, Manuel, 195n5
Ortiz de la Torre, Manuel, 156–57
otherness: economic use of, 144;
at Palacio azteca, 144; self and,
140, 141
Overbeck, Johann Friedrich, 38

Pacheco, Carlos, 23
painterly canon, European: art

critics on, 64; marketability of,
104–5; Mexican alternatives to,
54–58
painterly canon, Mexican, 16, 18,
29–31; Academia de San Carlos
on, 31; center and periphery
in, 51; consumers of, 49, 53;
critics on, 39–40, 49–50, 105;
debates over, 33; effect on
artistic development, 180; elites'
concern for, 32; gaps in, 34–35;
liberal perspectives on, 178;
"Mexican" themes of, 33–34;
negotiation concerning, 31;
public interest in, 47; traditional
perspectives on, 178. *See also* art,
Mexican
Palacio azteca (Exposition
Universelle of 1889), 25–26;
architectural styles of, 148;
cataloged exhibit of, 148–49;
commercial aspects of, 148,
178; exterior of, 142, 145, 148,
203n19; gods depicted at, 144,
146–47; interior of, 144, 146, 147,
148, 149, 203n19; nationalism
in, 148; national patrimony in,
149; otherness of, 144; problems
with, 138–39; seriality of, 148–49;
space allotted to, 149. *See also*
Exposition Universelle (Paris,
1889)
paleontology, Mexican, 90
Palmerston, Lord, 70
Paris World's Fair (1900): art as
merchandise in, 188n3; Mexican
participation in, 136
Parra Hernández, Félix, 193n69;
Still Life, 54, 56, 56, 193n71
El Partido Liberal, 120; on public
monuments, 117–18, 121

opinion on, 110, 121; role in
modernization, 109, 116–20, 121;
sacred qualities of, 131; safety of,
132; social class in, 25, 127–33;
subscriptions to, 129–33, 133;
unifying agency of, 129, 133;
unveiling of, 3; value systems of,
111, 132, 133; viewers of, 124–25;
visceral effect of, 127; visibility
of, 200n16. *See also specific
monuments*
public sphere, Mexican: cultural
objects in, 3, 4
Puebla (Mexico): art academy of,
44; colonial buildings of, 43;
genre painting in, 191n43; glass
factories of, 53

Quetelet, Adolphe, 157

Rama, Ángel, 20
Ramírez, Fausto, 23, 33, 144; on
Parra Hernández, 193n71; on
patria, 199n79
Ramírez, Ignacio: monument to,
122
Ramírez, José, 1
Ramos, Julio, 20, 188n3
Rebull, Santiago, 37
La Reforma, Mexican, 9; rhetoric
of, 11
Renan, Ernest, 126
Revillagigedo (viceroy), 97, 98
Revista de Sociedad, Arte y Letras,
117
revolution, and stabilization, 13, 14
Revolution of Ayutla, 7
Reyes, Vincent, 108
Riegl, Alöis, 107
Riva Palacio, Vicente: *México a
través de los siglos*, 194n4

Rivas Mercado, Antonio, 38, 108,
118
Robertson, William, 77
Rodríguez Arangoiti, Ramón, 118
Rodríguez Prampolini, Ida: on art
critics, 188n4; *La crítica de arte en
México en el siglo XIX*, 24, 39; on
European cultural influences,
38; on monuments, 122
romantic poets, Mexican, 139
ruins, indigenous, 8. *See also* pre-
Columbian monuments
Rutsch, Mechthild, 89
Rydell, Robert, 143

Sahagún, Bernardino de, 65
Saint-Aubin, Gabriel de: *Salon de
1767*, 36
Salcedo, Manuel, 47
Salinas, Carlos, 179
Salvin, Osbert: *Biologia Centrali-
Americana*, 75
Sánchez, Jesús, 66, 84, 195n7;
*Catalogue of the Historical and
Archaeological Collections*, 81; on
Mexican patrimony, 78
Sánchez Arreola, Flora Elena,
189n14
Sánchez Santos, Trinidad, 171, 172
Sánchez Solís, Felipe, 40–41,
190n32
Santa Anna, Antonio López, 6, 7
Sarlo, Beatriz, 20
Schávelson, Daniel: *La polemica del
arte nacional en México*, 136
Schreffler, Michael J., 199n85
sciences, Mexican: discourse of
origins in, 90; as lingua franca,
204n3; as marketing tool, 90;
nationalization of, 24, 105; and
patria, 174; popularization of,

Shelley E. Garrigan is assistant professor of Spanish at North Carolina State University.